IMAZIGHEN

IMAZIGHEN

The Vanishing Traditions of Berber Women

Margaret Courtney-Clarke
Essays by Geraldine Brooks

Clarkson Potter/Publishers
New York

For Luigi

Published by Clarkson N. Potter, Inc., 201 East 50th Street, New York,
New York 10022. Member of the Crown Publishing Group.

Random House, Inc. New York, Toronto, London, Sydney, Auckland

CLARKSON N. POTTER, POTTER, and colophon are trademarks
of Clarkson N. Potter, Inc.

Design based on original format by Massimo Vignelli

Manufactured in China

Library of Congress Cataloging-in-Publication Data is available
upon request.

ISBN 0-517-59771-3

10 9 8 7 6 5 4 3 2 1

First Edition

ACKNOWLEDGMENTS

However tenacious or obstinate a person can be in setting a target, seldom is one able to reach that target alone. The general concept and the material realization of a work are undeniably the concern of the author, but when the work spans considerable time—and in order to maintain the highest possible level—one needs unquestionable support from the outside, both morally and physically. Without the steady presence or even occasional or spiritual presence of so many people, I would not have been able—or known how—to overcome moments of absolute discouragement, of disappointments, or of physical difficulties that I encountered over the period of four years. It is also the very presence of these persons with whom I shared the joys and the moments of profound exaltation that filled these long years of travel and that now fill the pages of this book.

I am grateful to my father, Stanhope, whose love of Africa and reverence for life sustained me on all my journeys.

A thank-you to my friend of long standing Lauren Shakely, editor and unfailing shelter during my literary crisis and always a point of reference for good sense and sensitivity. Equal thanks to my agent, David Chalfant, who allowed me to move more freely and with the least anxiety by alleviating the weight of bureaucratic worries.

I am especially grateful to Maya Angelou, who—during many calm phone calls—inspired faith and courage that gave me the reassurance necessary to continue with my search.

To my special friend Geraldine Brooks, who was willing to share her professional expertise and knowledge of the world of Muslim women as well as the discomforts of traveling over forbidding terrain in order to write her essay for this book.

To Howard Klein I extend enormous gratitude for his dedication and invaluable assistance on the selection of photographs and design throughout these pages.

Of special significance was the initial endorsement of this project which came from Jean Dethier of the Centre Georges Pompidou in Paris. His dedication to the restoration and preservation of mud building in Africa will enrich future generations.

To all my friends and family around the world who have put up with my comings and goings, with long silences and sometimes my outbursts, I am indebted for their patience and understanding. In particular I would like to thank Valerie Cann, who has witnessed the birth—and saga—of the three books in this series, and whose assistance and trust have been invaluable throughout these years; Taina and Rocco for providing a home filled with peace and warmth during my numerous visits to America; John and Chi, Cathy and Dempsey, Richard and Nola, Rita and Gigino, and my assistant, Virginia. Thank you.

A sincere thank-you to all those people who assisted with the logistics and enabled—on all levels—free movement throughout the countries visited during this project. In particular: the Ambassador of the Kingdom of Morocco to New York, Dr. Abdeslam Jaidi, whose constant concern allowed our work to flow smoothly; the Gouverneur Chef de Cabinet du Ministre d'Etat à l'Intérieur et à l'Information in Rabat, Dr. Othman Bouabid, for his kindness and efficiency shown at all times; the Wali of Fez, Dr. M'hammed Dryef, for the hospitality and for sharing his profound knowledge of his country; the Directeur du Projet Haute Atlas Central, Dr. Abdelaziz El Kathabi, for his care, competence, and friendship demonstrated during a journey into one of the most inaccessible parts of Morocco; the Délégué Provincial de l'Artisanat of El Hoceima, Hamid El Gannab, for his patience and ability to fulfill some bizarre requests from a curious Anglo-Irish photographer; Aïcha and her three sons, Mohammed, Brahim, and Alì Lemnaouar, who provided a real home for us on each of our journeys to Morocco. To Brahim and Alì our appreciation for weeks of travel and for sharing Berber culture with us through endless hours of translation from an untold number of dialects; Abdenour Serbouh, "Dinor," my Algerian driver, interpreter, guide, bearer, and endless moral supporter, for his enthusiasm and energy and laughter. To all his extensive family throughout the Great Kabylia, for their immeasurable hospitality; Anne Moreau and her family in France, for sharing their valuable knowledge of Algerian pottery; Azel Arab Mernissi —an official guide in Fez—for his kind help, impeccable manners, and the humanity shown during our brief period together; Abdellah Idrissi Sghiouri and Aïcha Rachidi of the rural commune of Beni Frassen; all the *gouverneurs*, *chefs de cercle*, *caïds*, *khalifahs*, *sheikhs*, and *mokadems* who helped along the way to realizing this book.

I am of course most deeply indebted to Luigi, who has given his time, his energy, his knowledge, his help, and his absolute dedication to this project. *Grazie.*

CONTENTS

PREFACE

"Life is a loom, whose threads are the days. God decides when to cut the threads, even though [the work] is unfinished."
—Ancient Berber Proverb

MY JOURNEY FOR THIS BOOK began fifteen years ago, when I first started leaving my home in New York City—and later Italy—to document the mural paintings and personal adornments of the Ndebele people of southern Africa. At the time I had no idea I would traverse the Sahara desert and the sometimes barren and inhospitable landscapes of West Africa or scale the forbidding heights of the mountainous regions of North Africa—all in search of the women who for centuries have personalized their domestic environment and made it unique with their splendid creative spirit.

After working and living with the Ndebele and publishing those photographs in *Ndebele: The Art of an African Tribe*, I set out to look for women in West Africa who use decorative motifs to add color and warmth to their living spaces. Although much has been written about vernacular architecture and decorative artifacts from Africa, few books or articles record information about women and their art. *African Canvas* is the result of three years' work in West Africa. In the last stages of photographing that book, I came across Muslim women in Oulata, Mauritania, who decorated their mud dwellings with motifs inspired by their devotion to Islam. This dynamic architecture so intrigued me that I decided to return, traveling across the Sahara along the camel routes to North Africa and ultimately to the Berber women of this book.

The unique artistic traditions of women in Africa —their mural painting, pottery, weaving, and also the space that governed their lives—are vanishing, just as the cultures that gave birth to them are vanishing. Even in remote towns and villages the younger generation has begun to reject the traditional way of life, and Islamic fundamentalism, European and colonial influences, and emigration of North Africans to the cities, to Europe, and across the Atlantic Ocean have disrupted the ancient rhythms of life.

Searching for mural art, I first encountered the Berber women in Algeria who still decorate the interiors of their homes, but political upheaval prevented me from returning to continue my research and photography.

My search then took me to Morocco and Tunisia, and after I spent time with Berber women, the focus of this book shifted. I was so moved by the hard lives that Berber women lead, especially those eking out a living in remote and isolated mountain areas, that I could not let their tasks and burdens pass unacknowledged. Despite the privations of their daily lives, Berber women have always found time to make pottery and do weaving, not only using what the earth gives them to make their environment livable, but also bringing a bit of beauty into a harsh world.

Very often, when I arrived in a village—alone and laden with camera equipment—they avoided eye contact, much less conversation. In a dramatic contrast to all my previous experiences in Africa, I could not talk directly with the women but first had to negotiate with their husbands—if there was no husband then the next male in the patriarchal line—to allow me to photograph the women themselves. The men were obsessed about the idea that images of their women would be sold on the streets of Paris on postcards, as has frequently occurred when foreign photographers have entered their secluded world. But there were also times when the women were merely ordered to cooperate.

During these journeys, I frequently felt as if I were an intruder and was never sure whether I was doing the women a disservice by interviewing and photographing them. Because my male interpreters

viii

were generally forbidden to enter their domain, I had to rely on a sense of humor and laughter and body language to win the women's trust. As I spent time with them in their cooking areas and participated in their domestic activities, such as baking bread and making butter, they began to feel at ease with me. The scarves that covered their heads were allowed to slip down, revealing the tattoos that decorated their faces. When they took my hands finally, and began the long procedure of decorating them with henna, I knew I had been accepted as a friend.

For ten years I had traveled alone in Africa, but the rough terrain of the Atlas Mountains of North Africa made me rethink this habit, as did the extreme climates and, worst of all, the aggression and frustration of dealing with a male-dominated world. I persuaded my husband, Luigi Minissi, to join me, and it made my mission more credible and tolerable to the men. A woman traveling alone in predominantly Muslim countries is generally regarded with suspicion. The Berber men had no concept of what I was in search of and thus could not comprehend my passionate interest in their wives' seasonal domestic activities. It was the men of North Africa, after all, who were renowned for their faience pottery, mosaic tiles, wood inlay, silver jewelry, and infinite examples of fine workmanship. Luigi's presence also afforded me protection and helped ease my way into the women's realm even though he was often excluded. From a personal point of view, Luigi kept me going when frustration and futility started to set in. On our last trip, we were joined by the writer and reporter Geraldine Brooks, who was as much at ease having her hands hennaed or dipping them into *couscous* as she was bouncing over rough terrain or poignantly attempting to carry a woman's load of firewood.

One of the hazards of traveling is adapting to social customs. Although I am an accomplished tea drinker in the British tradition, I had never encountered the elaborate, drawn-out ceremony of drinking sweet mint tea, which is fundamental to every encounter and social occasion in North Africa. It is immediately offered as a gesture of hospitality and welcome, whether you are buying a carpet or trying to gather information. It is often served with a snack such as bread or almonds—or both. Yet even after spending several hours in this polite social ceremony, we were often refused access to the women we wanted to photograph.

Only in retrospect have I realized that it was while partaking of this everyday ritual that we made many friends and learned a great deal about Berber customs and traditions.

Mealtimes were another opportunity for our hosts to offer us their generous hospitality. We were treated as guests of honor and on a couple of occasions were given the eye of a sheep—considered a great delicacy. The meals were always bountiful, no matter how seemingly spartan the home. And when we were entertained by the hierarchy of a town or community, the meals were lavish—an entire roasted sheep followed by a chicken *tajine* and huge dishes of *couscous* served with onions and milk topped with steamed lamb ribs—and the inevitable mint tea. Even spaghetti was produced one day—a tribute to our own tradition—steamed all day like their *couscous*.

Although we were always made welcome, it was sometimes difficult for me, as a woman, to feel included when women were so obviously excluded. The men received and entertained guests in an area reserved for this purpose, and although women prepared the food, it was left at the doorway—or passed under the tent—for the men to serve to their guests.

During our travels in the Rif Mountains, we encountered difficulties of a bureaucratic nature. Our research led us to traditional pottery by women in an area that happened to coincide with a viable economy sustained by *kif*—marijuana—on the one hand, and a black market trade route (for

illicit arms trading to support current Islamic extremists) that links Morocco with Algeria. Because of this, we had to rely on local officialdom.

We were escorted by Mr. El Gannab, Délégué Provincial de l'Artisanat. A handsome gentleman in his forties, he was one of the kindest, gentlest, and most obliging men we had met in all of our travels. He was in many ways a total bureaucrat, accustomed to years behind a desk. Upon meeting us, he immediately responded with interest and enthusiasm to our strange requests and soon understood that by accompanying us he would have an opportunity to enrich himself spiritually and professionally. During the ten days we spent together, we watched him transform from an impeccably dressed town gentleman—in jacket, tie, and highly polished shoes—to a relaxed country man in *burnous* and *babouches*, the typical hooded cloak and heelless slippers worn by rural men. He was elated to have found with us a part of his forgotten heritage which was no more than thirty miles from his office but which he would never have found alone, satisfied as he was with the status he'd attained. We have no doubt he will return many times to his mountains.

Ultimately, our best sources for subjects turned out to be the weekly *souk* that occurs in every town, village, or rural region, throughout the Maghrib. It is at the *souk* that people gather to sell, buy, eat, socialize, and even have a tooth extracted. Because of this we planned our itinerary around the days of the *souk* that in rural areas are named after the day of the week: Souk el Had is "the first" or Sunday market; Souk el Khemis, "the fifth" or Thursday market. A *souk* is easy to find because it is usually marked by a mule "parking lot" which always caught our attention. We were fascinated by the assortment of colors and sizes of the mules and the infinite variety of the burden of their wares stuffed into brightly woven saddlebags.

In the fall of 1994, one particular *souk* saved the entire trip. Our search for women who made

pottery had led nowhere and our cameras had been resting for weeks in our dustproof backpacks. We were in a region halfway between hills and the high mountain ranges of the Rif and had witnessed, with real fear and anxiety, the havoc a storm could cause when there were no longer trees or vegetation to stop the ferocious progress of erosion. We had seen cars, gardens, and animals washed away in a river of mud. That day, the *souk* felt the affects of the torrential rains too. The stalls were anchored in mud and our feet were caked with it.

The day before, we had attempted to reach a promising location, but where there had been a "road" through a dry riverbed there was now a genuine river which blocked our way. At least, we thought, there was no dust. There was also no pottery.

Entering the *souk* with little enthusiasm or prospect of finding either handmade pottery or the women who made it, we roamed the stalls— filled with the usual spices, vegetables, plastic containers, kebabs, fried sardines, used clothing, and endless rows of monotonous fabrics. Just as we had almost relinquished hope, at the very next step, only a few feet away, half hidden behind mules and a bush, there appeared like a miracle—a group of four women seated on steps with a dozen or so pieces of pottery at their feet. As often happens when one has almost given up, luck turns and gives the courage to go on.

The clay pots were high in quality and elegant in form. The women had departed from their homes at the early hour of three in the morning, and after traveling on the backs of mules for six hours, they arrived at the *souk* to sell their week's handiwork. After many days spent with our hands idle, Luigi and I wished for nothing more than to go to their home to speak, to see, to photograph the preparation, the work, and the firing of their pottery.

There was only one way to reconcile our needs with theirs, and that was to buy all of their

merchandise. Zoulikha and Boujemaate and their pottery accompanied us (and two government officials) in our four-by-four vehicle to their home. For a small fee we arranged for the return of their mules later that night. The ride up the mountain turned out to be a remarkable experience.

The seven miles back up the mountain on a track that had washed away took us four hours up a muddy riverbed—an obstacle course of pebbles and boulders. Elsewhere in Africa I had had to improvise bridges to cross over rivers and streams; here, we had to excavate mud from under our vehicle so we could pass under a primitive bridge for mules.

We reached our destination. The vehicle could go no farther—but there was also nothing visible in the cool tranquillity of mist that clung to the mountain slopes. Following our potter friends with our backpacks and the dozen pieces of pottery we had bought, we climbed into the mist until we came upon an enclosure of prickly pears—the entrance to their home. We shared mint tea, almonds, and honey, followed by freshly made bread and buttermilk.

The drizzle came. We had to move fast to capture our new friends on film, their nimble fingers molding wet clay, smoothing the rough surface with a rounded stone. Lumps of clay emerged into recognizable forms—a pot, a bowl, a brazier. The drizzle turned to rain, the rain into torrents. We left before the road we had traveled transformed into a raging river.

Behind every photograph in this book is an adventure—and the life of a Berber woman continuing the traditions of her ancestors. In one of the region's dialects, the Berbers call themselves *Imazighen* (the free people). For the people I now think of as friends, it is my hope they will always have their freedom.

Margaret Courtney-Clarke
November 1995

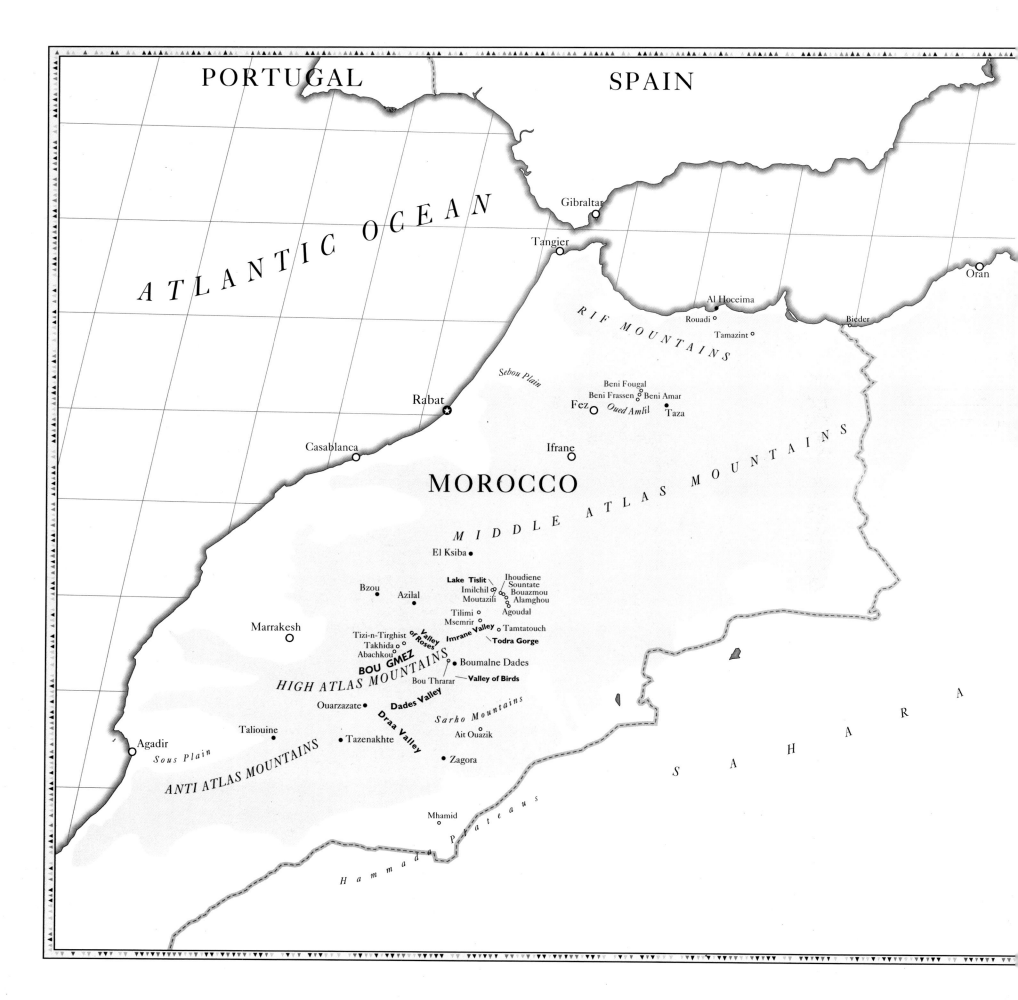

PORTUGAL

SPAIN

ATLANTIC OCEAN

Gibraltar

Tangier

Oran

Al Hoceima

RIF MOUNTAINS

Rouadi

Bieder

Tamazint

Sebou Plain

Beni Fougal

Beni Frassen Beni Amar

Rabat

Fez *Oued Amlil* Taza

Casablanca

Ifrane

MOROCCO

MIDDLE ATLAS MOUNTAINS

El Ksiba

Lake Tislit Ihoudiene

Sountate

Bzou Azilal Imilchil Bouazmou

Moutazili Alamghou

Tilimi Agoudal

Msemrir

Marrakesh Tizi-n-Tirghist **Valley** Tamtatouch

of Roses

Takhida **Imrane Valley**

Abachkou **Todra Gorge**

BOU GMEZ Boumalne Dades

HIGH ATLAS MOUNTAINS

Bou Thrarar **Valley of Birds**

Dades Valley

Ouarzazate *Sarho Mountains*

Draa Valley

Taliouine Tazenakhte Ait Ouazik

S A H A R A

Agadir *ANTI ATLAS MOUNTAINS*

Sous Plain Zagora

Mhamid

Hammada Plateaus

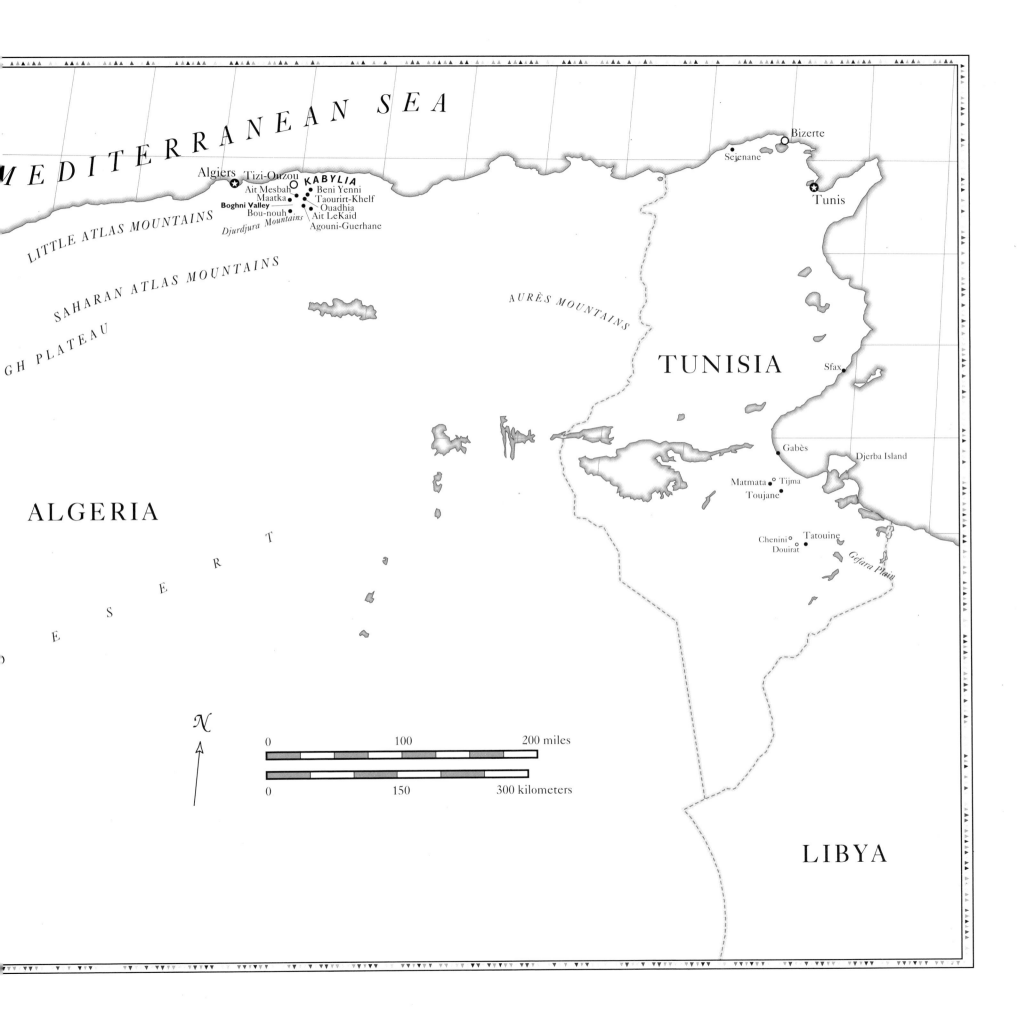

MEDITERRANEAN SEA

Bizerte

Sejenane

Algiers Tizi-Ouzou
KABYLIA
Ait Mesbah Beni Yenni
Maatka Taourirt-Khelf

Tunis

Boghni Valley Ouadhia
Bou-nouh Ait LeKaid
Djurdjura Mountains Agouni-Guerhane

LITTLE ATLAS MOUNTAINS

SAHARAN ATLAS MOUNTAINS

GH PLATEAU

AURÈS MOUNTAINS

TUNISIA

Sfax

Gabès

Djerba Island

Matmata Tijma
Toujane

ALGERIA

Chenini Tatouine
Douirat

Gefara Plain

D
E
S
E
R
T

N

0 100 200 miles

0 150 300 kilometers

LIBYA

AMONG THE BERBER WOMEN

By Geraldine Brooks

WHEN I FIRST MET Margaret Courtney-Clarke in spring 1993 I had already been a foreign correspondent in the Middle East for six years. In my travels, I have seen many things—war, hardship, and famine—but I had rarely seen terrain so remote and intractable and a people so bound to a life of physical toil as I did on the journey she and I made for this book in 1995.

Margaret had already made many trips to visit the Berber women of the High Atlas Mountains, so that spring she was my guide on this, her last shoot there. As women who had experienced many lonely adventures as part of our work, both Margaret and I shared a fascination with the lives of the women we had met. In the mountains of North Africa, we found women in caves, tents, and mud houses, in villages, and in isolated nomad settlements. What follows are their stories.

She sits at the back of the cave, surrounded by piles of fresh-shorn fleece. Her hands are never still.

As she speaks about her life on this stony, desiccated mountain, she brushes the fleece and twirls the carded fibers into a filament on a simple hand-carved spindle. Her palms are callused and cracked from carrying water, milking goats, grinding flour, and chopping wood. Yet her fingers move fluidly over the wool, creating order from chaos with the skill of a conjurer.

The roof of the cave is blackened by smoke and scented with thyme, for Lho Ait Lakha fuels her cooking fires with bushes of the wild herb that she grubs out of the bare hillside, roots and all.

When winter comes and the bitter cold creeps down the snow-dusted mountains, Lho sets up her loom in the back of the cave and starts weaving, as she has every winter for the last thirty-eight years. She was just ten years old when she made her first piece, a brown-and-white-striped *djellaba*, or winter cloak, for a man she didn't yet know who would one day be her husband.

Lho lived in a village then, far from these isolated, cave-pocked mountains. Ahmed, a shepherd, saw her by chance when he came to the village market to buy supplies. He spoke to her father, who agreed to the match. Lho was just fourteen years old when Ahmed brought her to this cave on the mountain of the Ait M'Goun people, in the Valley of Roses of the High Atlas range of southeastern Morocco.

Far from tarred roads and European tourists, Lho lives now as Berber women have lived for centuries, her days defined by relentless toil. She and her family eke out a living from a herd of two hundred sheep and goats. In winter, her work moves inside the cave, to the loom. She makes the rugs that warm the cave's earth floor, the saddlebags for hauling supplies, the blankets for the cold nights, the thick *burnooses* for her husband and son and, for herself, the *handira:* the Berber woman's cloak. Striped distinctively to signify tribe, the thick wool blanket falls from shoulder to ankle. Most winters, because the method she uses is so time-consuming—passing each thread by hand across the loom without aid of a shuttle—she will complete only three items, just enough to supply her family's needs.

As she weaves, she draws on a repertoire of symbols that predates the Roman Empire. There are symbols for grains, such as barley, and staples, such as olives. There are symbols for the tools of everyday labor—a snow shovel for removing snow from fragile sod roofs, a rake from the fields, a pair of scissors, even the clip that holds a weaving taut on the loom. And there is the eye of the partridge, a diamond-shaped motif that represents the bird's

unblinking stare, always on watch against lurking evil. In Algeria, Berber grooms give their brides a real partridge, in a cage, to hang on the doorposts of the home.

Although in her mountain isolation Lho is unaware of it, the very same symbols are being woven in cloth, fired on pottery, painted on walls, and tattooed into flesh in mountains and valleys across three countries. Everywhere there are Berbers—which means throughout the mountains and rural communities of Algeria, Morocco, and Tunisia—the same vocabulary of symbols is repeated. Berbers no longer speak the same language. Their tongue belongs to the Hamitic group and is related to ancient Egyptian. Without a written form, geography and geology have fractured the Berber language into at least five mutually incomprehensible dialects. But the visual language endures.

Or it has, until now.

The list of threats to the Berber heritage is a long and diverse one. As overgrazing denudes the hillsides, making fuel and fodder harder to come by, jobs in the cities beckon Berbers from their ancient lands. As they leave, tourists arrive— their money and their tastes creating income opportunities, but often at the price of abandoned traditions. In Algeria, radical Islamic movements and the government's uncompromising resistance have brought violence and upheaval to the remotest villages. Everywhere, the growing acceptability of intermarriage with Arab neighbors strengthens national identity and opens new opportunities, but gradually erodes the individual character of Berber culture.

Some Berbers regard the change with reluctance and face it with dread. Others welcome it, tossing off the old ways like a suit of uncomfortable clothes. But whatever their attitude, the change comes, remorseless and irrevocable, and has already swept away centuries of tradition in just the last few years.

The Berbers are the indigenous people of northwest Africa, the region Arabs name the *Maghrib*, which means lands of the west, or of the setting sun.

Traces of Berber tribal communities can be dated to between 2000 and 1000 years B.C. The Berbers call themselves Imazighen—the free people. It was the Romans, who colonized North Africa in A.D. 46, who named them *barbarus*—barbarians—for their fierce behavior in battle. Likewise, a Berber word for foreigners—*roumeen*—may well derive from "Roman."

As hardy people have often done, the Berbers retreated to the fastness of the mountains or the desolation of deserts to be out of reach of their would-be rulers. Roman-era maps testify to the natural difficulties encountered in the North African terrain. Maps of lands that now are Morocco are thickly annotated with warnings, such as *"Hic sunt leones"*—Here are lions. The lions are gone now, hunted to extinction around the turn of the century. But like their mountains—soaring in some places above 10,000 feet—the Berbers endure.

For many art critics, the pottery of the Berbers recalls Etruscan ware, leading them to conclude that the Berber work was influenced by the Roman colonizers. But at least one critic, Jeanne D'Ucell, in *Berber Art: An Introduction* (1932), suggests that the opposite might have been the case, with the graceful ovoid form of the Berber olive oil carriers and the stark Berber decorations somehow making their way across the Mediterranean to influence the Etruscan potters.

The Berbers did embrace the Romans' religion, at least for a time, becoming Christians. (Saint Augustine's mother was a Berber.) But the Christian roots must have remained relatively shallow, because when Islam arrived with the armies of Arabia in the 7th century, the Berbers quickly became Muslims and remain so today. Still, they retain many pre-Islamic customs, such as reverence for saints, whose shrines dot the countryside. There is also an animistic sensitivity to the crop-nourishing forces of soil, sun, and rain. Belief in the evil eye and in the power of magic also endure side by side with Islamic teachings.

When a Berber revolt threw out the Damascus-based Umayyad rulers in A.D. 740, Islam remained a unifying force among the sometimes fractious Berber tribes. Ibn Batuta, the Muslim Marco Polo, whose account of his pilgrimage to Mecca and throughout the Islamic world of the 14th century is a classic of travel writing, was a Berber born in Tangier.

It was a Berber dynasty, the Almoravids, who carried Islam into Spain in the 11th century. The Europeans hated and feared the Berber invaders. The fighting was, by all accounts, terrible. "[T]hese shaggy warriors from the desert and the wild foothills of the Atlas were alien to every sentiment of civilization," writes Joseph McCabe in *The Splendours of Moorish Spain*. "Densely ignorant, completely callous to bloodshed and torture, tireless in their strength and religious, chiefly in their belief that any outrage on an infidel was an act of piety, they left behind them, when they moved, a seared and agonized countryside."

Another Berber dynasty, the Almohads, driven by a militant ideology of religious reform, replaced the Almoravids and pushed the Islamic empire from the Atlantic coast to Libya. Yet they too proved incapable of managing such a vast territory for very long, and their political edifice began to tear apart early in the 13th century. By mid-century, Christian uprisings had all but driven the Almohads from Iberia. Only mountainous Granada, north of the Strait of Gibraltar, remained in Muslim hands.

The Berbers paid dearly for their brief primacy after the Christian reconquista. But it was fellow Muslims, not Christians, who exacted the largest toll. Arab communities, remnants of the 7th century conquerors, had grown progressively

stronger through a series of alliances with enemies of the Berber sultanates, and a gradual Arabization eventually dealt the Berbers a defeat more comprehensive than any they had yet suffered. Berbers all but abandoned coastal settlements and retreated again to North Africa's inhospitable mountains and deserts.

Many settled Berber farmers were forced to forsake their traditional farmlands and become nomads, drifting from oasis to oasis on the fringe of the desert, or from high plains to valleys with the changeless rhythm of harsh mountain winters. The British soldier and explorer T. E. Lawrence understood the nature of the nomads' life, calling it "that most deep and biting social discipline." But the farmers who managed to retain some scraps of land understood discipline, too—the discipline of winter blizzards and summer droughts in a barely arable landscape.

Until the middle of this century, the Berbers experienced an isolation almost unmatched in the Northern Hemisphere, sealed off from the rest of Africa by the vast expanse of the desert and from the Europeans by the formidable barriers of the mountains.

The mountains explain everything. At their highest, they are the saw-toothed peaks that a child draws: rain- and wind-lashed, sand-blasted, sun-scorched, snow-scoured rock faces locked around human settlements like battlements. Erosion and overgrazing have bared the rock strata, exposing them like the weathered, clean-picked bones of an unburied corpse.

The austerity of the landscape begets the austerity of Berber design. The bare, ribbed cliffs suggest the play of dark and light in the stripes of the *handira*, the tents, and the floor coverings. The jagged rock peaks are echoed in the angular lines of motifs used in tattoos or on pottery.

And always, in weaving, painting, or architecture, there is symmetry. The Berber feel for symmetry is apparent even in their farming. There is a

geometry to the fields that goes far beyond straight-plowed furrows. Manure sits in rounded mounds waiting for the spreader. Scythed winter wheat waits for collection, arrayed in bunches like the tufts of wool that sometimes punctuate the design of a *handira*.

The buildings, meanwhile, seem to grow from the dust and the living rock. Mud and stone hamlets-cum-strongholds cling to the crags, spilling down the slope so that the threshing floor of one becomes the sod roof of the next. In the late 1890s, a British traveler named Anthony Wilkin reached one such hamlet, El Arbaa, in Algeria, and described it as "so built that it could defy a host. . . . Every house is a little fortress in itself, and the village, to any marauding band, impregnable."

Perhaps Wilkin was correct in his military assessment. But a different kind of host has invaded El Arbaa today. A hundred years later, a visitor to the village finds it almost engulfed by the sprawl of the nearby town of Beni Yenni, the largest settlement in the Kabylia region. Modern brick structures now dwarf the ancient mud dwellings.

It is necessary to travel to Algeria's far less accessible Djurdjura Mountains to find villages that still look as El Arbaa once did. Some of them can only be reached by muleback. Others, only a mile or so apart as the crow flies, have no linking roads or tracks, so that residents grow to adulthood never meeting neighbors from the next village.

Always, in these more remote towns, a single structure dominates all others. Above the town or at its center, wherever the ground yields the most strategic site, rises what looks like the mother fortress. It is the villagers' granary—their life's blood in such difficult and unbountiful lands. Built of mud, its walls 3 or 4 feet thick, it is defended from behind slit windows and crenellated parapets.

From outside, the granary looks like a castle. Inside, it is a honeycomb; each small, cell-like

room containing a single family's grain harvest. In normal times, each family draws only from its own storeroom. But in times of famine or crisis, the supplies are pooled and rationed. This system reflects the complex and ingenious order of the Berbers' unique social system, a system that well suits both an independent spirit and an even stronger desire never to fall under the influence or control of outsiders.

Traditionally, about a dozen extended families live in each of the fortresslike hamlets. Once again, symmetry rules: As Thurston Clarke observes in his October 1982 analysis of Berber social structure published in *Geo* magazine, the hamlets usually are grouped in sets of four or six, divided by shared pastures or farm gardens. Together, the hamlets form a village. Three or four such villages, sharing a valley or a mountainside, generally contain all the members who identify themselves as belonging to a particular tribe.

This larger entity—the tribe—is easily activated in time of war. But the smaller units protected Berber autonomy in times of defeat. Having fought as a unit, the Berbers can quickly melt back into their hamlets, leaving no evident central authority to cede power. The would-be conqueror must scramble to exert control over each tiny hamlet, one by one.

It was this structure that exhausted the French, both in Algeria and in Morocco. The French occupied Algeria in 1830 and began penetrating Morocco from about 1900, conquering the Arab cities of Casablanca in 1907 and Fez in 1911, with the Moroccan sultan, an Arab, accepting a French protectorate in 1912.

But the Berbers were another matter. In a novel written during more than twenty years of Berber rebellions that followed, a French officer complains: "When you wish to pacify them, you will find before you only a scatter of humanity. You have to chase after each tent in order to talk to the head of each small family, and to establish any sort

of control over them requires years. If you face them in battle, though, they will fall upon you all at once and in vast numbers, and you wonder how you can possibly extricate yourself." It wasn't until 1933—and the use of air strikes on remote mountain outposts—that the last of the Berber rebellions was put down and Morocco unified. For the first time, Arab lowlands and Berber mountains became a single governable entity.

Even after the French pacified the last Berber strongholds, however, they did little to influence the culture, preferring indirect rule through Berber tribal structures still in place. Large-scale change did not come until independence, with Arab rule and, in particular, the primacy of the Arabic language, which is taught in school in place of the dialect-fractured, unwritten Berber tongue. For many years, use of Berber in any official context was forbidden, and since it has no written form, it still may not be used for any legal matters. It is only recently that Berber-language films and news broadcasts have become commonplace.

But as Anthony Wilkin reflected after his turn-of-the-century travels in Algeria, there were aspects of Berber life that remained uncolonized: "[T]hey have been repeatedly beaten, forced back from the plains, obliged to grant rights of way to the pastors of the Sahara, even in their last strongholds and fastnesses at the heads of the mountain valleys. They have had impacted upon them the Arabic jargon of the invader, his system of government . . . and last of all, his religious belief. . . . On the other hand, the peculiar houses and utensils may have a long life. The manufacture of pottery, the weaving of burnouses and carpets will go on as perhaps it went on in the pre-Roman days."

And so it has. But for how much longer is uncertain.

The number of Berbers today cannot be reliably determined. While most of the population of the Maghrib is of full or part Berber descent, the number still considering themselves Berber,

speaking the language and conscious of a distinctive non-Arab culture, may be a little more than half the population of Morocco and a little less than half in Algeria. In Tunisia the numbers are far smaller.

Yet as the 20th century draws to a close, Berber women in Algeria still paint the earth interiors of their homes with vivid murals. Weavers in Morocco's High Atlas Mountains sit behind looms all winter creating austerely beautiful weavings. Potters in Tunisia use goat-hair brushes bound with clay to apply green-black plant dyes to wide plates and water jars. Men still build dwellings with mud bound with straw pressed between lashed timber forms.

But it is necessary to go farther into the desert and higher into the mountains to find such things. And even in the remotest villages, signs of encroachment and change are everywhere. Today, mass tourism and MTV are posing a greater threat to the Berbers' ancient crafts and enduring visual vocabulary than any invading army ever has. As tar roads reach mountain villages, they bring the possibility of cheaply available synthetic dyes rather than the soft hues of natural wool or natural saffrons, hennas, and the mossy greens of mountain plants. And the roads also bring convoys of package tourists whose eyes are more easily attracted by lurid pinks and acid greens than the steady march of black and cream on a traditional *handira*.

Even before the roads are built, outside influence comes through the very air. In mountain hamlets so isolated they must still be reached by muleback, or by hours of precarious, bone-jarring four-wheel-drive travel through streambeds, it is possible to find small mud-brick coffeehouses with satellite dishes perched atop their sod roofs. Inside, the hamlet's young men sit glued to TV programs from Turkey, Egypt, India, France, Britain, and the United States. For most Berbers, the days of isolation are over.

Many of the changes come, also, from well-meaning but poorly informed efforts to generate income for Berber women. In the large High Atlas regional town of Azilal, for instance, an official with a Ph.D. in public policy and administration from an American university heads an artisans' center that teaches the local Berber women to weave Persian-inspired knotted carpets or to embroider Arab style, with no reference at all to their own age-old Berber methods, symbols, or design.

In Tunisia, a unique Berber way of life is slowly being effaced by the urge to modernize. Tunisians who retain a distinct Berber identity are concentrated in the south. More than a thousand years ago, Berbers in Tunisia's harsh southern deserts began to dig their dwellings underground as protection against the region's blazing summer sun and icy winter winds. Anthropologists called the underground inhabitants "troglodytes," a name usually applied to primitive cave dwellers.

In fact, the ancient homes of the Berbers are more like huge pits than caves. A deep, open-air hole forms the central courtyard with rooms radiating into the earth. From above, such villages look as though they have been carpet-bombed. For centuries, the only desert Berbers who didn't live deep underground were the dead ones. Cemeteries in such settlements typically consist of shallow graves at ground level, dozens of feet above subterranean mosques.

But in the 1960s, Berber men began leaving the local olive groves for jobs in the northern city of Tunis, or overseas. Returning with money and exposure to modern ways, they began making changes. Now many Berbers are climbing out of the earth and into above ground houses. "I grew up at the bottom of society," a young woman named Essia told writer Tony Horwitz when he visited the town of Matmata, 300 miles south of Tunis, in 1989. "I don't see why my children should do the same."

Jalil Mabrouk, a university graduate, disagreed.

Lighting a candle, he descended through a tunnel leading to the foyer of his home. He pushed open a thick wooden door and, just inside, a donkey munched seeds beneath a ceiling blackened by fire. Nearby, Jalil's bedroom is hollowed out of clay and is two stories belowground. "If everyone leaves their holes our culture will be lost," he said. His parents recently had moved into a house, leaving him the donkey. "I don't want to be the last of the troglodytes." His brother, Habib, felt differently. "Jalil is entitled to his views," he said. "But I don't think it's a crime to like furniture and tile floors."

For some, the urge for change is simply a sign of the Berber generation gap. "Young people always want modern things," an older Berber, Ali Abdullah, told Horwitz. "A roof, windows, toilets. What can a father do?" To visit a neighbor, Ali Abdullah paused at the lip of an abysslike hole, sunk in surrounding sand. "May we come in?" he yelled. A woman's head popped up from the earth, 50 feet from the crater. "The front door's open," she said, vanishing down the tunnel sloping into her home. Bas-reliefs of a fish and a hand adorn the entryway. Inside, the seventy-year-old woman heated water on a wood fire and complained that her grandchildren want to move "into town," a troglodyte euphemism for aboveground housing. Ali Abdullah shook his head sympathetically. "There's no respect anymore for the old ways," he said.

The old ways aren't easy. Rain, though rare in this arid region, can create puddles in a troglodyte's living room. And there is always the risk that stray animals or toddlers will plummet into someone's courtyard in the dark. But modernizing holes is difficult as well. Plumbing, for instance, is hard to install.

"Troglodytes may be interesting to tourists," says Behir Glidi, who now lives in a house. "But it's no fun being one." More than a thousand holes already have been abandoned by young men like

Behir. There is little separation between the old and new quarters of town. Piles of concrete and gravel line the town's main street. For now, many aboveground families are keeping their holes for sleeping in summer. And power lines drape over the edge of many holes, with a few television aerials poking up from the lips of craters.

Matmata's fascination for tourists ensures at least some small degree of preservation, even if only as a museum of a vanishing way of life. But about 150 miles farther south, an equally rare form of architecture and style of domestic life is being abandoned even more quickly than that of the troglodytes. In Douirat, about 12 miles from the large trading town of Tatouine, only four families are left of the eight hundred that once inhabited its honeycomb of multistoried tunnel-shaped structures burrowed into the sides of the mountains. Based on the *ghorfa*, or single curved room of shaped mud formed over hay bales, the dwellings were originally constructed to keep inhabitants safe from marauders and a harsh climate. Each *ghorfa* sits alongside or piles atop another. In some structures, the tunnel-like rooms cluster like beehives to a height of five stories.

Everywhere, the unique aspects of Berber culture are under pressure. In Imilchil, in Morocco's High Atlas Mountains, it is possible to witness an erosion both literal and figurative.

Imilchil's forbidding remoteness has been compromised by the widespread popularity among tourists of a renowned annual wedding festival, at which Berber youth search for spouses or plight troths to their chosen mates in memory of a fabled Berber Romeo-and-Juliet pair of doomed lovers who killed themselves rather than submit to their families' injunction against marrying. At festival time, the town and its surrounding villages are overrun by camera-clicking tourists. Somehow, instead of reinforcing the region's heritage as something to be valued and guarded, their presence has led to a headlong rush away from the past.

In the center of town, the fortresslike granary, the town's most beautiful and significant landmark, partly collapsed in 1994. Now its side gapes open, revealing the warren of small storage rooms within. Nothing has been done to repair the breach. Another winter, and the weight of snow on the surviving walls likely will pull them down as well.

Touda Oulmimed lives just a few winding alleys from the crumbling granary. The same winter that brought its collapse brought catastrophe for her as well, for an accident damaged her hand and put an end to a lifetime of weaving. Touda, in her late sixties, cherishes tradition. Her designs never varied from the patterns that are not only unique to the Imilchil region but are often passed down, in their subtle particulars, from mother to daughter in a family. The younger weavers of the region do not feel this duty to the past.

Touda's young neighbor, twenty-four-year-old Rabha Ben Lahsen, weaves in a corner of her home's reception room where her husband entertains his friends. When the men arrive, Rabha must leave her loom, because it would not be appropriate for a woman to remain in men's company. For that reason, most women set up their looms in the kitchen so their work can proceed uninterrupted. When we visit her on a May morning, she is at work at her loom, making a cushion cover, as her infant daughter crawls nearby.

Rabha's weaving is particularly skillful. Her cushion is woven with what is perhaps one of the Berbers' oldest symbols: the cluster of diamond shapes that represent the lion's paw and dates back to the days when lions roamed these mountains. But like the lions, the meaning of the symbol has disappeared, at least for Rabha, who no longer knows what the diamond shapes mean. She simply finds the symmetry of the motif pleasing.

When the weaving is done, she will decorate the cushion with a plethora of shiny silver spangles—

another break with tradition. When the spangles first started to make their way to mountain markets, "we never wanted to use them," Rabha says. But four or five years ago, when she started to think about selling some items of her weaving, she found that spangled items were more readily marketed. Now the bits of shiny plastic are inevitably stitched to the fine weaving. She leaves them off only the items she makes for herself. One of these is a recently finished bread cloth, used to wrap the dough as it rises and to keep loaves warm after baking. Its warm reds and blacks and simple stripes are entirely traditional, and Rabha is surprised when her visitors express interest in buying it.

After a glass of sweet, mint-scented tea, Rabha walks with us up the hill to the kitchen of her parents' home, where her sister is also at work at a loom. Here, the erosion of tradition has gone a step further. Rabha's sister Beha is making a carpet that has nothing to do with Berber design. The colors are harsh synthetic reds rather than the soft tones of henna, and many of the fibers are man-made rather than local wool. The design—a central medallion—is the product of a far-distant culture.

What is unchanged, however, is the role the weaving plays in the women's lives. Everywhere in Berber language and culture, weaving is a metaphor for life, for creativity of all kinds, and for the uncertainties of human existence. When a Berber woman has a child, her friends will greet her with the exclamation: "Your weaving has been granted holiness and happiness!"

The loom is a place to gather and gossip, to sit and to contemplate. By comparision with their other tasks, weaving is leisure. Two or three days a week, the women must gather wood for cooking fuel and heat. This is grueling labor, involving setting out at four in the morning to trudge up the mountain and returning thirteen hours later, burdened like a mule with some hundred pounds

of thorny brush. Each year the labor gets harder, as deforestation denudes more of the mountainside within a day's walk from the town. At dusk, groups of women—walking bundles—can be seen making their slow way down the mountain. Often they are singing together: "God, send me a good husband to save me from this terrible work!"

As Beha weaves, a neighbor, thirty-nine-year-old Kia Ouzin, squats on the floor alongside the loom and chats about the many changes the women have experienced in their lives. The faces in the kitchen tell of one change. Kia, Rabha, and Beha all have tattoos on their chins, brows, and necks, put there when the women were about eight years old. The symbols of the tattoos are the same symbols of good fortune and bounty that are found in the weaving and fired onto the pottery. But Kia's seventeen-year-old stepdaughter, whom she has raised from the age of one, has no such tattoos on her face. "It's a new generation—nobody wants it anymore," Kia says. "Before, it wasn't good to be without a tattoo; now it's no good to be with it. If the girl visits the city, it marks her. Everyone will know she's from the country." In other words, a hick.

What is passing away is an exuberance of decoration that has impressed strangers since the 17th century. "The women through all Barbery, weare an abundance of Bracelets on their arms" wrote William Lithgow in a journal of his travels between 1614 and 1632. The women, he added, "turne also the nayles of their hands and feete to red, accounting it a base thing to see a white naile." A few years ago, skilled tattooists and henna artists were much in demand. Henna dye would be painted on the skin in patterns as elaborate as lace and unique to the shape of the individual hand or foot. These days, if henna is worn at all, it is often just a crude smear of color on the nails, the palms, or the soles of the feet. Stores sell stencils so that mass-produced patterns can be applied in a fraction of the hours a traditional

application would take. And the stencil patterns are arabesques, not Berber motifs.

"All the clothes are changing," reflects Kia. "We used to wear the *handira* all day every day, and the fibula"—a silver brooch-cum-necklace of two ornate clasps linked with a chain. "But now," she adds, "we only wear such things for festivals." In fact, Kia doesn't wear a *handira* at all. She sold her last one and hasn't been able to save enough fleece from her small flock to weave a replacement. Instead, she wears a piece of printed fabric, rather like a tablecloth, that she purchased cheaply at the market.

The women don't particularly regret the change. "Those clothes were heavy," she shrugs.

In the larger and more accessible towns, women weavers —traditional or nontraditional—are becoming increasingly hard to find. In the Moroccan town of Boumalne Dades, Aïcha, a widow and the family matriarch, presides over a domain that begins at a high mud wall and a large metal gate—a blank face that reveals nothing to the outside world of the main street. The door opens on a series of four courtyards surrounded by mud-brick buildings, each courtyard marking out a space that becomes progressively more private as it recedes from the street.

The women of this household never enter the front courtyard, and never use the front gate. The entrance and the first part of the compound are reserved for the world of men; the truck drivers who come to load and unload goods for the family's trading company. Women are a rare presence in the second courtyard as well, for this one is surrounded by the formal reception rooms where the sons of the family entertain. Daughters and daughters-in-law come here only when strangers aren't present —to clean or to tend the small garden of mint and verbena used as tea flavorings. Aïcha is the only one who has a role here, occasionally, to accept greetings and courtesies due to her as the honored mother of grown sons.

The women's domain begins in the third courtyard, where the family rooms cluster. The fourth court is the region of women's work. It contains the well and the manger for the family livestock: cow and calf, chickens, a few sheep. Two kitchens open onto it: one for bread baking over an open fire; another, with a small gas hob, for the cooking of *couscous* (semolina) and *tajines* (a stew of meat, fruit, and vegetable).

Even for this large and rather affluent family, women's labor is incessant. In the courtyard, Aïcha's daughters-in-law bake bread while their daughters make butter, swinging a sheepskin of cow's milk from a forked stick. Young girls enter and leave the house from the rear door, which opens on to a warren of alleyways filled with women, making their way to and from the gardens that supply alfalfa for the livestock, wheat for the *couscous*, figs, peaches, and almonds for the table, and hedgerows of roses to give sweet-scented petals to be strewn on swept floors.

Aïcha, the matriarch, sits in a shady corner and waves a hand at all the activity, explaining why no one in her family has time for weaving anymore. Her husband died in 1977, having lived a life that spanned the great change in Berber trading from the days when his camel caravans crossed the Sahara to Mali and Niger to the modern era, when the camels made way for fleets of trucks. Aïcha raised seven children—a girl from her husband's first marriage and three sons and three daughters of her own. Her youngest, Fatima, married early in 1995 in a wedding ceremony celebrated for six days.

As the daughters moved out to live with their husbands' families, daughters-in-law have moved in. Two sons have married. The youngest, Ali, is still considering who should be his bride. "I have to decide whether to marry for myself, or for my family," he says. If his choice affected only himself, he says, he would choose an educated girl with a career of her own. But such a woman

wouldn't fit into the closed world of the family compound, where the valued skills are farming, making food, and getting along with the other women. Wives who don't fit in are quickly divorced, with the decision to end the marriage more often made by the mother-in-law than by her son. The decision has heavy consequences, since Islamic law gives fathers custody of the children. In many cases, a divorced woman never sees her children again, and they are left to be raised by the new wife, who may or may not care for them. Sadia, the third wife of Aïcha's second son, is raising five of the ex-wives' children as well as two of her own.

In this family, rugs and clothing are bought, not made, and even though the brothers' business includes trading in Berber textiles, the family living quarters are furnished with nontraditional designs. Indeed, Aïcha is rather proud that her family doesn't have to weave. That, she feels, is something for less fortunate women.

Aïcha Moha Ait Kaider is such a woman. With just one tooth, a bowed back, and eyes deeply etched by laughter lines, she looks much older than the fifty-five years she estimates is her age. Returning from the fields as the light fades, she drops a heavy pile of alfalfa in her animals' feed trough and enters her small, earth-floored mud hut in the remote village of Tilimi in the High Atlas.

Aïcha and most of the women of Tilimi still wear the traditional *handira*, because they have no extra money to buy textiles that they haven't produced themselves. There are many explanations for the regional variations in *handira* designs. One tribe that sports a tricolor pattern of stripes is said to favor the design because it commemorates the fate of an important ancestor, who was murdered by a foe who stabbed him in the back three times. Aïcha's *handira* is distinctive; at its center, the march of black and white is interrupted by a sudden combination of dark blue and green.

From behind, when she walks, the colored accent runs straight down the center of her back. "It is my signature," she explains. "It gives me some sparkle."

Although she still works hard, her three grown daughters have taken over many of her chores, including much of the family weaving. Their handiwork, however, is nowhere near as fine as their mother's. "The young people like wide stripes," she says, fingering an inferior new handira. "They think it is more modern." She wonders if her granddaughters will weave at all. "When I was young, we didn't know what was going on outside the village. As far as we knew, there were four things a woman could do," she says, ticking them off on her callused fingers: "Water, wheat, wood, and wool." Now, she says, news of the outside world has come to Tilimi. Although she has no electricity in her hut, she sees television when she visits a richer neighbor. "Now we see the professions that women can have, and we see that this is necessary for a society." If she had a young daughter today, she says, she wouldn't sit her down at a loom.

"I'd send her to school," she says, folding the *handira* that may be the last ever made in that small hut. "I would like her to be a doctor."

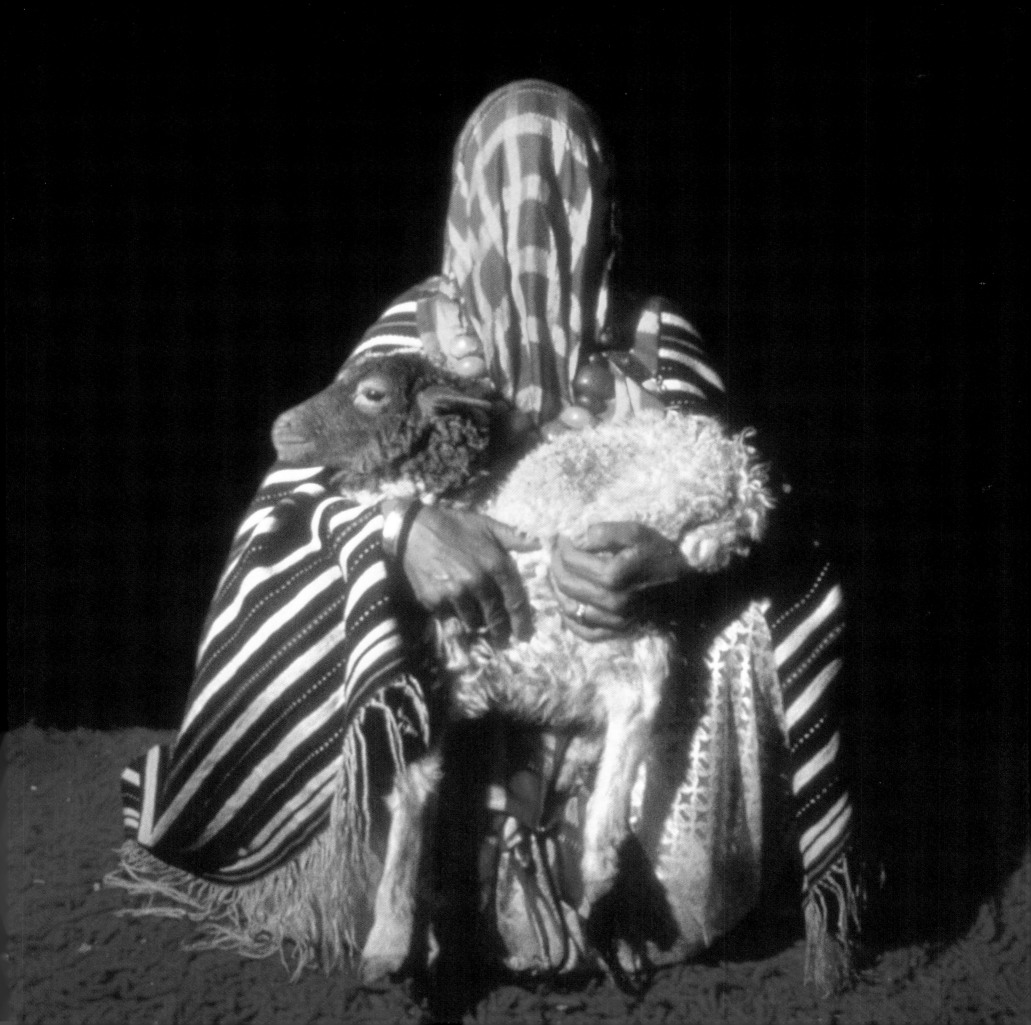

LANDSCAPE AND ARCHITECTURE

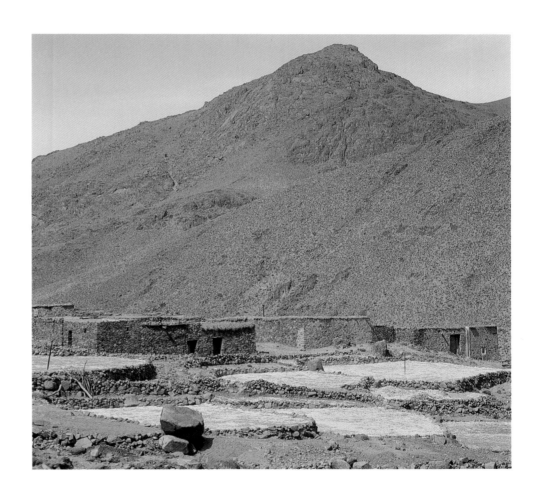

BERBERS LIVE IN EARTH'S extreme places.

Their lands are beautiful, but they are harsh. From snow-blasted mountain to wind-scoured sand dunes, the Berbers have been forced by their history to inhabit the barely habitable.

In spring and fall, the Berbers are the nomads of the Atlas Mountains, crossing the steppes with their flocks of goats and sheep, each family and its herd moving slowly across the khaki landscape like inkblots.

The Berbers also are farmers, tending patches of earth where river-sliced gorges plunge suddenly to narrow bottomlands, cultivated so intensively that each field looks like a plush green carpet unrolled on a raw rock floor. Sometimes wheat fields zigzag down sheer mountain faces, the scant topsoil and its precious crop held in place by the most precarious of terraces.

Human use has taken a high toll of this already forbidding land. As women gather wood for fuel and warmth, and as flocks gnaw on every shoot or sapling, erosion has laid the rock bare as a skeleton. In many parts of the Atlas and Rif mountains, only a few stunted trees remain as traces of what were once forests of Atlas cedar, holm and cork oak, and pistachio trees.

To live in places that are almost unlivable, the Berbers have become ingenious builders and burrowers. For materials, they use only what the place provides.

Wool from their flock becomes a nomad family's tent. Sometimes, such a tent might be a simple shelter from the sun, its interior flyblown and dusty. At other times, the tent may be as elaborate as a fairytale fantasy, its interior cunningly divided into utility areas for kitchen and storage while an inviting cushioned reception area is placed to catch the desert's grand vistas and rare evening breezes. Often, it is the women's loom that divides the tent's "rooms" and offers the women a measure of the seclusion demanded by Berber culture.

In the mountains, farming villages use the saw-toothed peaks almost as battlements. Enclosed by the crags, the buildings seem to grow from the earth and rock. Sometimes, the dwellings are constructed of mud bound with straw and pressed between lashed timber forms. At other times, they are made of stones laid one atop the other in patterns as intricate as a jigsaw puzzle. The need for a defensible perimeter pushed dwellings tight against each other, while economy of building meant that the terrace and threshing floor of one has become the sod roof of the next.

Tunisian Berbers have been particularly ingenious in inventing structures to withstand extremes. The desert dwelling troglodytes, for example, burrowed deep pits into the sandy soil to escape the harsh climate. In the mountains, Tunisian Berbers built honeycomblike mud dwellings made of curved rooms and mud shaped over hay bales. When the mud dries, the bales are removed, leaving spacious and convenient dwelling places that can easily be extended by adding additional rooms, or *ghorfas*, to the side or on top. Some are five stories high.

Occupied and maintained, the Berber dwellings have stood for centuries, providing reliable shelter. But in recent years, as the difficulties of rural life have lured Berbers to cities and towns, some villages have been abandoned. Without their human caretakers, the structures return to the earth in a few short years, eroding like children's sand castles with the oncoming tide.

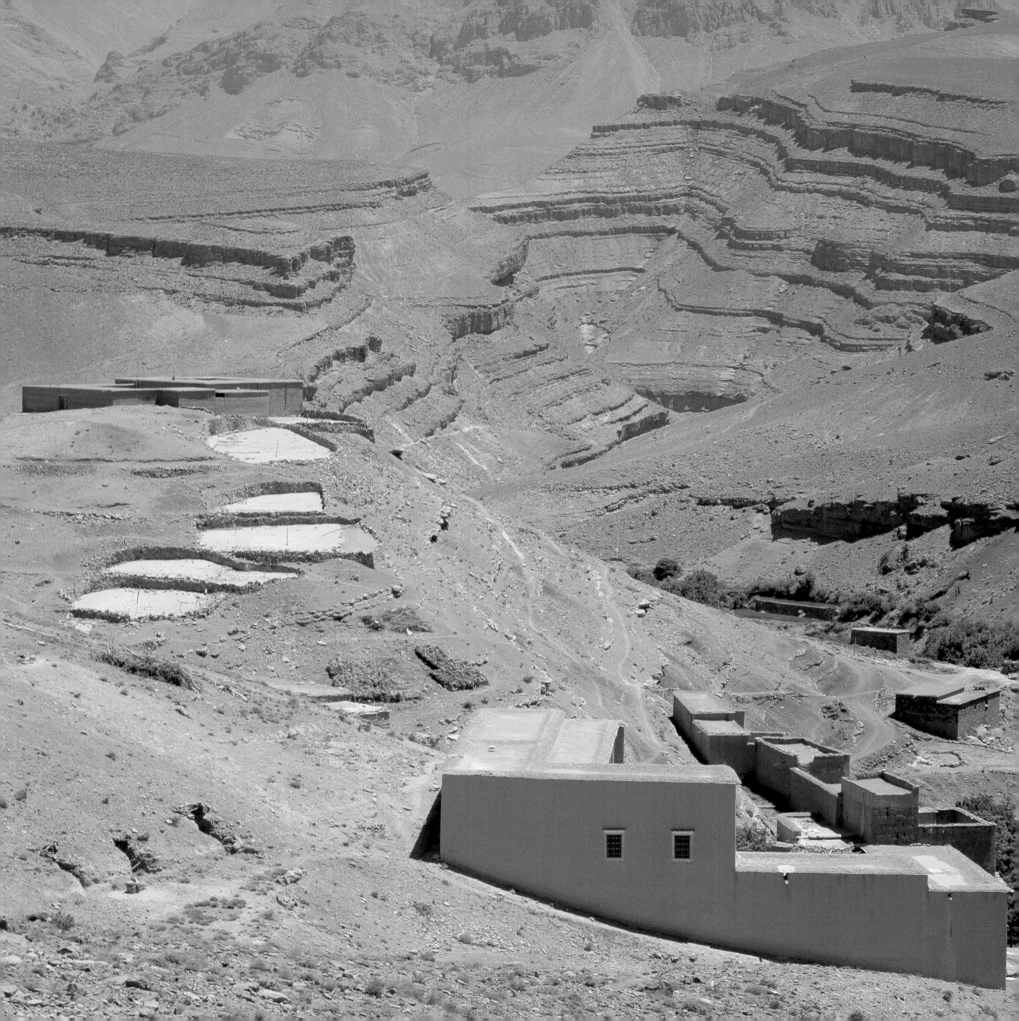

The almost Etruscan-like settlements between the folds of the landscape beneath the peaks reproduced the geometry of the rock formations, creating a perfect blend between the natural and artificial. Earth, water, and dry grass are the principal elements of this miracle. Preceding page: Dades Valley, Morocco. Throughout valleys and plains of the High Atlas Mountains of Morocco, villages and hamlets are of the same hues as the mountains on which they stand, the gorges in which they are hidden, and the ravines onto which they cling— an infinity of polychromatic possibilities that ranges from red to yellow to ocher to brown to orange.

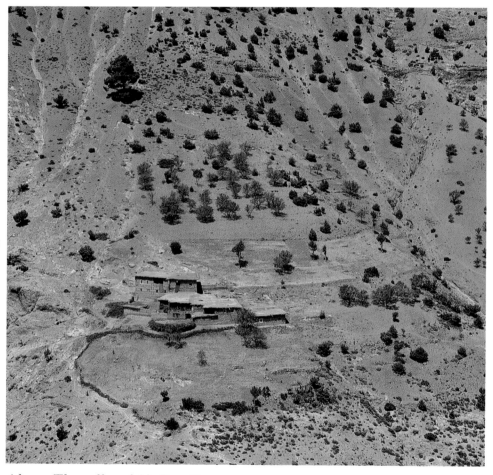

Above: The valley of Ait Bou Gmez, beneath the Tizi-n-Tirghist pass, central High Atlas Mountains. Opposite: Dades Valley, Morocco

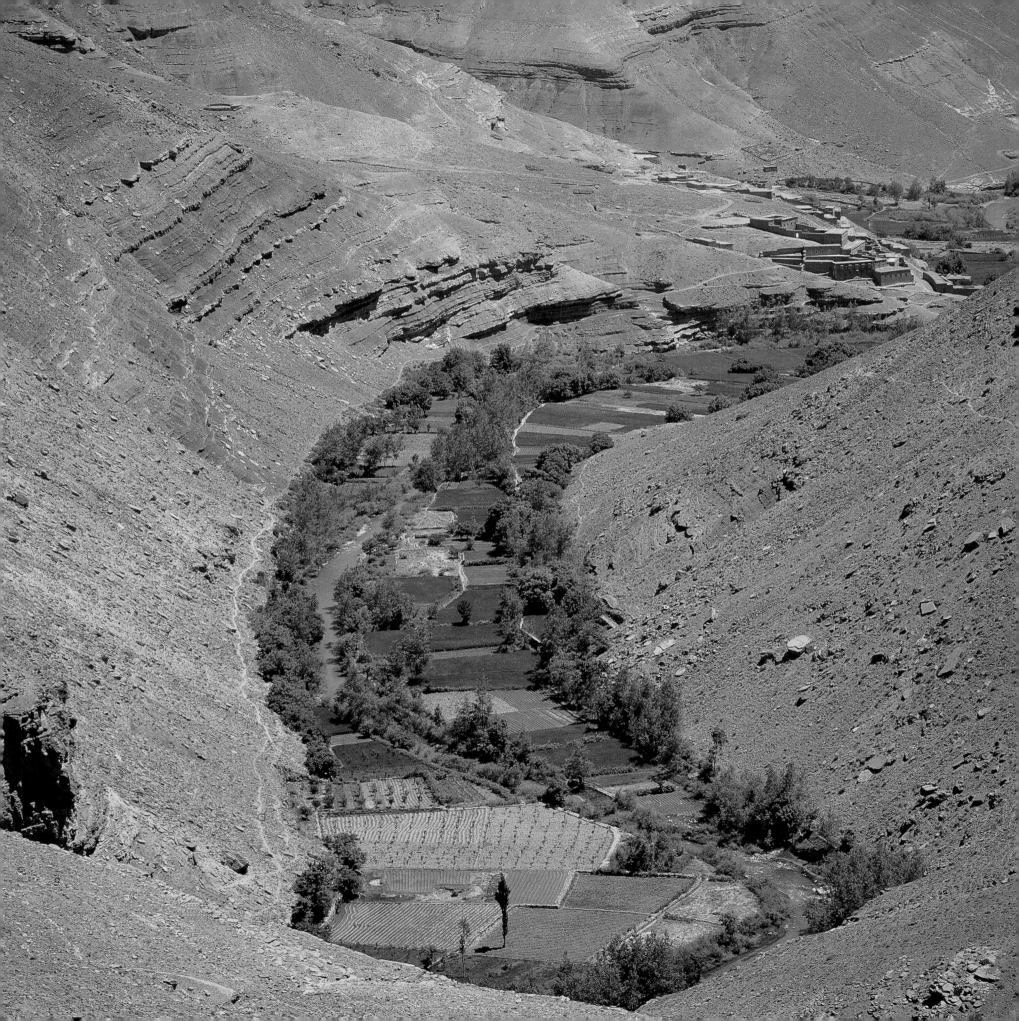

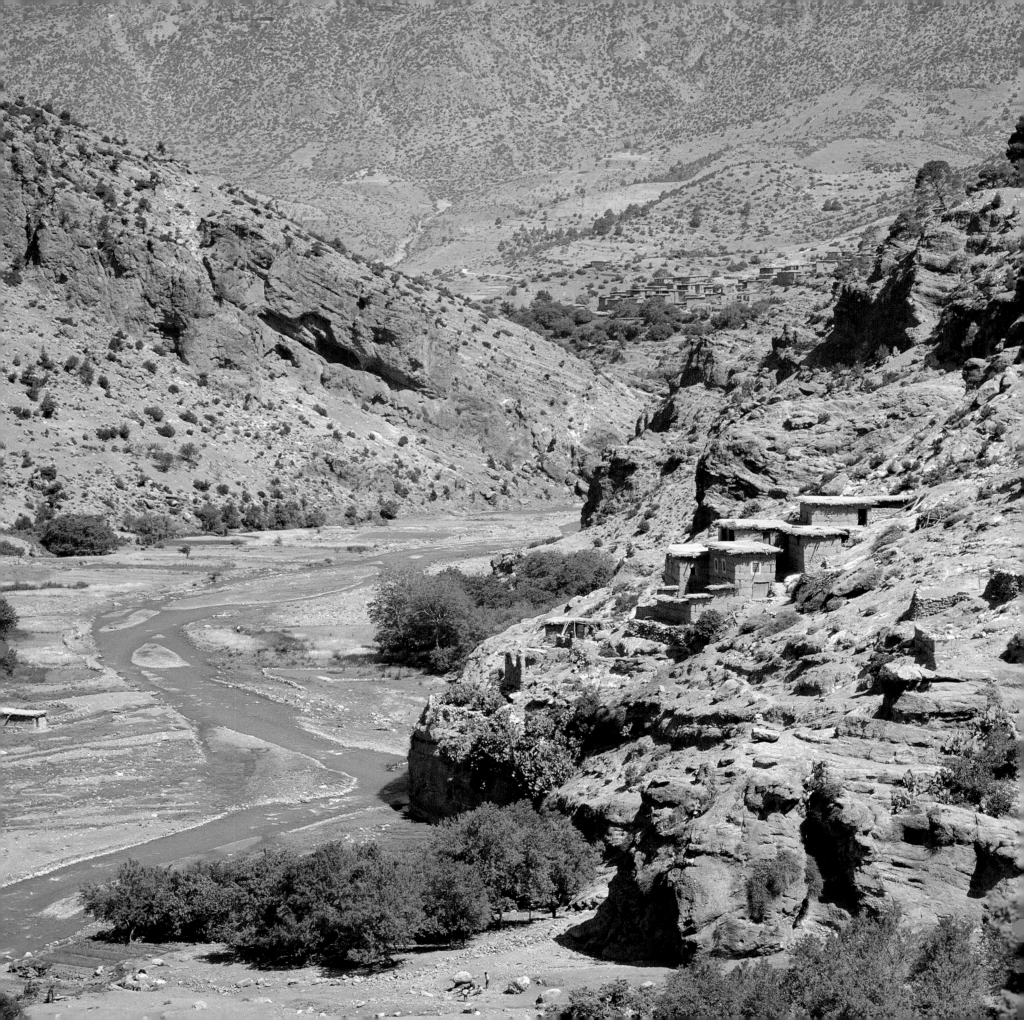

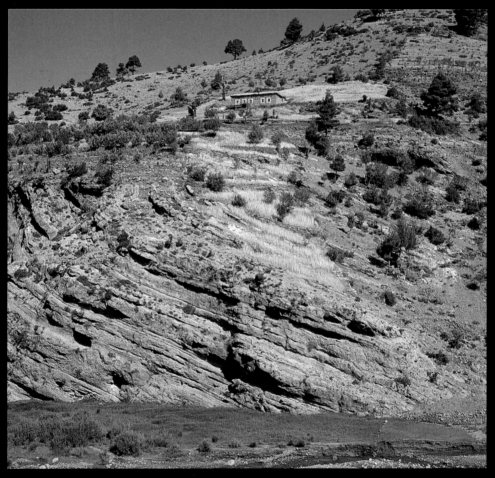

*Above and opposite: Minute wheat
fields chiseled into the sloped terraces
are cultivated with infinite care, and
during the brief summer shimmer in
the golden sunlight. The mountains
once were home to great cedar
forests. Now the few remaining trees
cling to the ravaged slopes, exposing
their contorted roots to the harsh
elements. A highway from the
principal town will soon force its
way into these valleys and
mountains.*

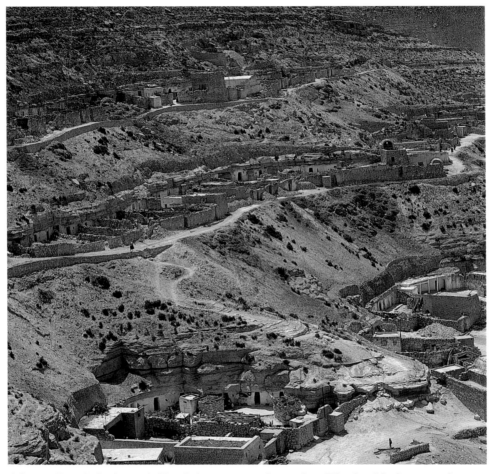

Above: Partial view of Chenini,
one of the last ancient villages in
southern Tunisia inhabited by
sedentary Berbers. Chenini is built
around two hills forming a
semicircle—like a huge amphitheater
—into which geometric horizontal
incisions have been carved to create
dwellings. The entrances form the
animal enclosure from which doors
lead into the cave homes.

Opposite: The fortified town of
Toujane (in partial view here), not
far from Chenini, dominates the
Gefara Plain as far as the
Mediterranean Sea.

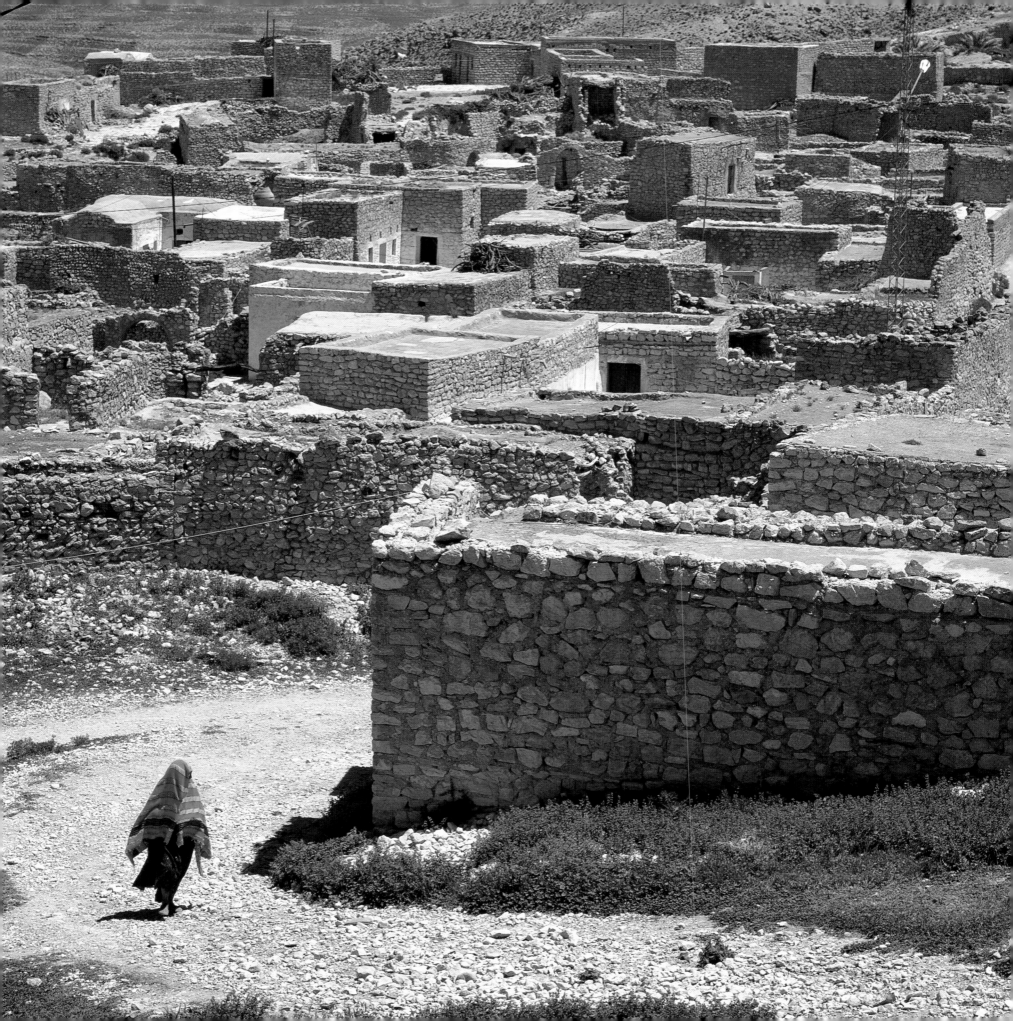

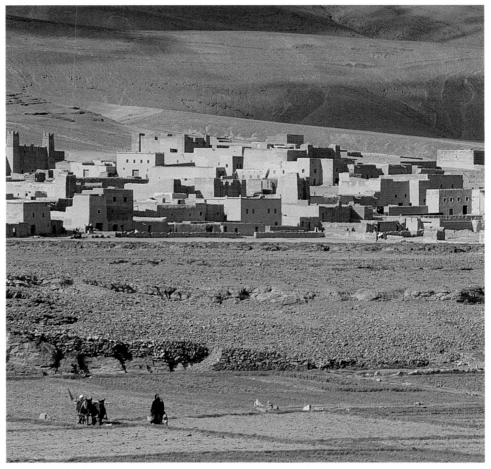

Above: One the many villages of the Ait Brahim tribe found in the eastern High Atlas Mountains near Imilchil, Morocco.

Opposite: Facade detail of a Casbah of the Glaoui tribe, near the southern city of Ouarzazate, Morocco

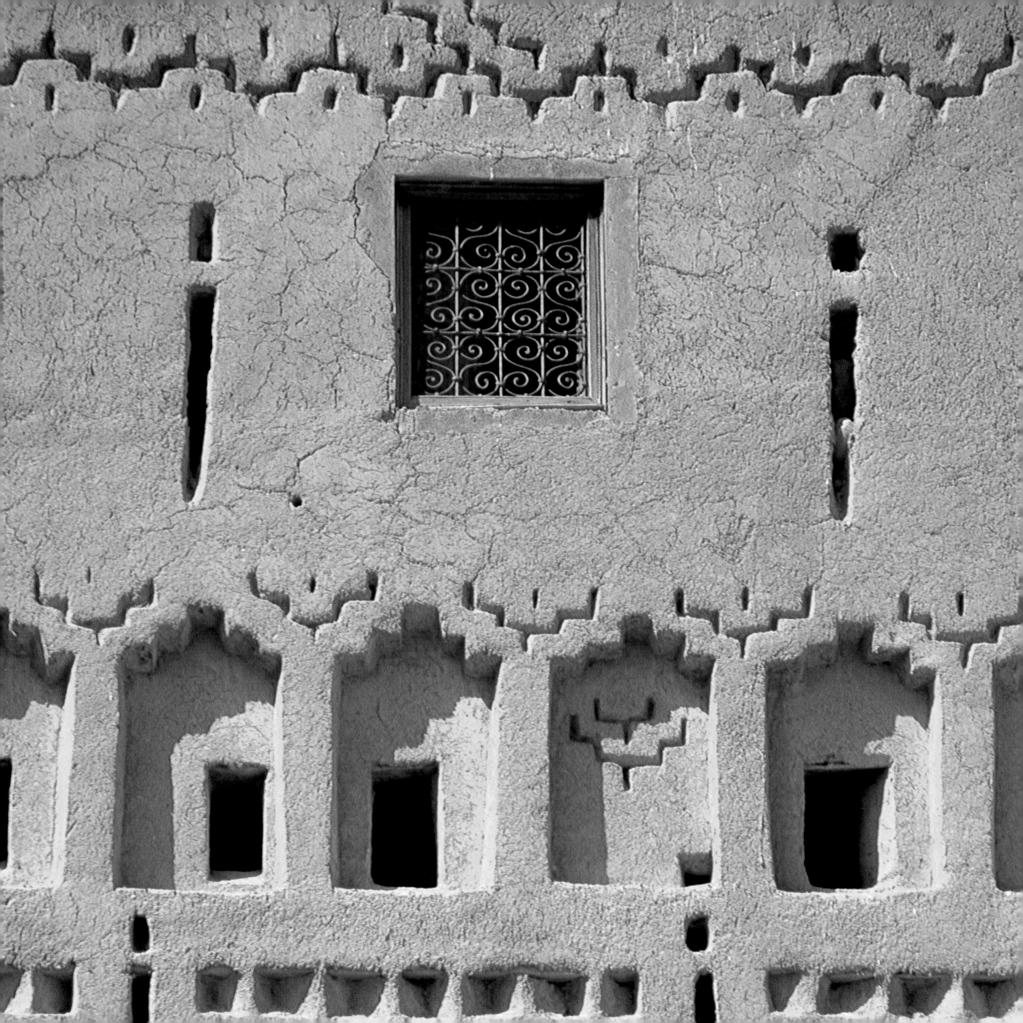

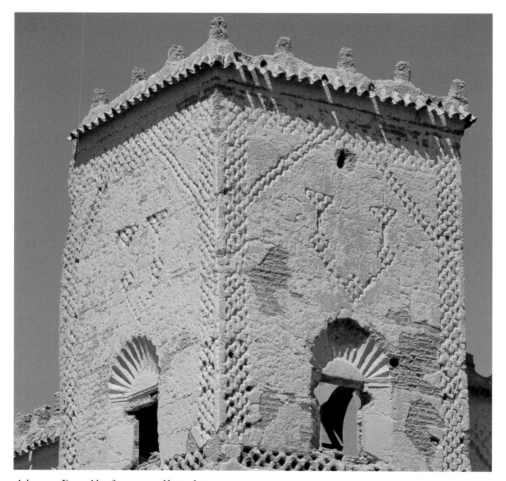

Above: Detail of a crenellated tower
once used as a granary, and part of
a casbah in Taliouine, Morocco

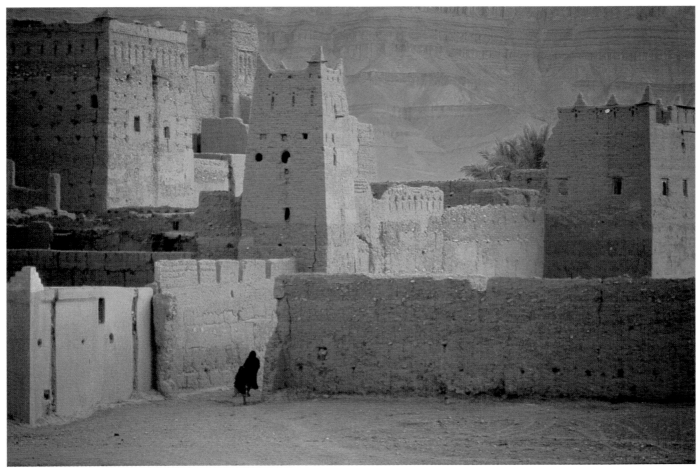

Above: Typical adobe buildings
found along the Draa Valley between
Ouarzazate and the Sahara, built
to be formidable and functional and
to serve as Berber strongholds.
Southern Morocco

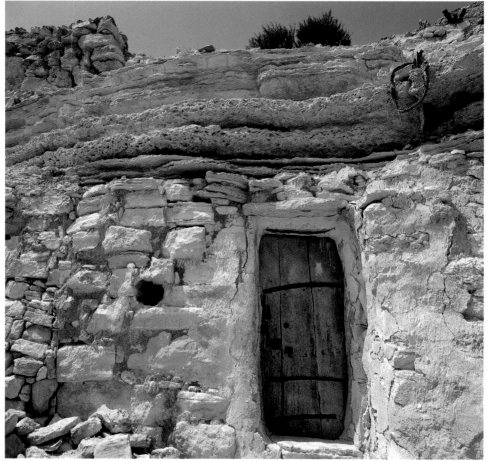

Opposite, top left: View from within a courtyard of a typical entrance showing the rectangular buildings with vaulted roofs (ghorfas) originally used as granaries. Douirat, Tunisia. Center left: Douirat, founded around the 15th century by Duiri Berbers, is inhabited today by only four extended families. Center right: Across the courtyard are the entrances to the cave dwellings. Douirat, Tunisia. Bottom left and top right: More than a thousand years ago, Berbers known as troglodytes tunneled homes beneath the ground, visible in the form of large craters that form the central courtyard. Always in close proximity to the troglodyte home is the domed koubba, a shrine that attracts pilgrims and is often the place of unusual rituals. Matmata, Tunisia. Bottom right: Ancient stone walls form the paths leading up into the village. Chenini, Tunisia

Above: Inside a walled courtyard that serves as an animal enclosure, a wooden door—the entrance to a cave dwelling—is built into the mountainside. Chenini, Tunisia

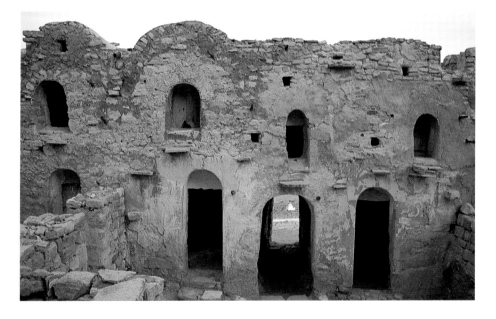
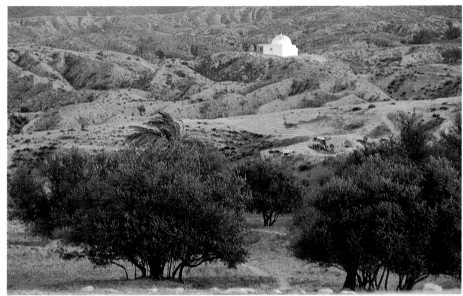
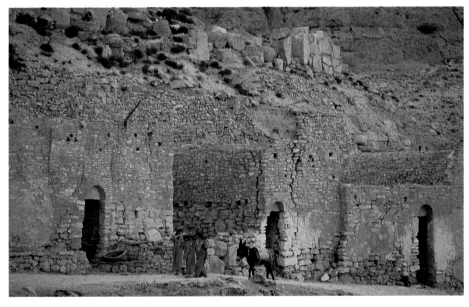
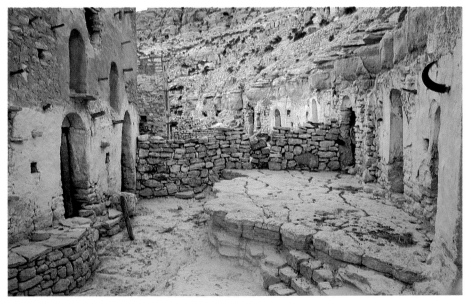
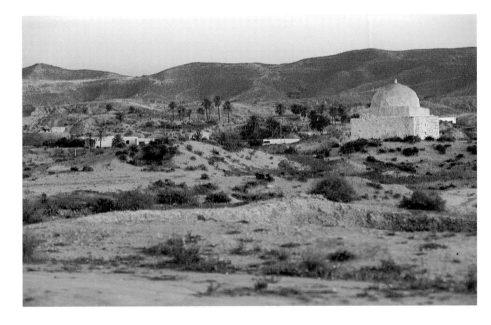
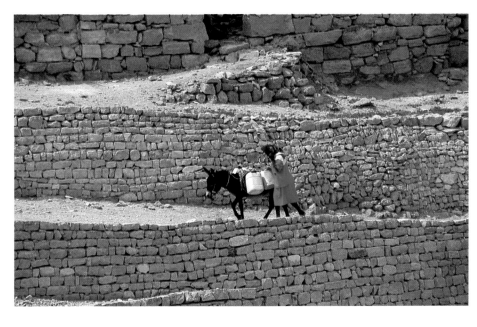

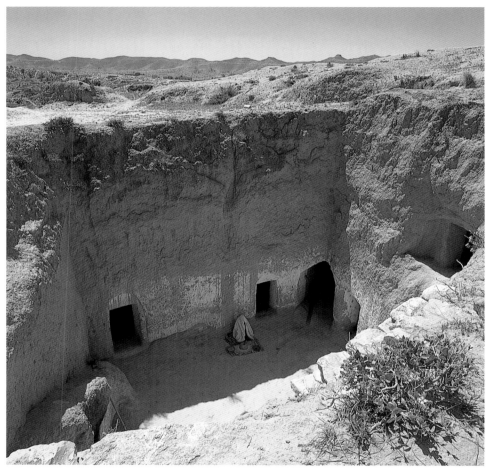

Above: One of the few inhabited troglodyte homes in Matmata, Tunisia

Opposite: In a shady corner, off the courtyard of her home, Gmar Azouz cards wool. Tijma, near Matmata, Tunisia

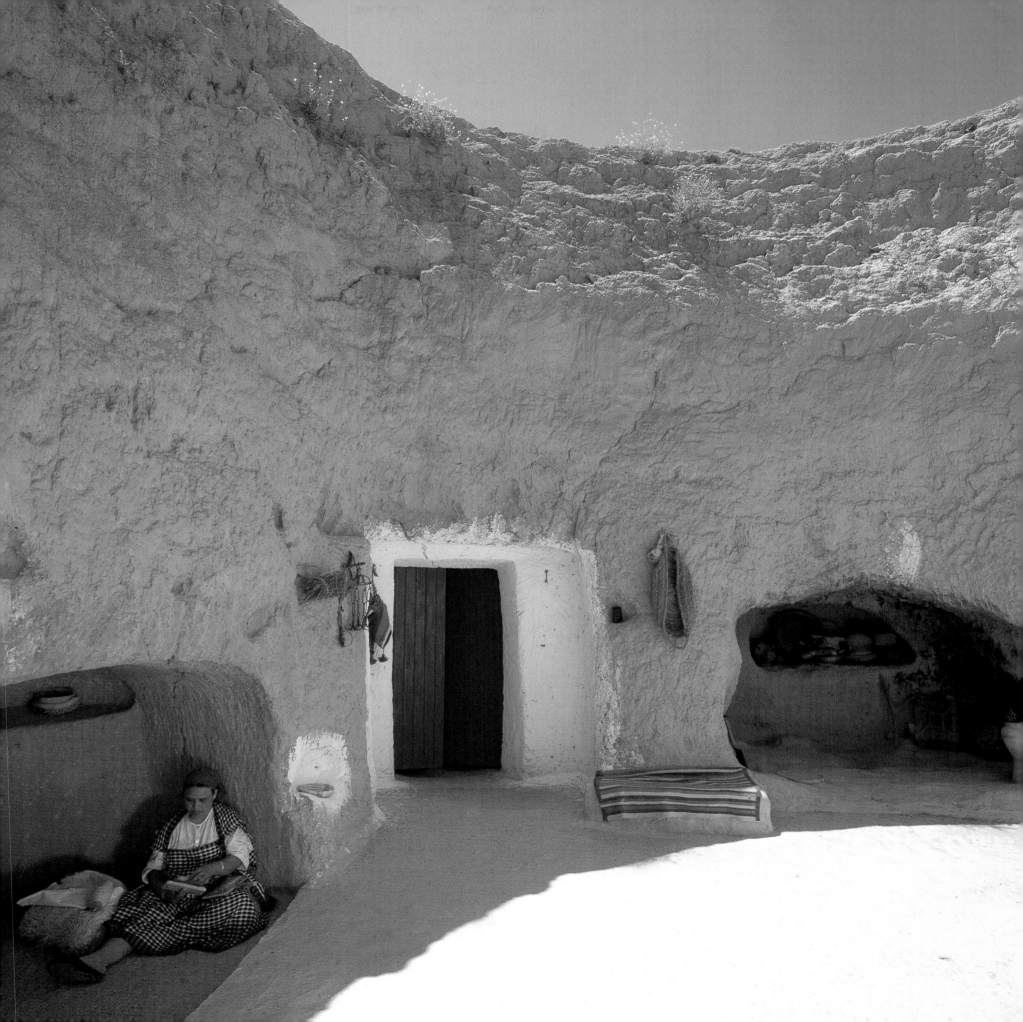

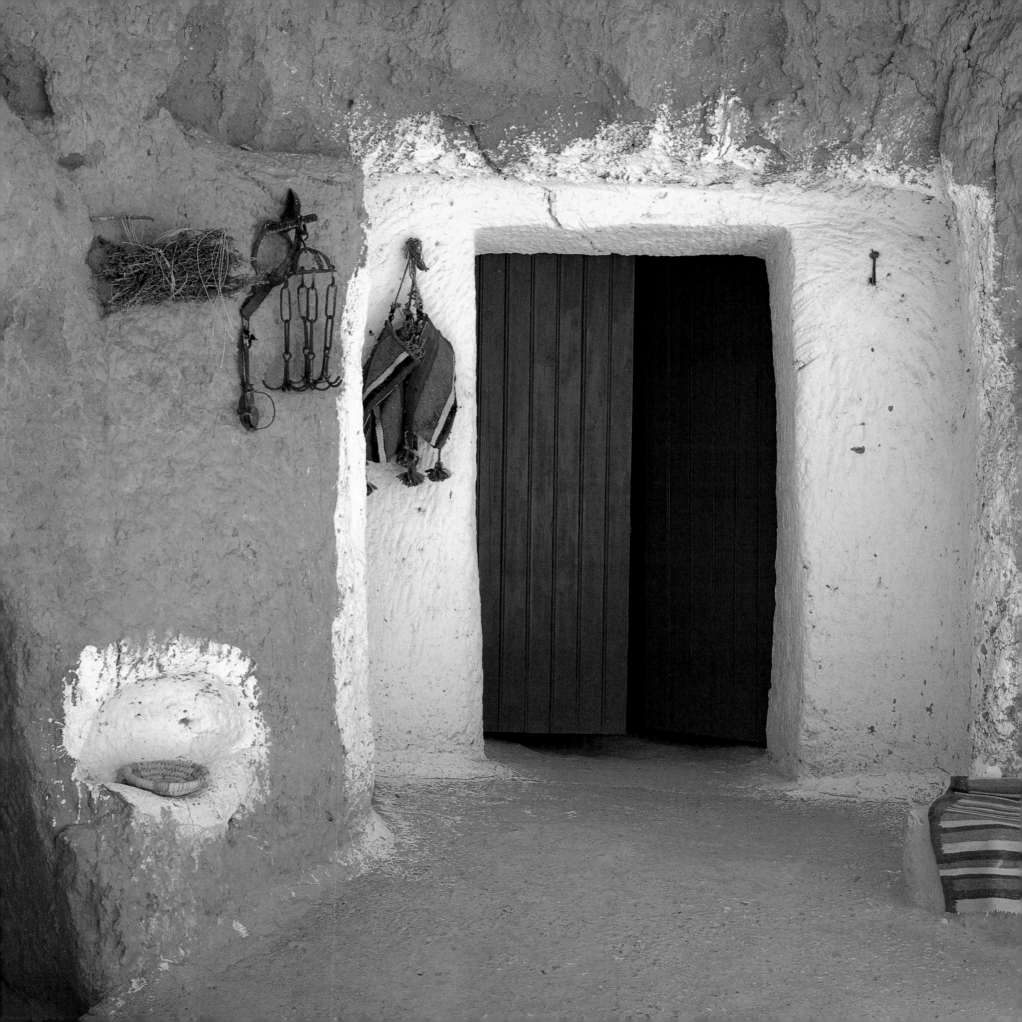

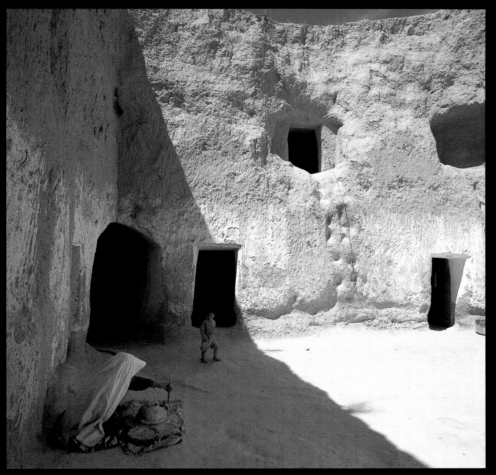

Opposite: A door off a courtyard leads into sleeping quarters of a troglodyte family in Matmata, Tunisia.

Above: A young woman grinds wheat on a traditional Berber stone grinder. On the far side of the courtyard, indentations in the mud wall serve as footholds and a rope as a handrail for access to the family granary above. Matmata, Tunisia

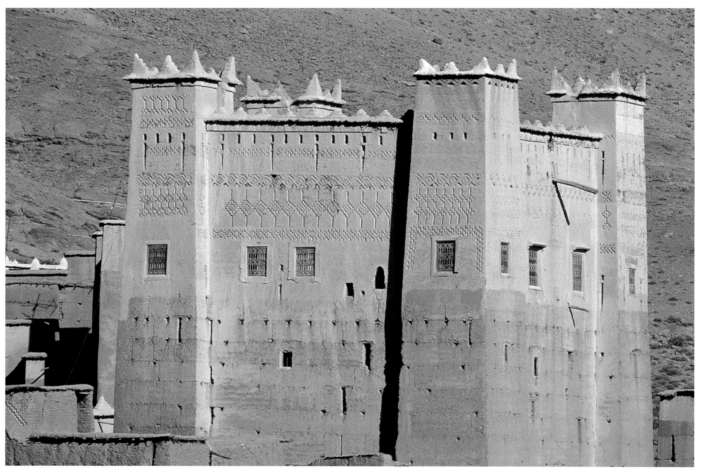

Above and opposite: The ever-present ksar *is distinguished from the rest of the buildings by its size and the turrets on its walls. Although majestic and awesome, the* ksar *reveals a sober understatement in its bas-relief ornamentation that is brought out in all its elaborate monochromatic complexity by the radiance of the sunrise and sunset. Beyond the colors, the forms, the massive solid walls interspersed with minuscule unadorned windows, always empty and dark, one senses eyes intent on watching the fields below and around. Without so much as a flowerpot on the windows, the village gives the sense of being abandoned over time. But from a lookout point from which rooftops and terraces can be seen as well as the fields of yellow corn, signs of life emerge: the vivacious red of peppers spread out to dry and an intricately woven rug hanging from a doorway. Atlas Mountains and environs, Morocco*

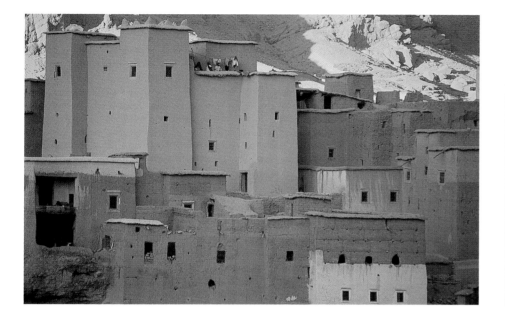
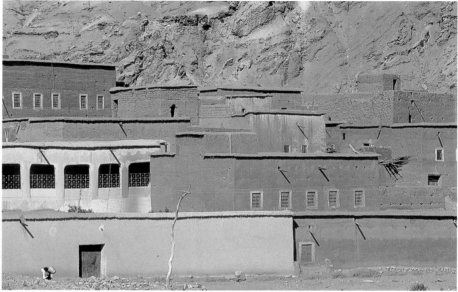
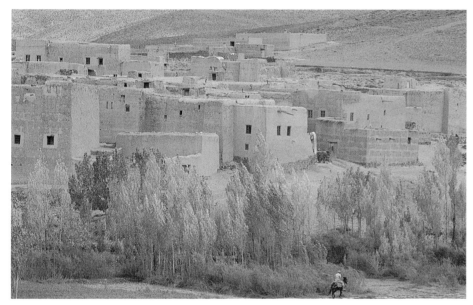

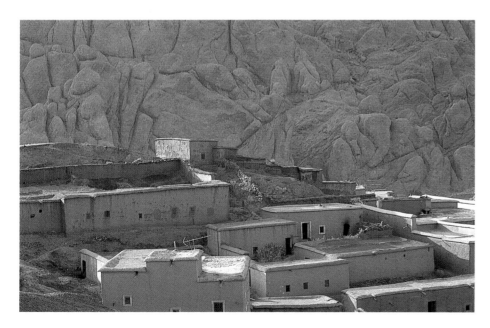
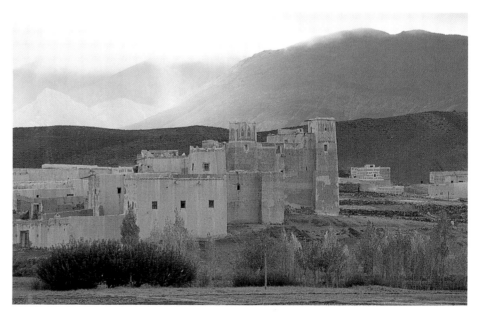

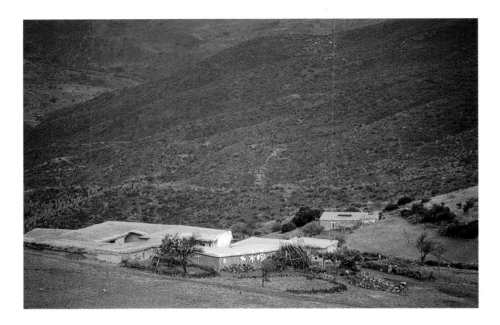

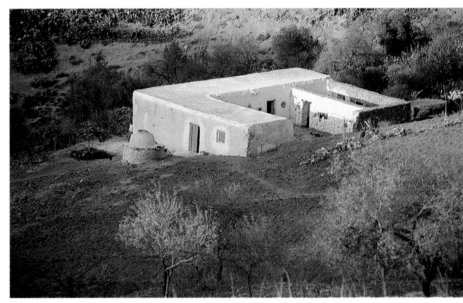
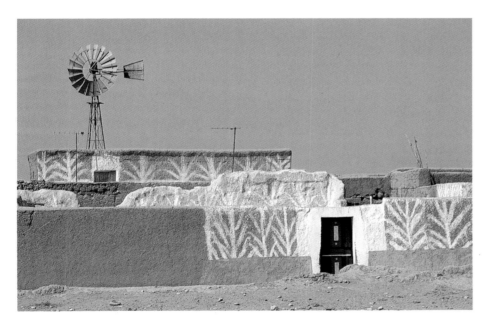
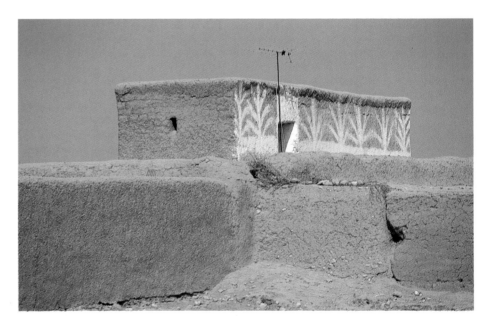

Below, and opposite, top left and right, center left and right: The Rif Mountains, the lowest of the four mountain ranges in Morocco, rise up from the Mediterranean coastline and reach back to the Middle Atlas. Forced by their history, the independent Berbers (Tarifcht) have learned to live in this extreme region where the struggle for survival is daily and indisputable. These peaceful landscapes with vast horizons belie the harshness and

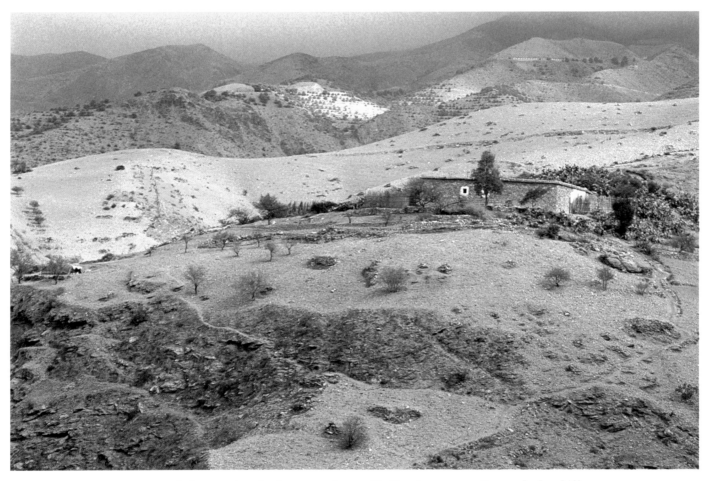

poverty of the people who have made this region their home for centuries. Opposite, bottom left and right: Many Berbers still believe in the evil eye and the power of magic along with the teachings of the Koran. Animal and plant symbols splashed on in white paint around windows and doors are believed to protect the inhabitants and ensure bountiful crops.

Following pages: Beneath the chilly mists of the Djurdjura Mountains in the heart of the Great Kabylia, scattered villages rest on hilltops linked by winding roads through valleys, towns, and fertile lands. At first sight, the villages are built of brick and concrete, but when one penetrates inside one can see, half covered by plaster, stone walls of some ancient dwellings.

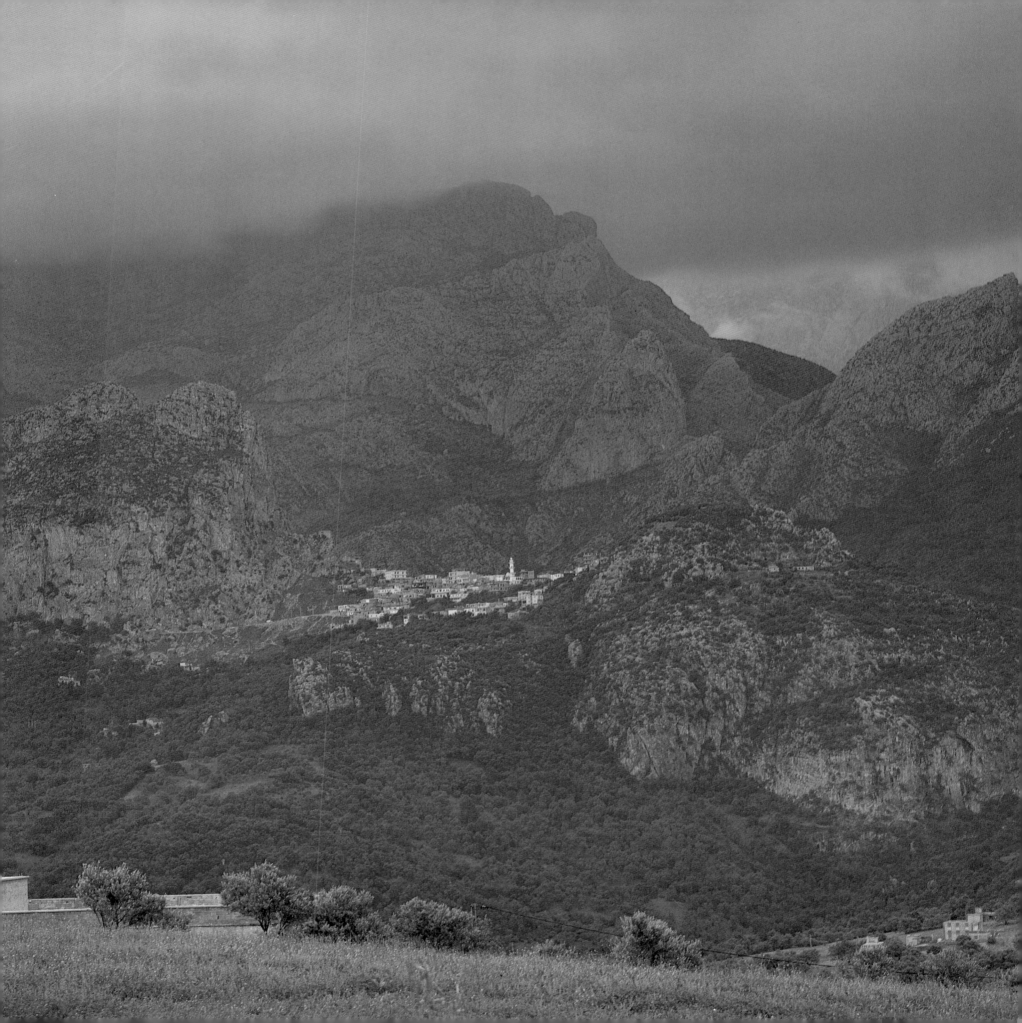

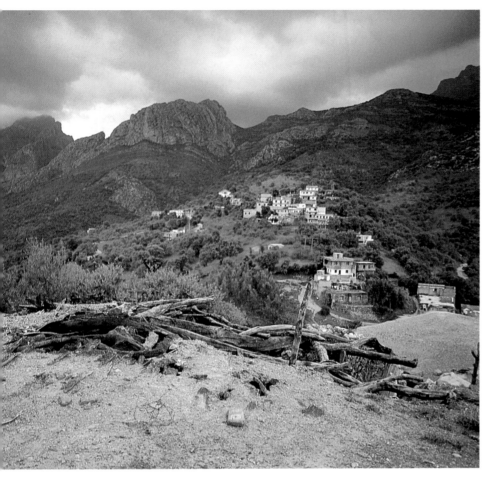
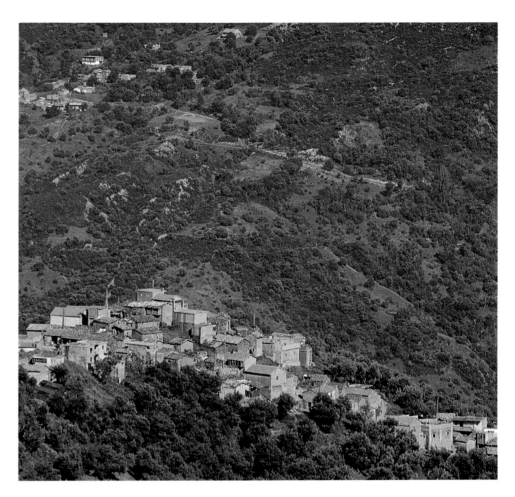
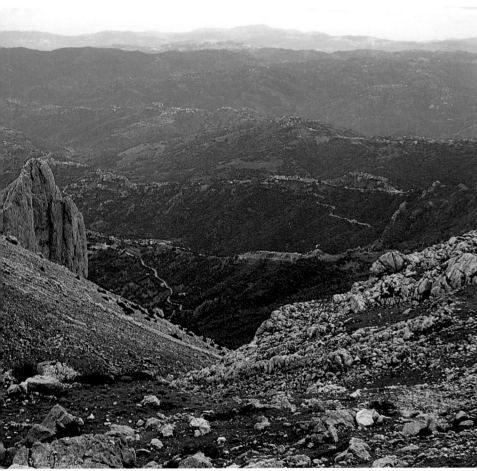
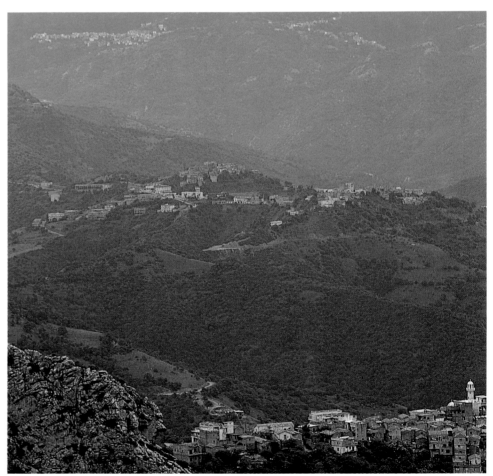

INTERIORS

When crops are harvested and snow blankets the fields, Berber women move indoors.

Today, the interiors they inhabit are mostly simple mud-walled rooms, lit by small windows and heated by wood fires. Whitewashed or in the ochers and grays of the original earthen construction, the rooms offer little in the way of decoration.

But it wasn't always so. Half a century ago or more, Berber women routinely decorated their interiors with a riot of color and texture. A large central room, lit only by skylights tucked in the beams, would be shaped during construction to provide beautiful and utilitarian storage spaces: shelves and bins for possessions and grain. Molding the clay by hand, the woman of the house would use the same vocabulary of motifs to create highly textured reliefs throughout. Over them, using colors gleaned from earth and plants, she would paint bright geometric patterns, highlighting the important motifs.

A few such interiors still exist in Berber villages in Algeria. Most of them were shaped and painted more than thirty years ago. No one now knows of any women still sculpting interior reliefs, and the painting that is done usually is limited to revivifying old and faded designs with new synthetic paints.

The decorated houses that remain all follow the same floorplan. Most consist of only a single, large room. One side is shaped to form a generous built-in platform, with a sleeping area above and mangers for a mule or sheep below. A fireplace in the corner provides warmth and a cooking area. The sleeping section is screened by several large storage bins—clay vats named *ikoufane*. Each *akoufi*, used to store grain, is quadrangular with a graceful cylindrical neck and round openings in front from which contents may be removed by the fistful. Smaller *ikoufane* may contain salt, dried figs, or other provisions.

Opposite: Two ikoufane, *built-in clay storage vessels for grains. The "eyes" serve to remove one fistful of wheat at a time. Home of Ahmed Ouacel and his family in a remote village of Ait LeKaid in the rural commune of Agouni-Guerhane.*

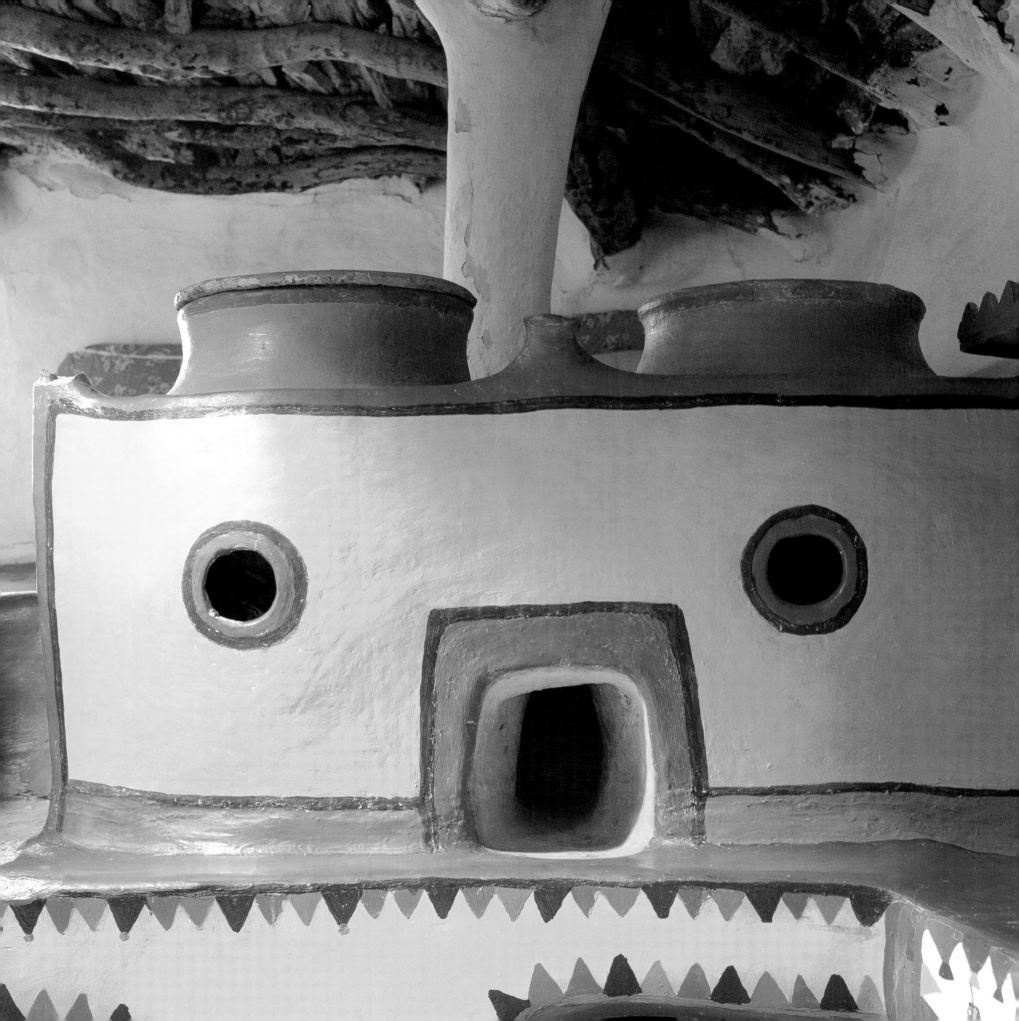

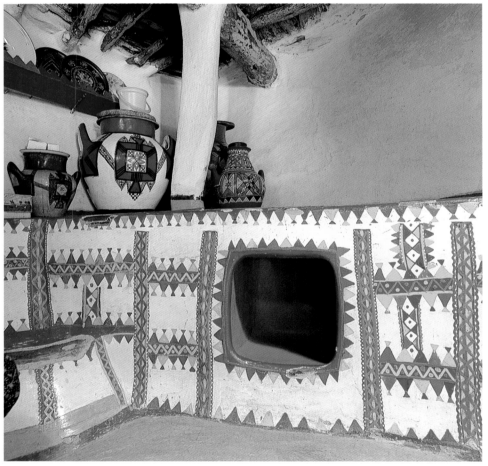

Above and opposite: Details from the same interior as the previous page. When residents from neighboring Aguemoum fled their village because of the plague, one survivor—an ancestor of the present owner—built his little house on the edge of a stony ridge across a narrow gorge. It was the beginning of the village of Ait LeKaid. At the time of this photograph, the eighty-year-old woman who painted the interior, mother of Ahmed, was dying on a bed nearby. Twenty years earlier she had decided to use permanent colors for the walls and pottery, knowing there was no daughter to continue the tradition.

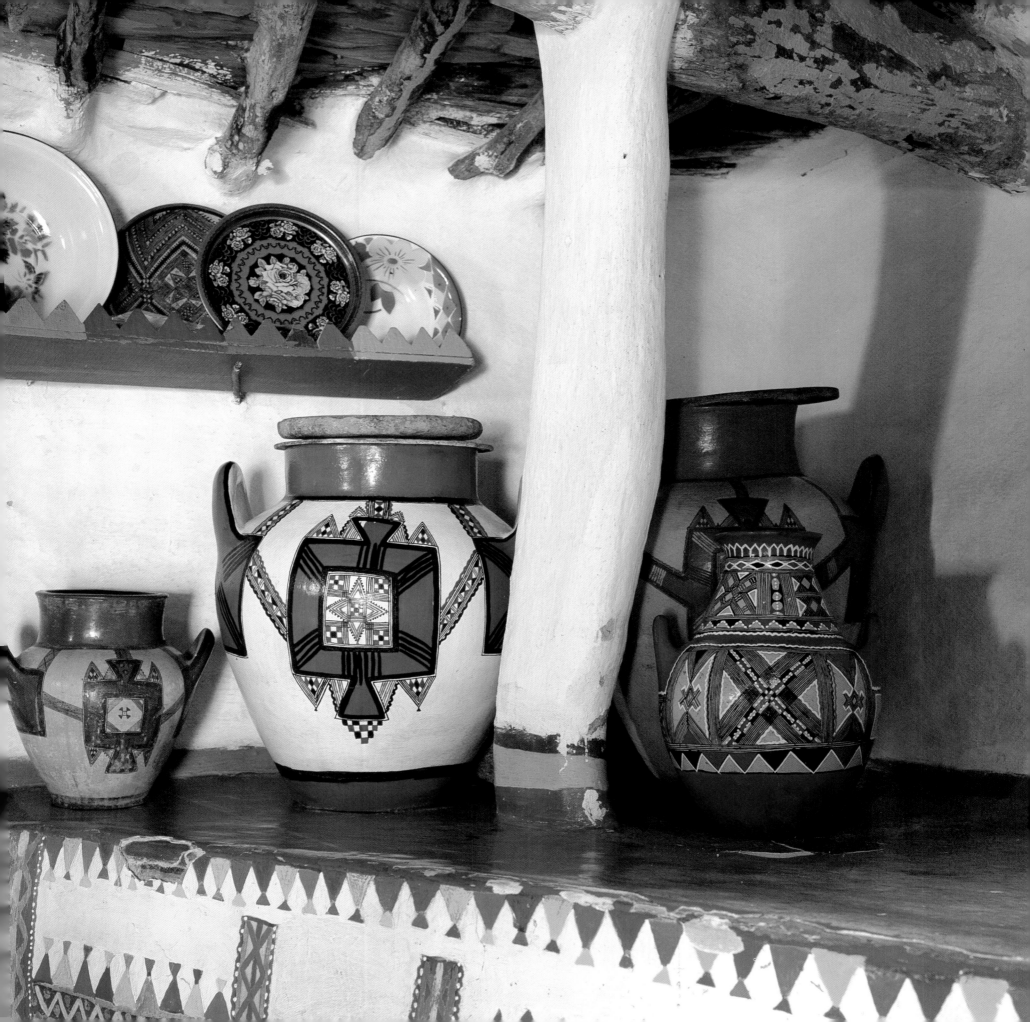

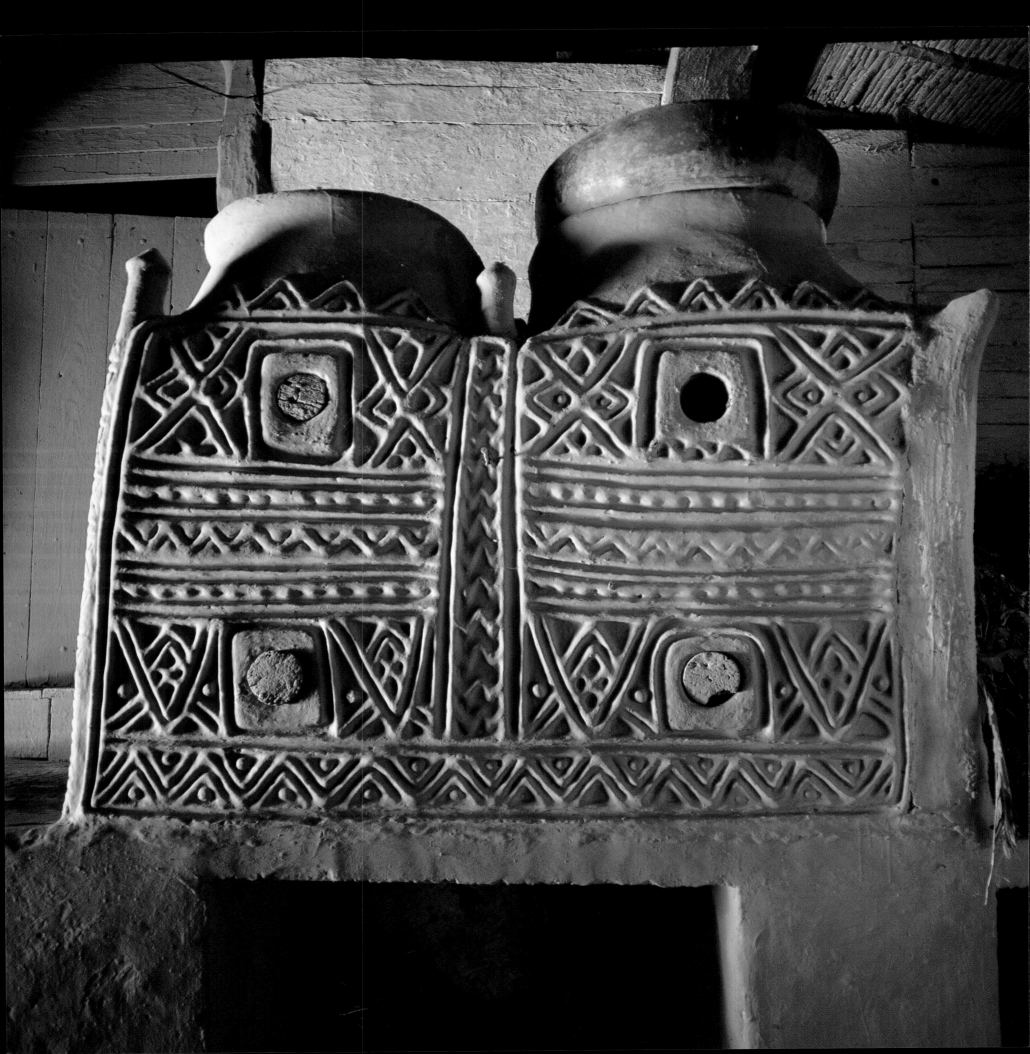

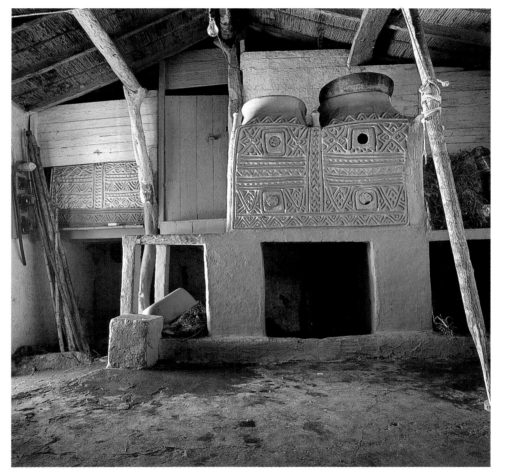

Opposite and above: Details from the original home of Ramdane Hales and his family in Ait Mesbah. These extraordinary storage vessels with painted motifs in relief are the work of Ramdane's mother when she was first married. Behind these blue ikoufane *is a loft for sleeping and a door that leads to an additional bedroom. Beneath is the stable with feeding trough facing the main living room and, on the left, a vertical beam remains of what was once part of a loom for weaving, as this traditional interior is now only used for the family's few livestock.*

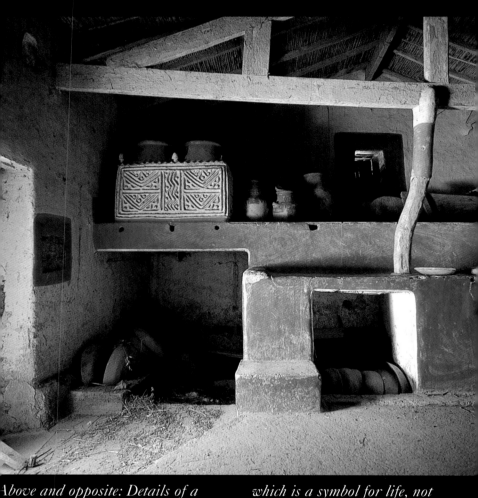

Above and opposite: Details of a traditional home interior near the village of Maatka, last restored and painted in 1972 and now used only for storage. In contrast to the green vegetation of the Great Kabylia landscape, red is frequently used by Berber women to decorate the interiors. Originally obtained from red clay and more recently from bought paints, red represents blood, which is a symbol for life, not hostility. Ikoufane are built in the most prominent position in the interiors, which explains their rich decoration—symbols of prosperity and of protection: the snake skin encased in chevrons, the leaves of the ash tree (revered throughout Kabylia), partridge, but also the scorpion and the frog to keep away the evil spirits.

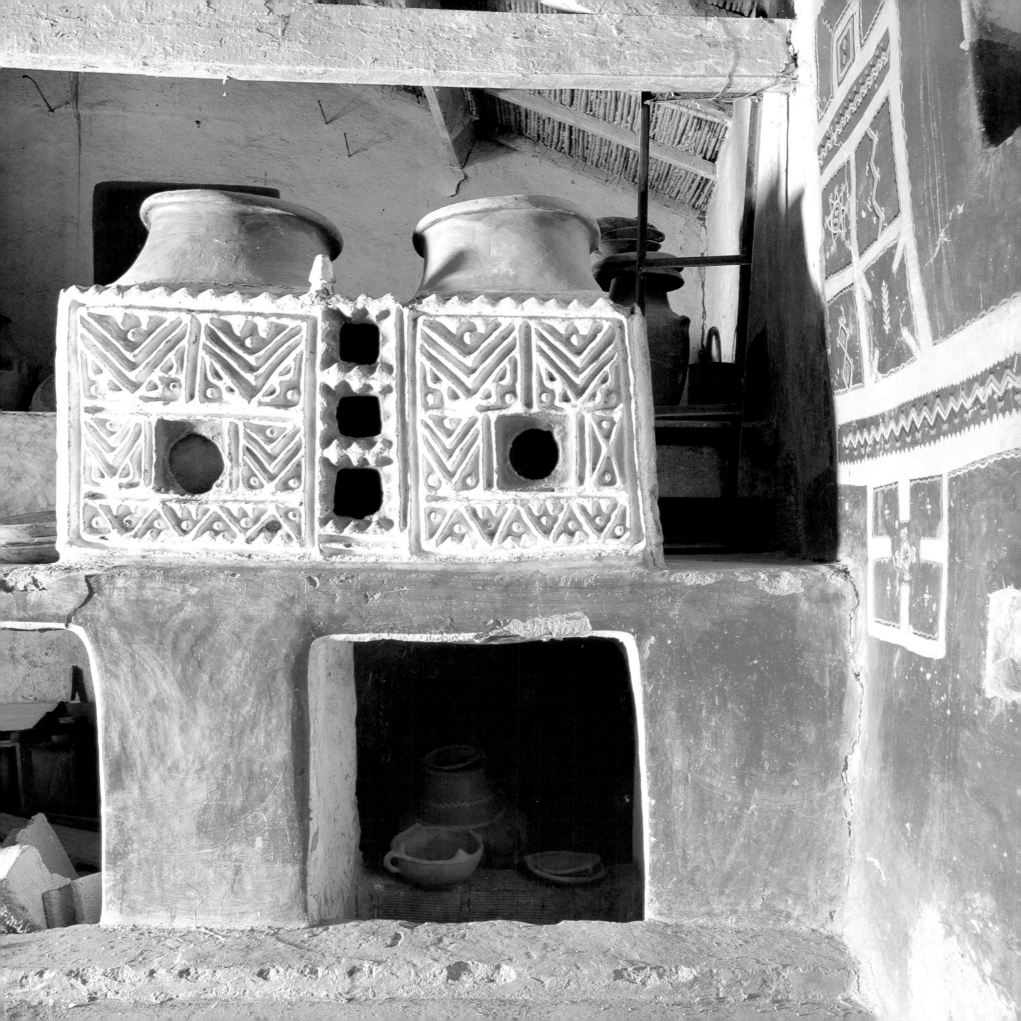

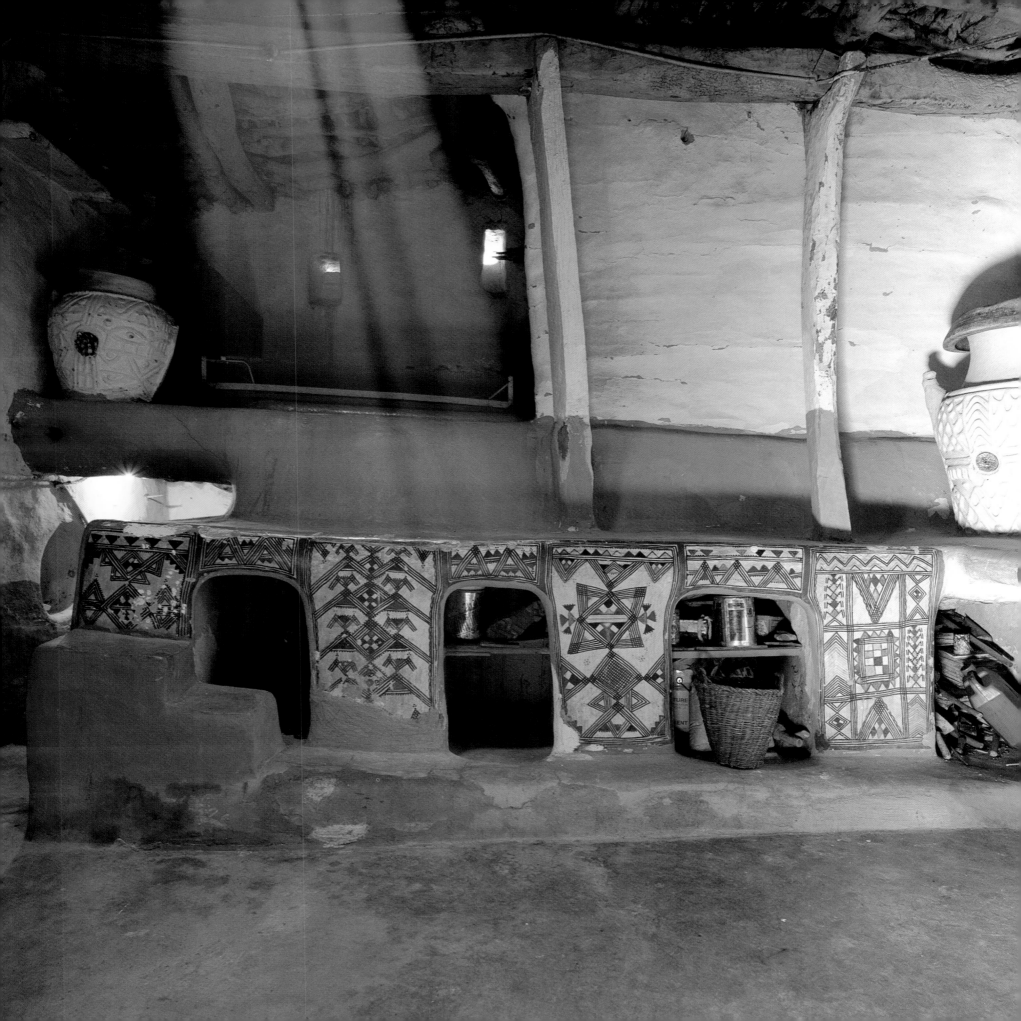

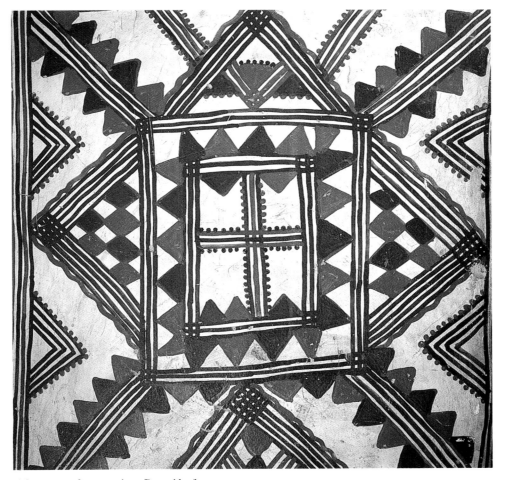

Above and opposite: Details from an exceptional interior, home of Bazi Merzouk from Agouni-Guerhane. The intricate mural decoration, painted many years ago by his mother, is filled with motifs representing animals, insects, plants, and objects from a woman's realm —a decoration harmoniously integrated with the architectural forms of the interior.

WEAVING

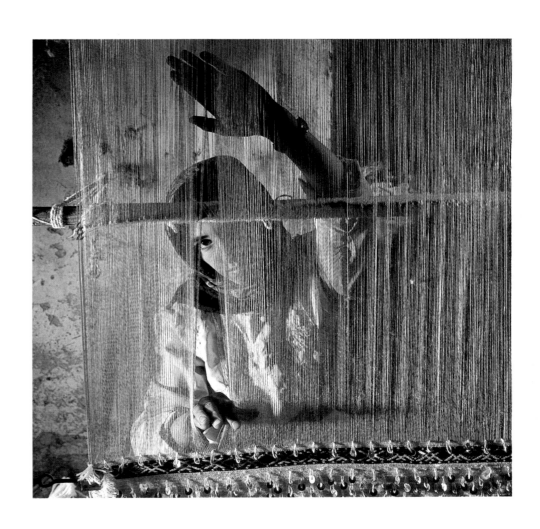

LIFE, SAY THE BERBERS, is a loom on which God holds the threads.

Weaving, a constant in so many Berber women's lives, has become a metaphor for survival and creativity. When a Berber gives birth, neighbors admiring the baby congratulate her on the beauty of her "weaving." When a weaver completes her work, she utters an invocation: "The life of the weaving has come to its end. Not so, please God, the lives of my household!"

The weaver's task starts at the river, where she washes the newly shorn fleece. When the wool is dry, she divides it into long, strong fibers to be spun into thread for the warp, and shorter, curlier fibers for the weft. Often, the wool is left in its natural hues of cream and rich brown. Other times, it is dyed with a palate of colors traditionally drawn from the earth and plants in the locality. Saffron gives warm yellows; the root of the madder plant and the juice or skin of pomegranate hot reds; indigo yields blues from pale sky tones to rich midnight black. Green can be obtained by a second dyeing of saffron wool in indigo.

Even the intricate woven rugs of the Middle Atlas are made on the simplest of looms, often constructed of nothing more elaborate than sticks and stones. With a few words from the Koran or a prayer to her guardian angels, the weaver sets up her loom in a few minutes.

She begins by driving four pegs into the earth floor of her kitchen or courtyard with a rock, then lays two sticks behind them for warp beam and breast beam. Taking the warp wool, she runs it back and forth between the two beams. A rod, balanced on stones placed either side of the warp, is laced to the lower warp threads to form a heddle. Raising the heddle raises every other warp thread, creating a space through which the weft thread can be passed by hand.

If the woman is a nomad whose family is in need of a tent, she will assemble her loom outside, horizontal with the ground, suspending her heddle from a pair of sticks held in place by stones.

It is the work of the patient, for each item may take months to complete. A good weaver completes only about three items in a winter, when the weather closes in and causes a pause in her farm labor. But most Berber women say the hours at the loom are their most pleasant: seated indoors, often in a kitchen warmed by cooking fires, and with the company of other women who drop by to lend a hand or share the latest news.

Preceding page: Fatima Khella, village of Alamghou in the High Atlas Mountains, Morocco
Opposite: Sixty-eight-year-old Touda Oulmimed of the Ait Haddidou tribe, covered in her handira, deftly spins a fine thread of wool using her toes. Imilchil, Morocco

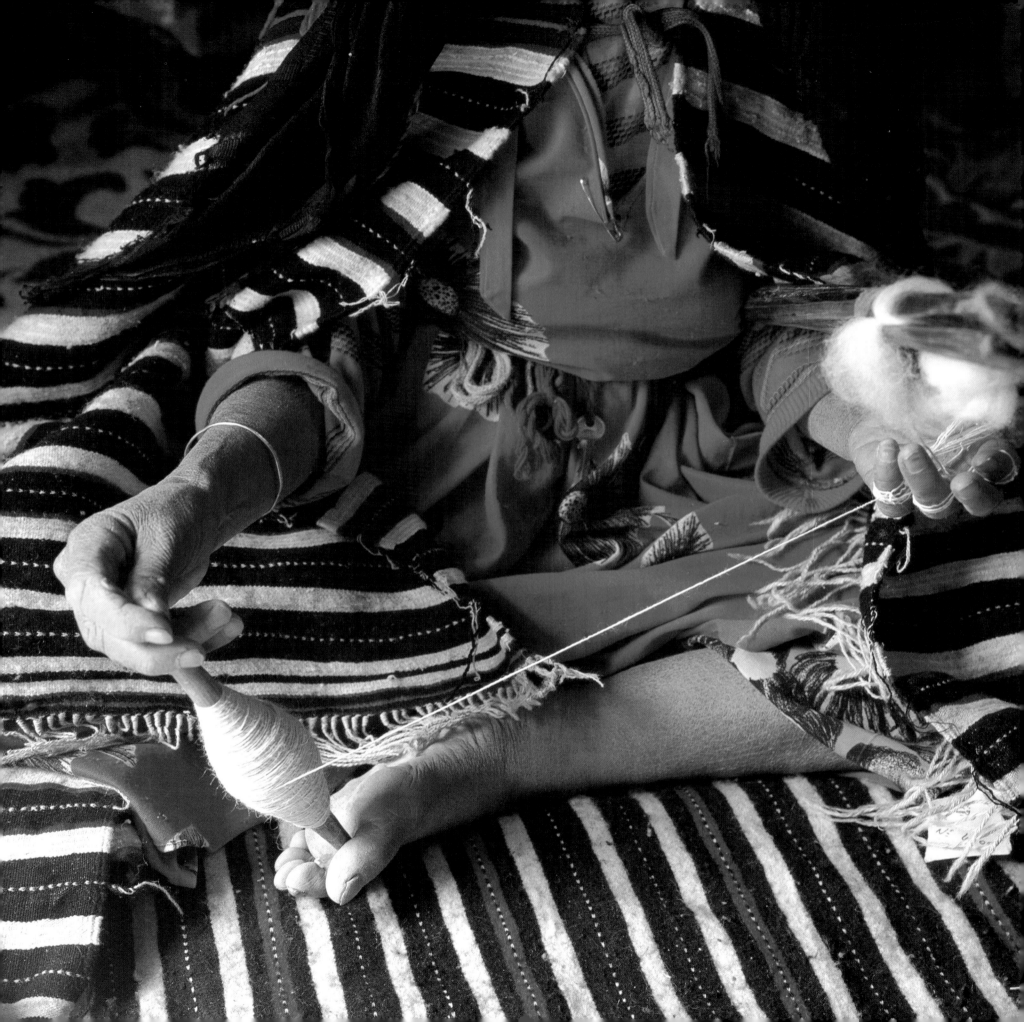

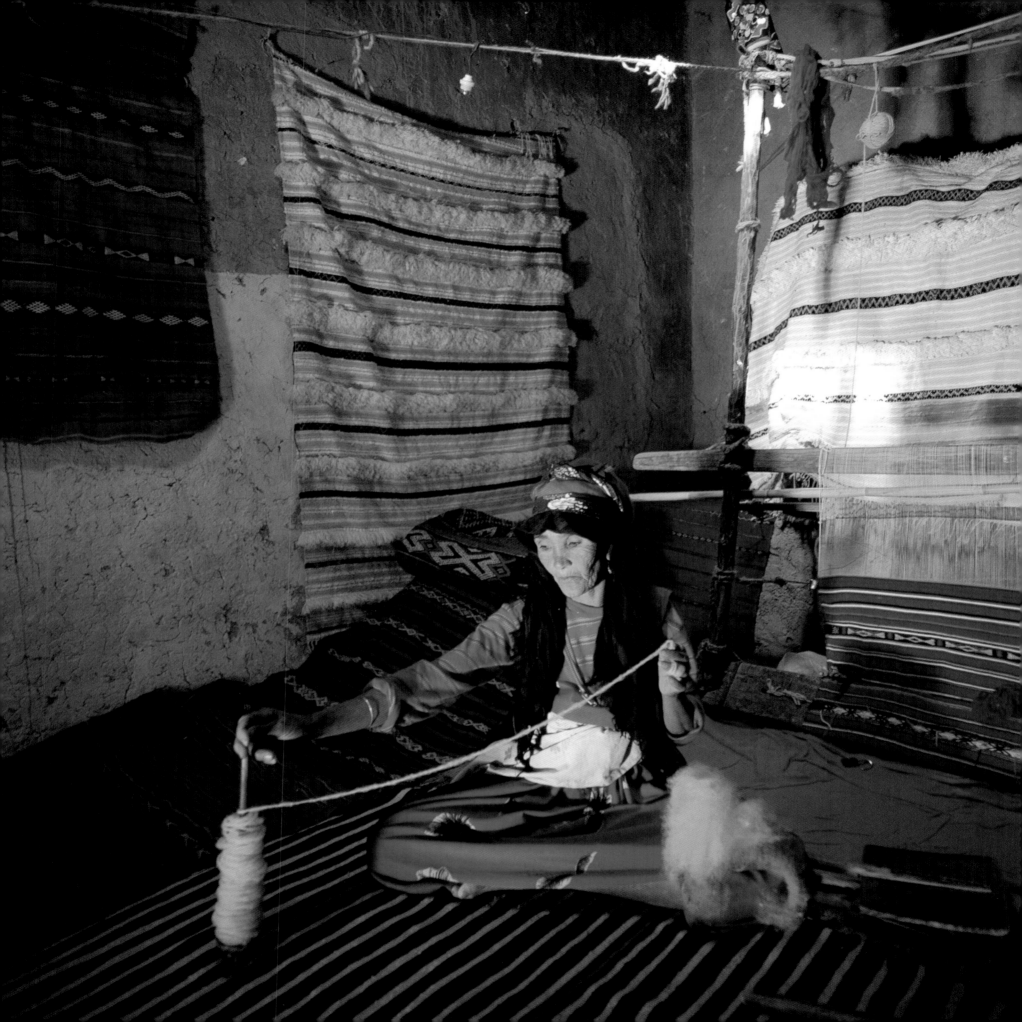

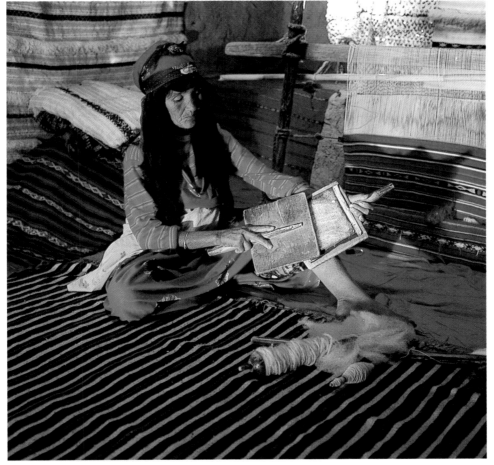

Opposite: A ray of light through a hole in the ceiling illuminates Touda Oulmimed in her home in Imilchil, Morocco. She is surrounded by the ceremonial handira and typical red-striped bread cloth that she has woven.

Above: Touda cards wool prior to spinning rough weft yarn as seen opposite. On my return a year later, in 1992, Touda had broken her wrist from a fall in the snow and had not been able to carry out any of her usual activities.

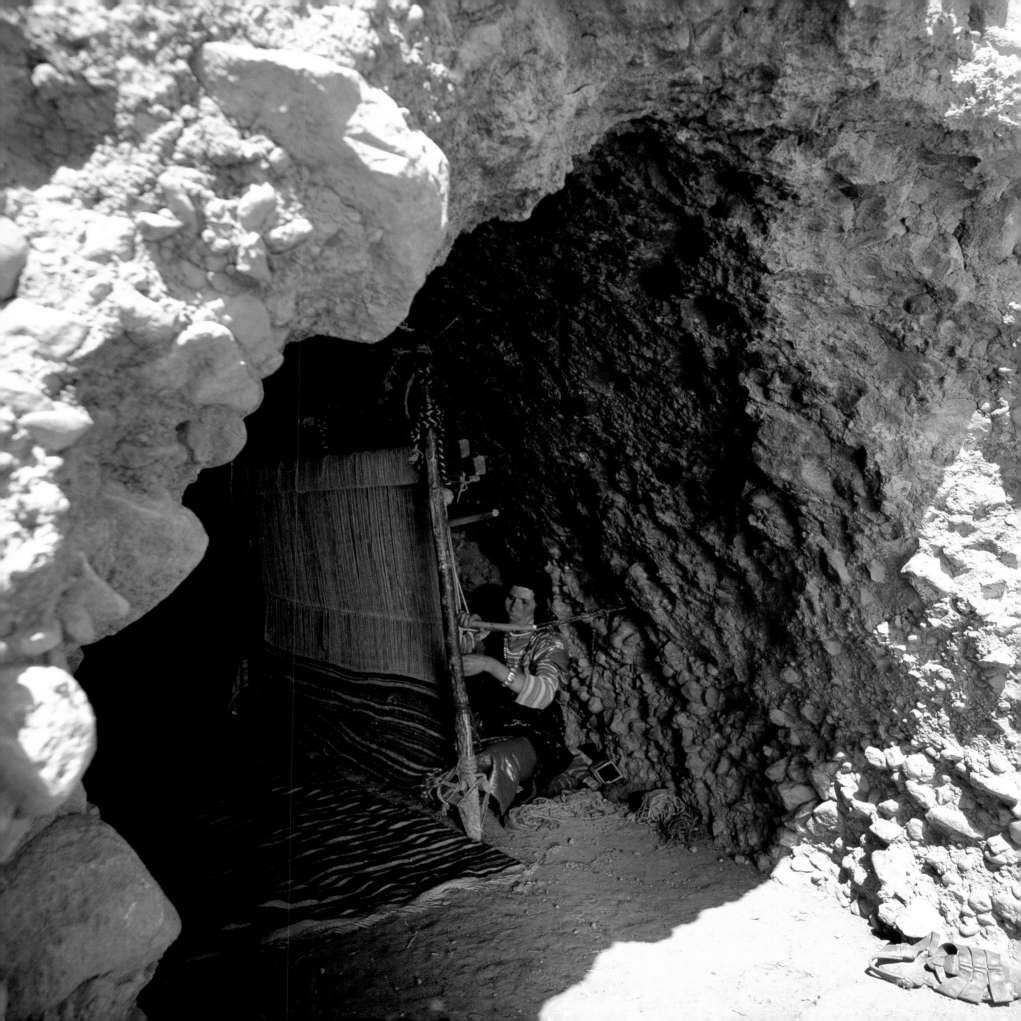

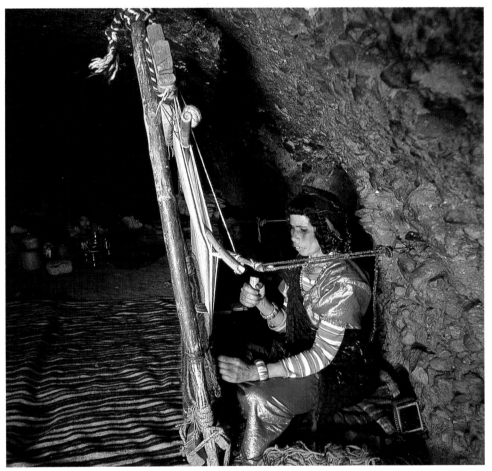

Following pages, top left: Aïcha Ouchaoua from Imilchil, Morocco, works on an unusual knotted carpet made with synthetically dyed green and red wool. Top right: Messaouda Hendel from the village of Taourirt-Khelf, near Beni Yenni in Algeria, weaves a plain woolen blanket. Bottom right: Sixty-year-old Lala Keltouma weaves in the village of Takhida in the Bou Gmez Valley, Morocco. Bottom left: Rabha Asakawfaliba works on a knotted rug near Ifrane in the Middle Atlas Mountains of Morocco. Following pages, far right: Fifty-five-year-old Aïcha Oubenmou weaves cloaks typical of her tribe, the Ait Haddidou from the High Atlas, Morocco. Divorced, she lives alone and supports herself by weaving and selling the striped handiras.

Opposite and above: In the Valley of the Roses, high in the Atlas Mountains of Morocco, Lho Ait Lakha of the Ait M'Goun tribe lives with her husband and son in a cave. Lho has set up a simple loom near the entrance of one of the three caves that make up their home.

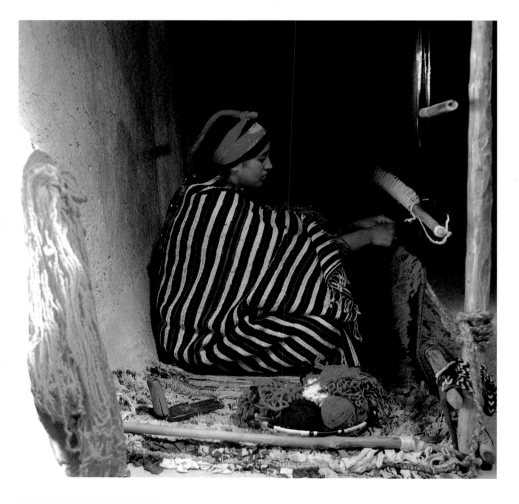
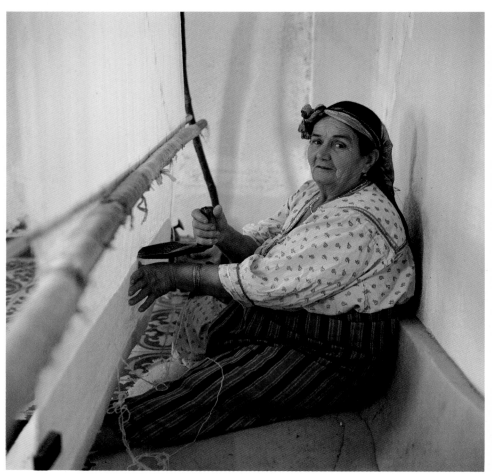
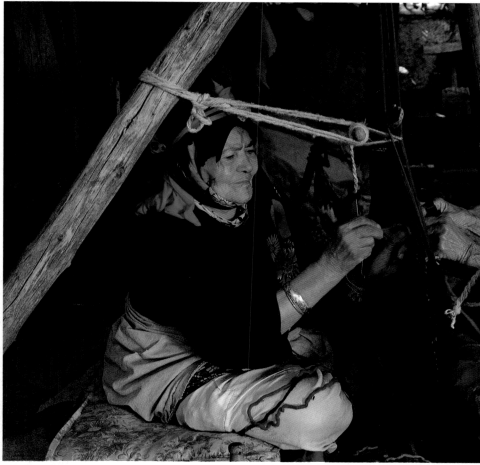
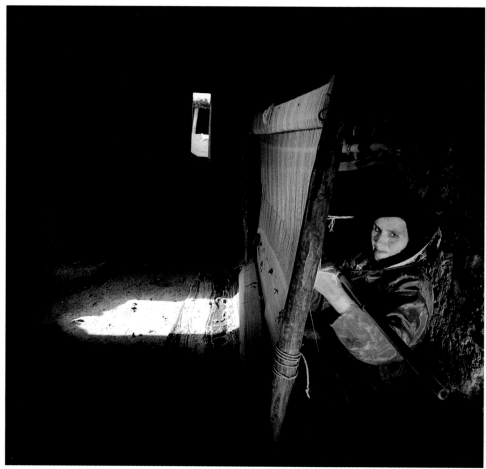

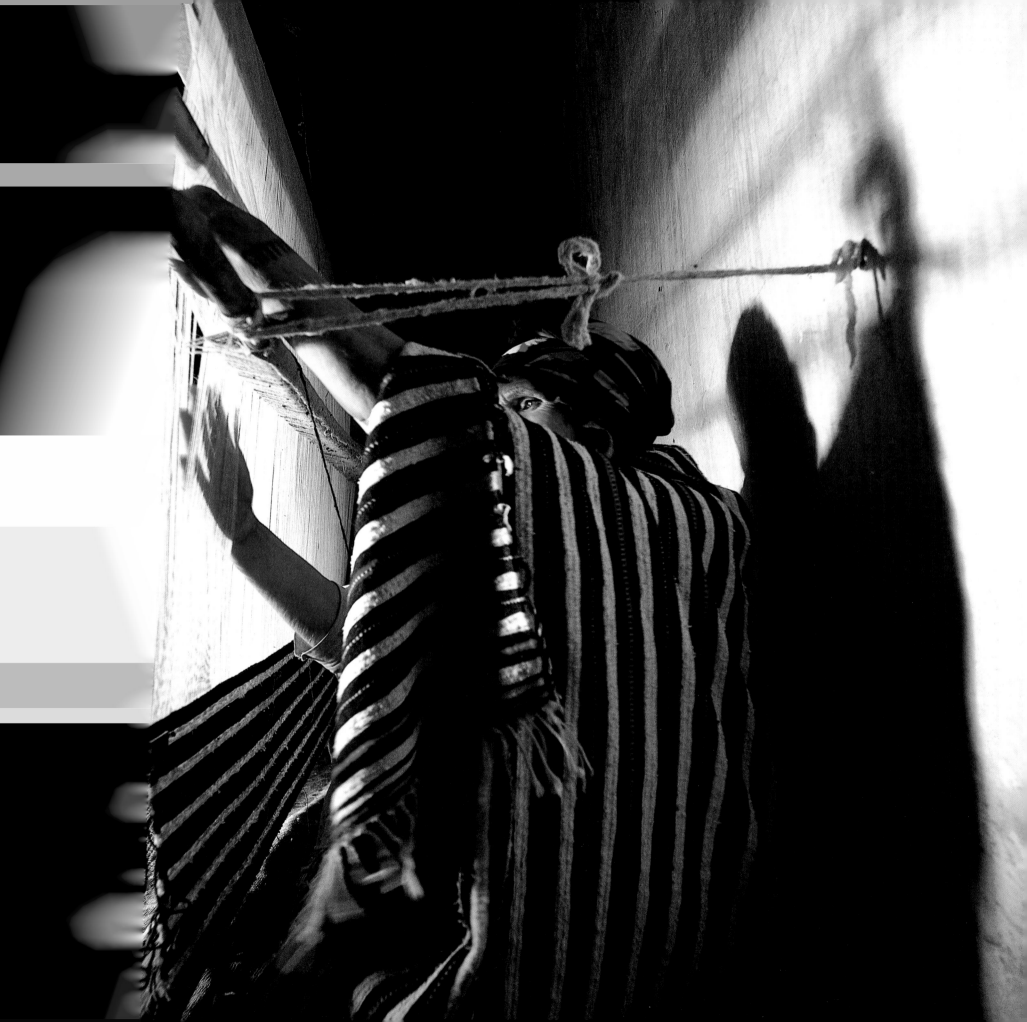

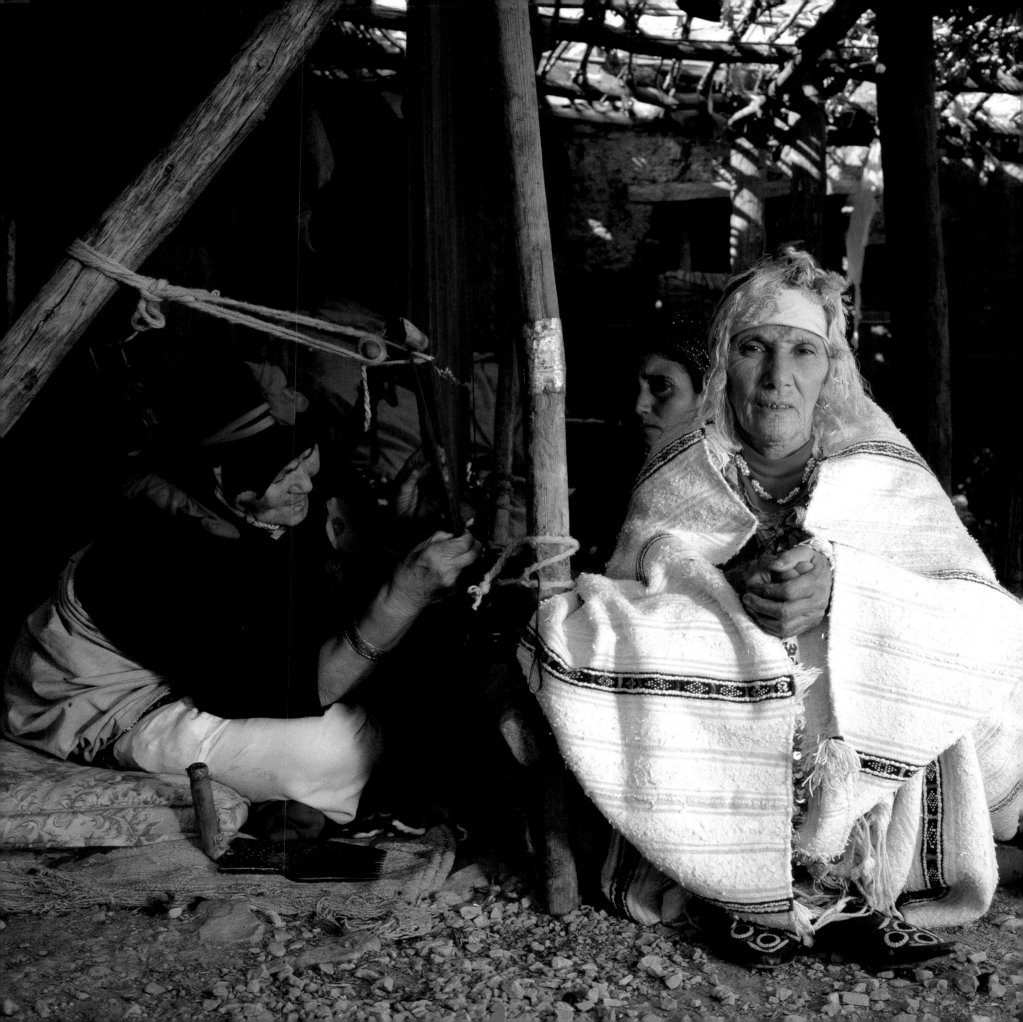

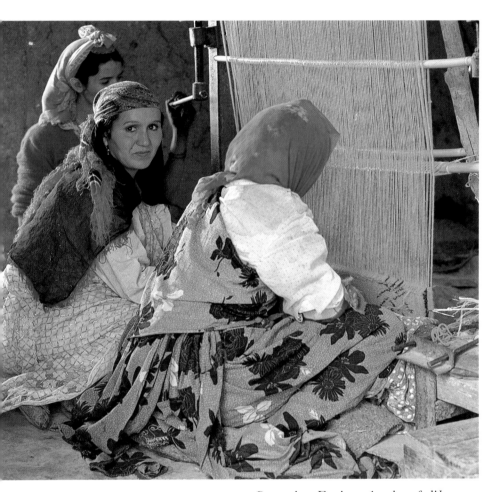

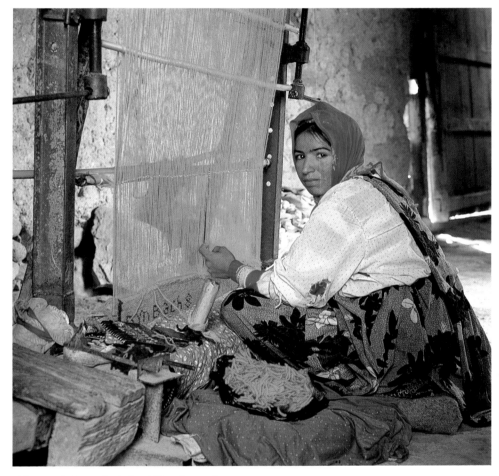

Opposite: Fatima Asakawfaliba wears a white handira *decorated with narrow strips of colored patterns, a style typical of the Middle Atlas that is usually worn on social and special occasions.*

Above, left and right: Ijja, in red scarf, is joined by her friends Katouma and Fatima, as they work together on a knotted carpet in Ijja's home near the village of Tazenakhte in the Anti Atlas region of Morocco. Before they set up the loom, the women had already spun and dyed the wool, using saffron grown in the region.

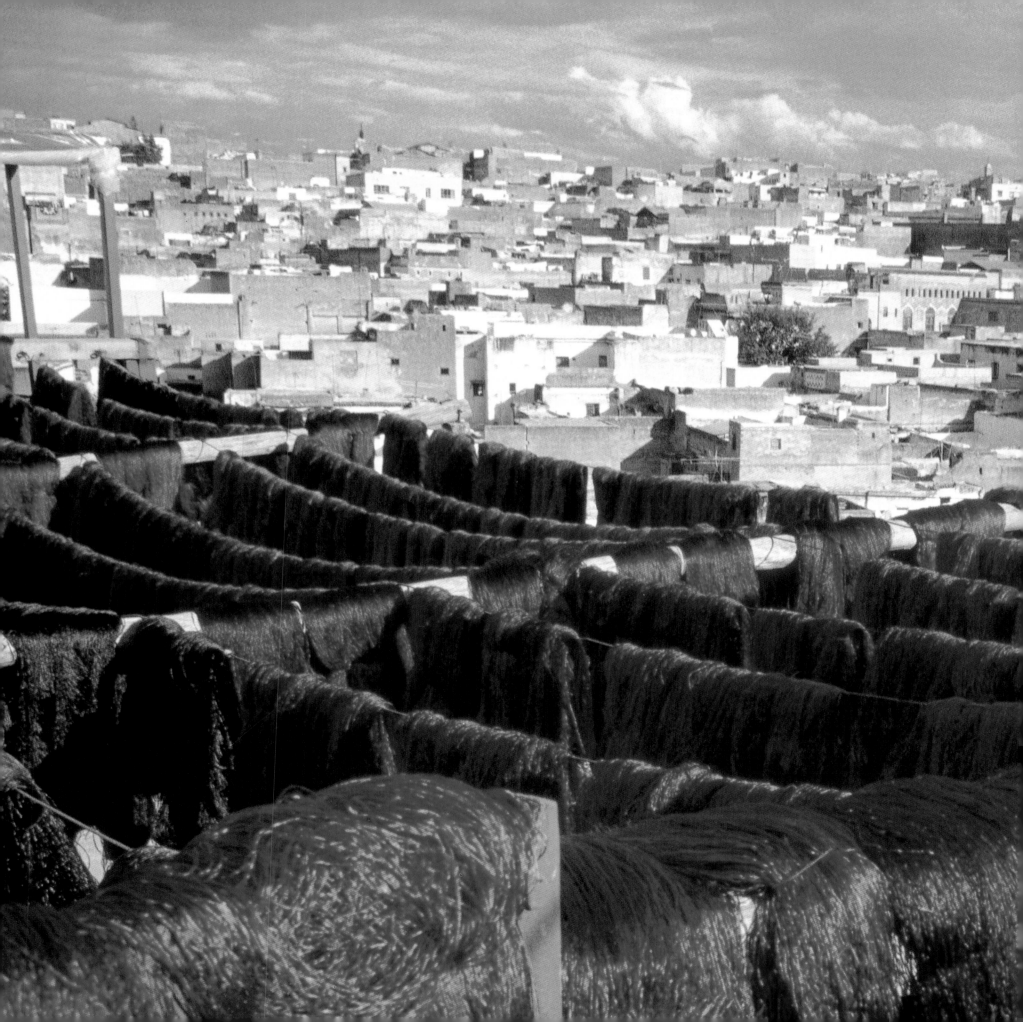

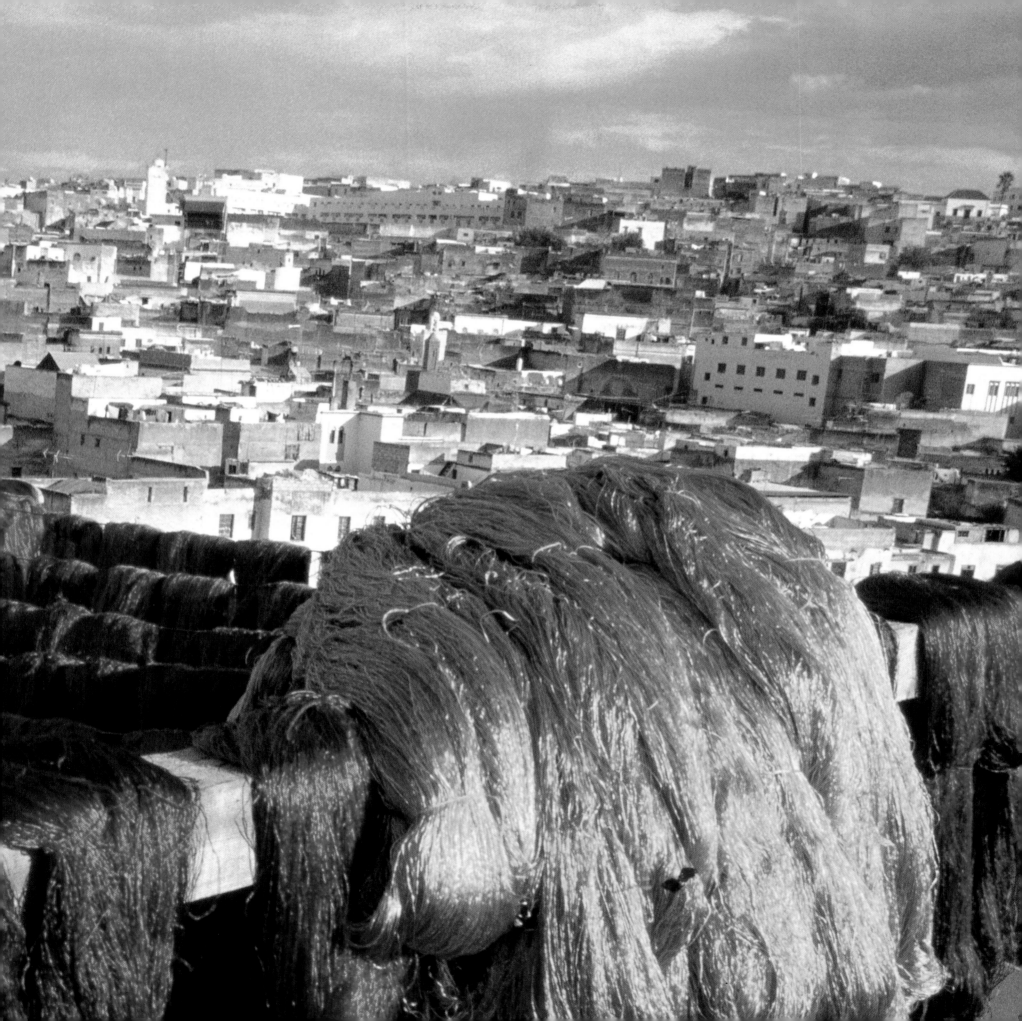

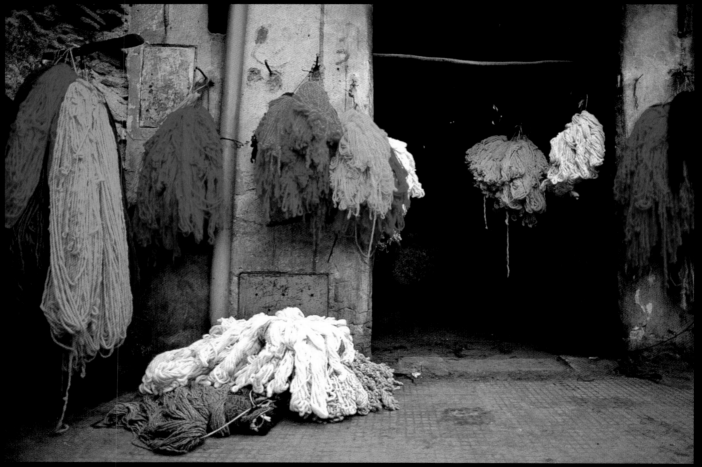

Preceding pages: Skeins of synthetic fibers are hung to dry over a trellis on a rooftop above the city of Fez, Morocco.

Above: Skeins of synthetically dyed wool dry in the souk *of Marrakesh, Morocco.*

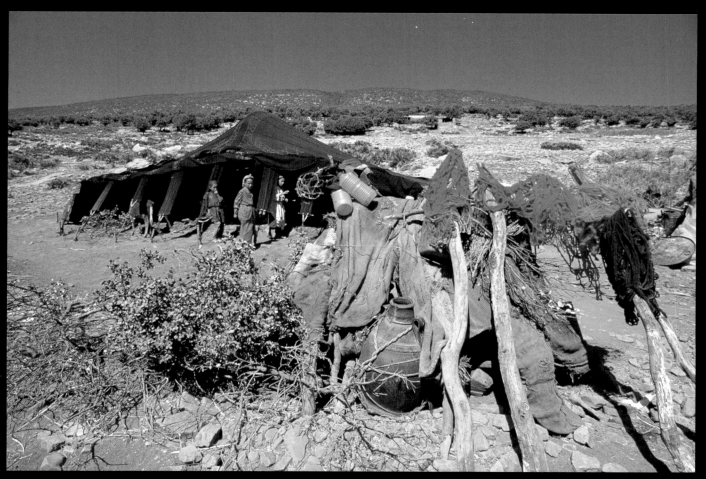

*Above: Near El Ksiba in the Middle
Atlas Mountains, wool is hand-dyed
and hung out to dry outside the tent
of the nomadic El Matawi family.*

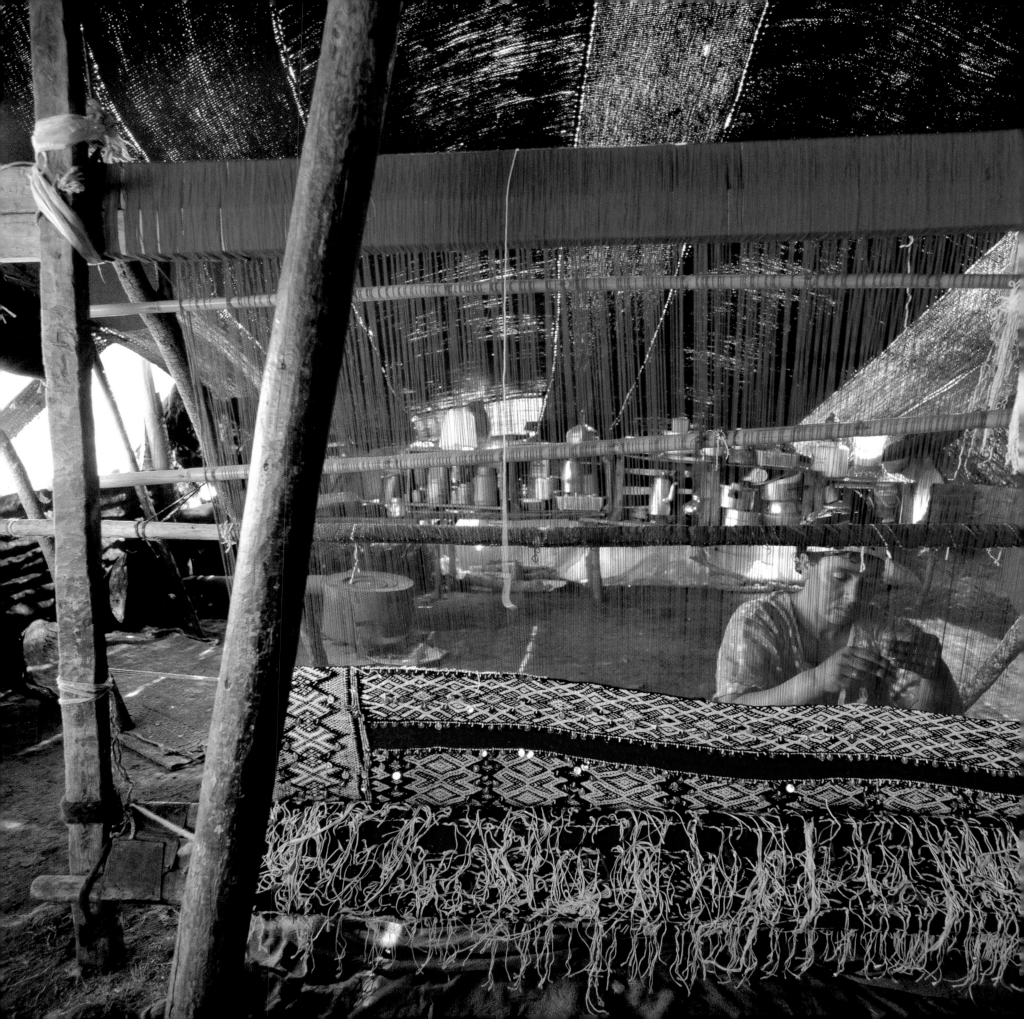

Opposite: Yamna Irbiene learned weaving from her mother before she married and settled for a nomadic life. She spends her days weaving in the tent while her husband tends their livestock. They have two children and move between the High Atlas and the Middle Atlas Mountains in Morocco in search of pastures. Right: For the past seven years, a family of the Ait Atta tribe, have lived in this tent in the Todra Gorge, near Tamtatouch, Morocco. Below right: Fatima El Matawi's two daughters help her to complete a knotted rug for their tent floor. In tents, a loom separates the women's domain, which includes the cooking area, from the reception/ sleeping area. The most notable fact of the nomadic way of life is that even though circumstances may require a family, like the one in the Todra Gorge, to remain sedentary for several years, not an inch of land is cultivated—not even a leaf of mint for their tea or a blade of grass for their sheep and goats.

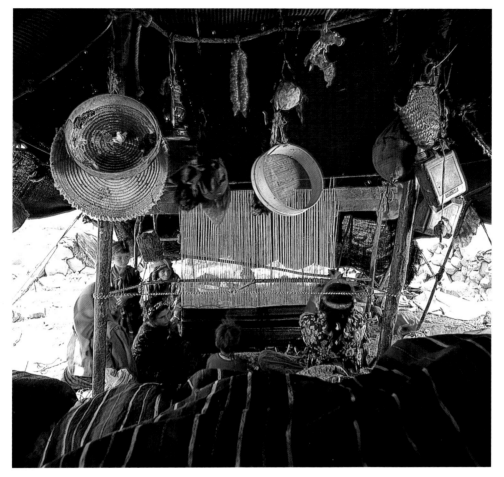

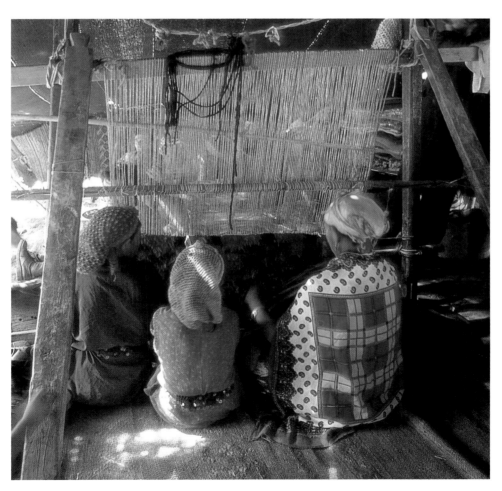

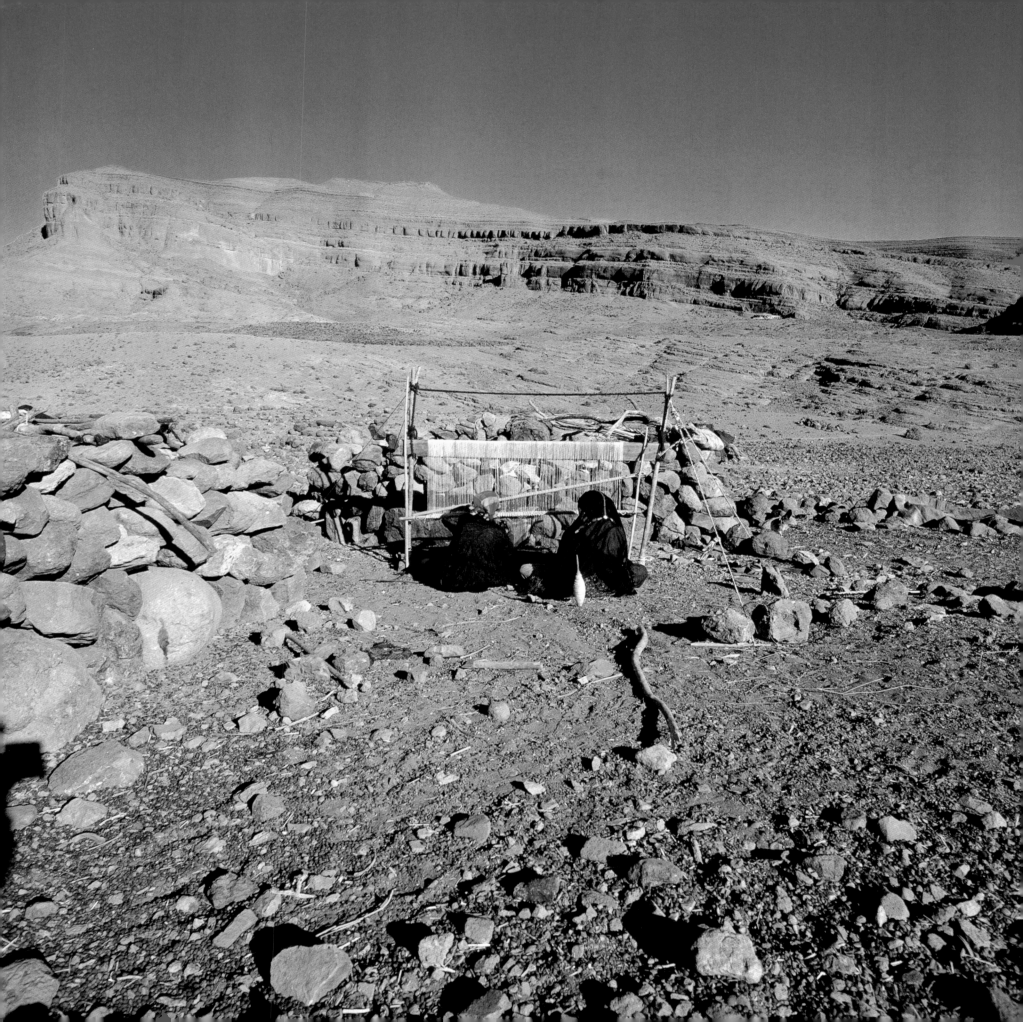

Opposite and right, above and below: About 50 miles from Boumalne Dades, crossing a tortuous track in the Sarho Mountains, a part of the Anti Atlas range, groups of nomadic people from the Ait Atta tribe live in tents surrounded by corrals made of stone walls. Their permanence depends on the availability of grazing and of underground water for themselves and their livestock. While the men tend the flocks, the women spend most of their day under the harsh sun, weaving sections of cloth from goat and camel hair to repair their tents— and occasionally weaving a rug for the floor. Shy and unaccustomed to visitors in this remote valley, Ajou Moha and Aïcha Dahoud, robed in thin black cotton handiras *with colorful embroidery, have settled here for the winter with their families.*

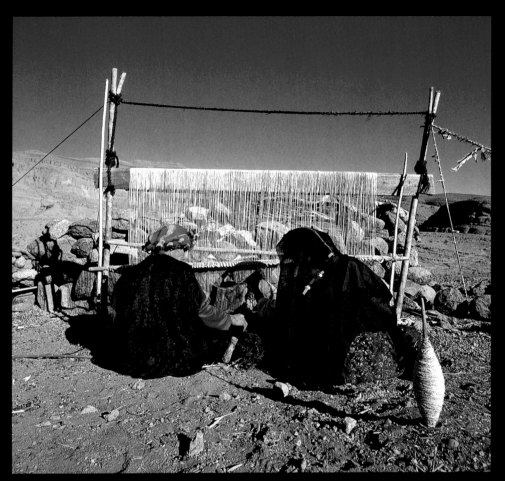

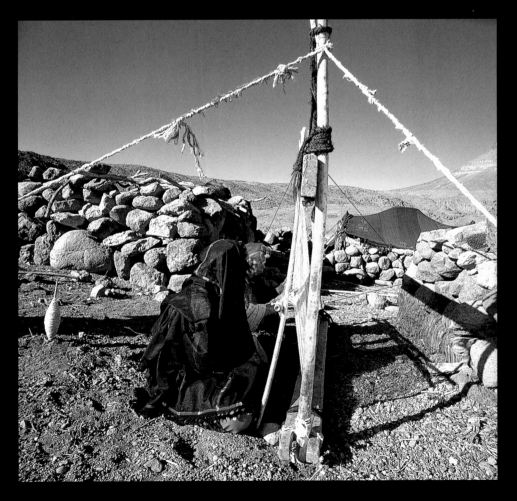

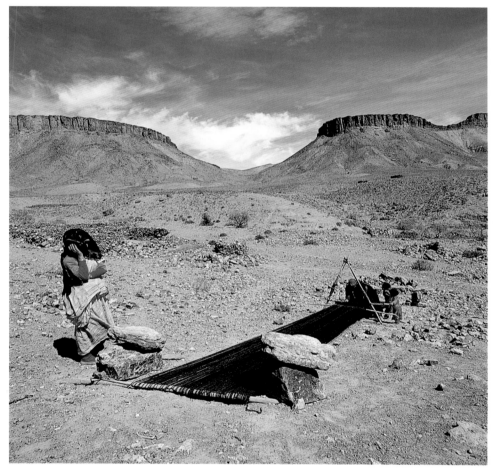

Above and opposite: On a wide and dusty plane, in the Sarho mountain range, 3 miles from the village of Ait Ouazik, Touda Ali weaves a tent strip from sheep's wool and goat hair on a primitive horizontal loom anchored by massive boulders.

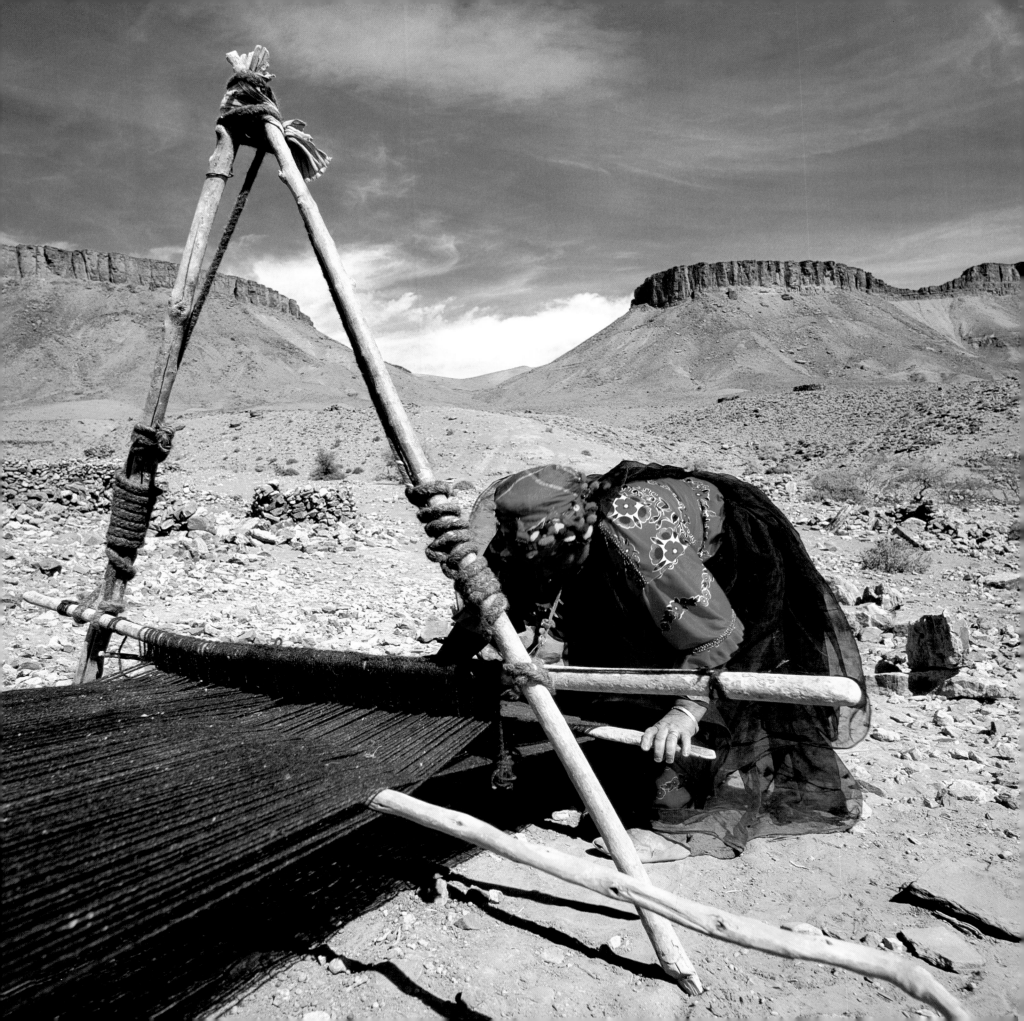

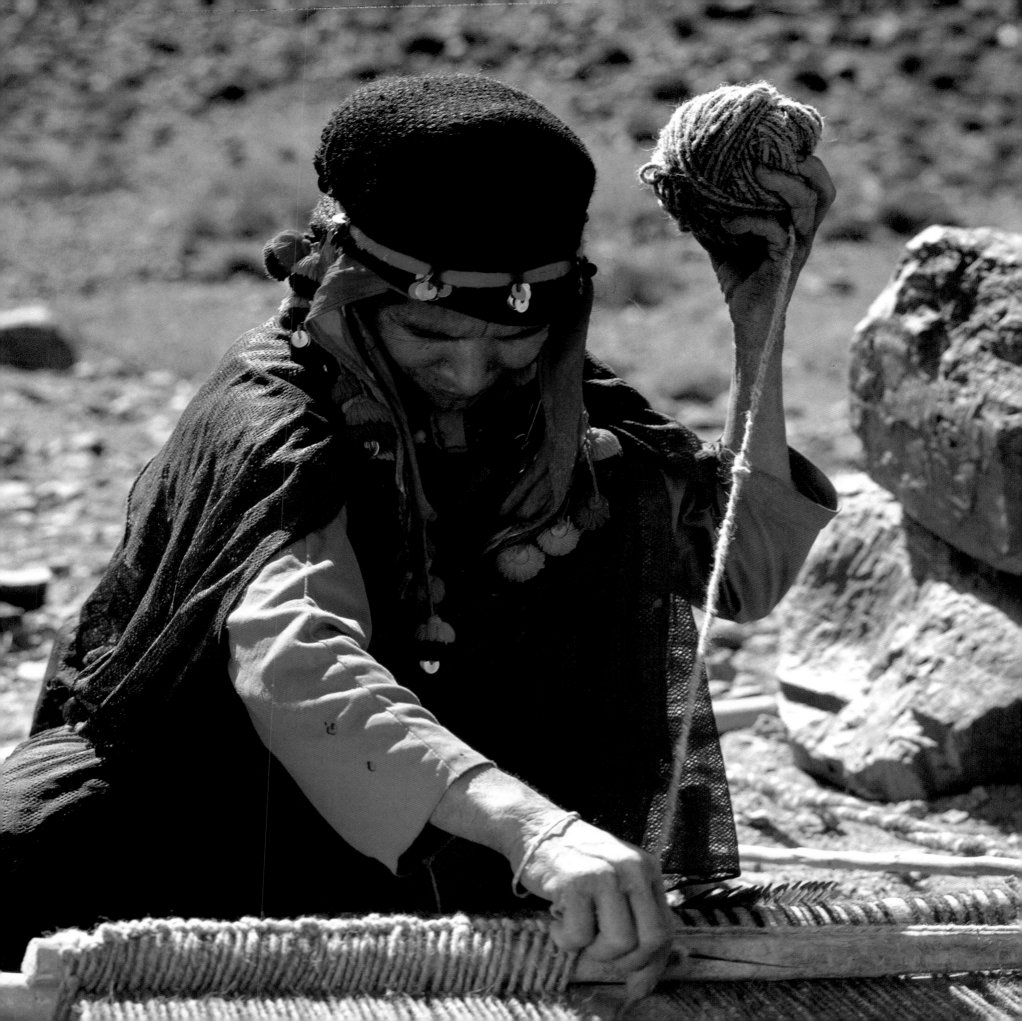

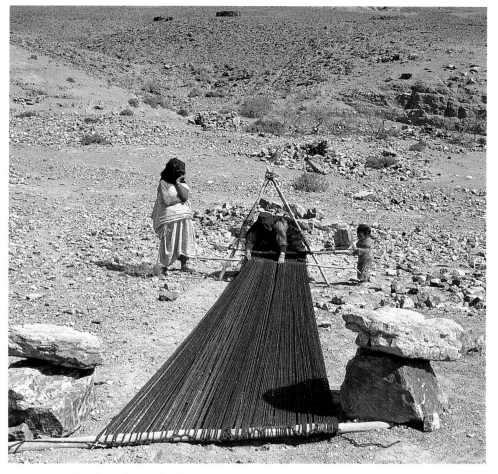

Opposite: Tloho Mhamed of the Ait Atta tribe uses a cocoonlike ball of wool as a shuttle and pushes it through the narrow spaces between the threads of the warp of her horizontal single-heddle loom.

Above: The women of the Ait Atta tribe use horizontal ground looms with a heddle suspended from a pair of sticks. They weave cloth from goat hair and sheep's wool to make the tents that are their homes while tending their flocks in high mountain pastures when the snow has melted.

Although Berber women spin their
own wool, different groups use
different methods, as seen here with
three women from Morocco, who
weave cloth for handiras, *tent
fabric, or cords. Below left: Aïcha
Ait Kaider from Tilimi in the High
Atlas uses a long distaff tucked
under her belt which leaves both
hands free to control the spindle.
Below right: Halima from the
southern desert town of Zagora
draws out ram's wool fibers and*

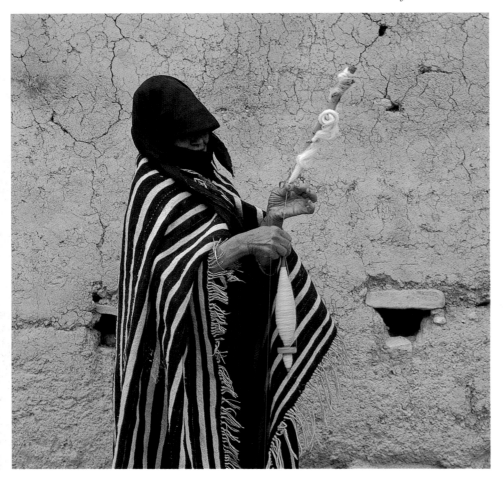

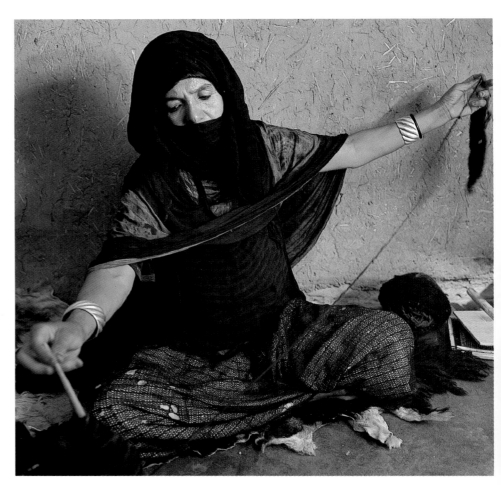

*winds them onto the spindle by
twisting the wool between her fingers.
Opposite: Zahra Belarbi from the
lower plains of the Middle Atlas
near Oued Amlil uses her thigh to
control the long spindle.*

*Following pages: Women of the Ait
Haddidou tribe from Imilchil in
Morocco lay the warp by winding
the spun yarn around three pegs
posted in the ground. The distance
between the pegs is based on the
width and length of the garment to
be woven.*

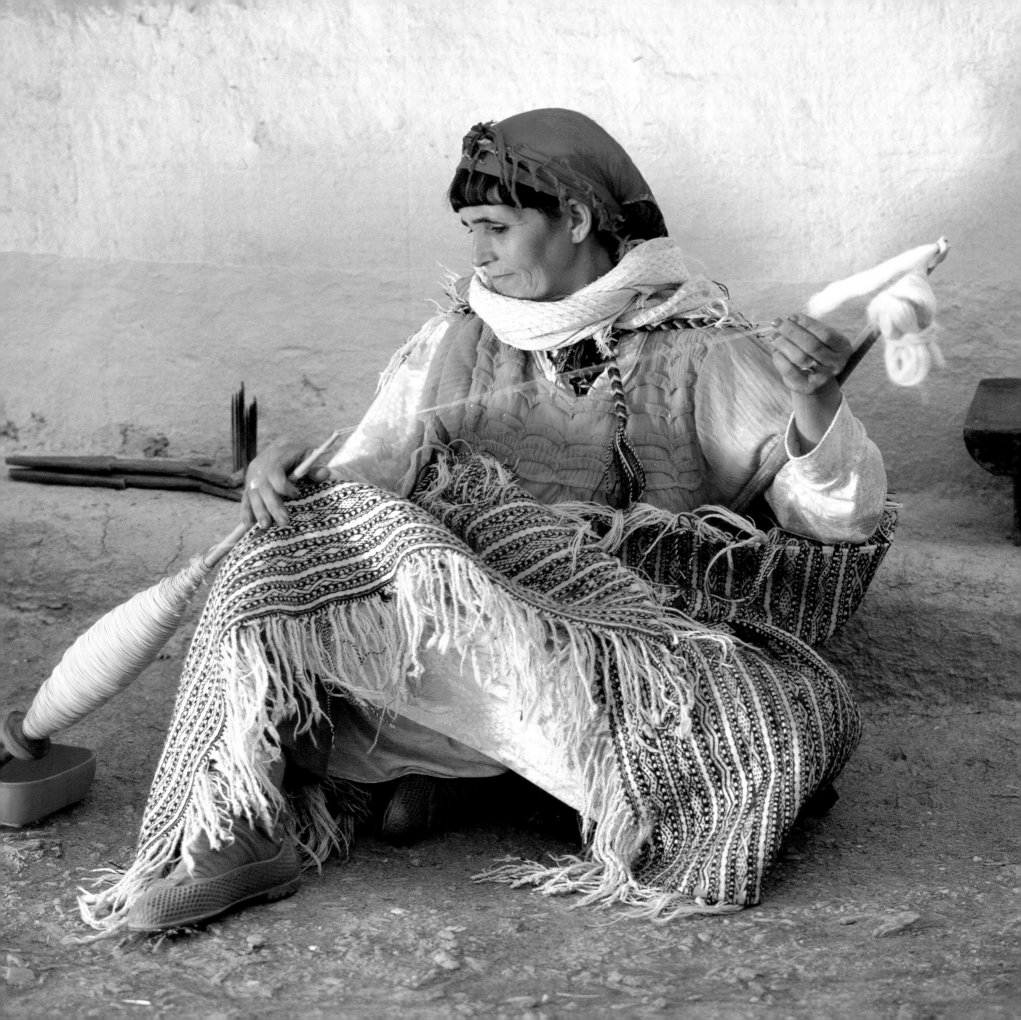

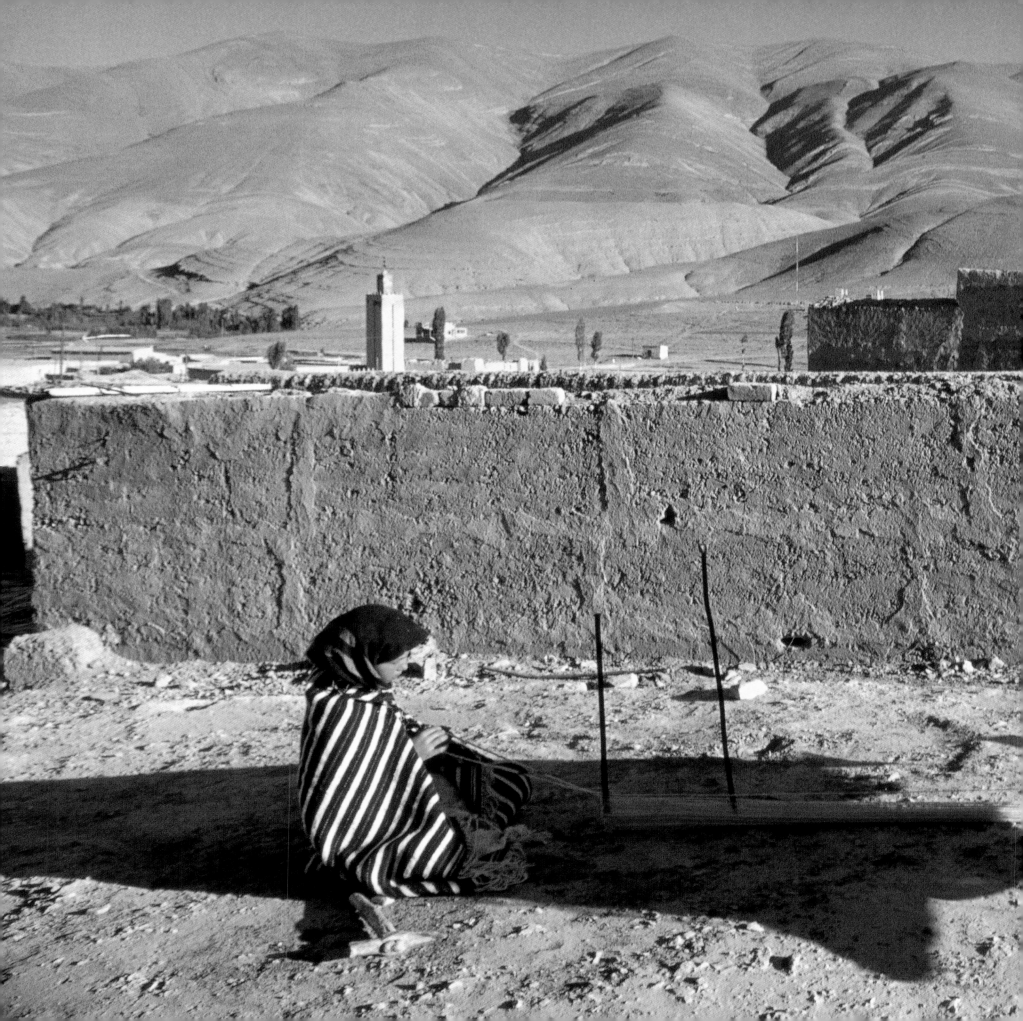

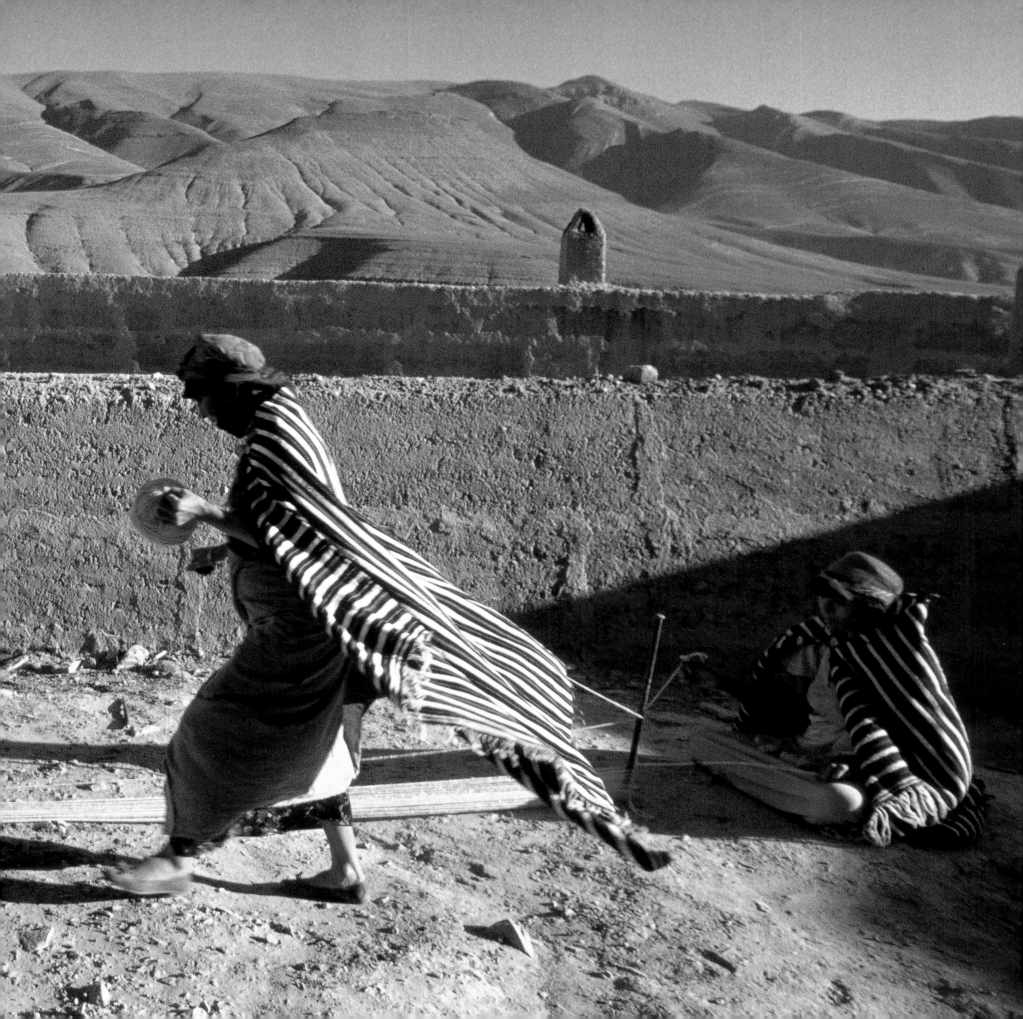

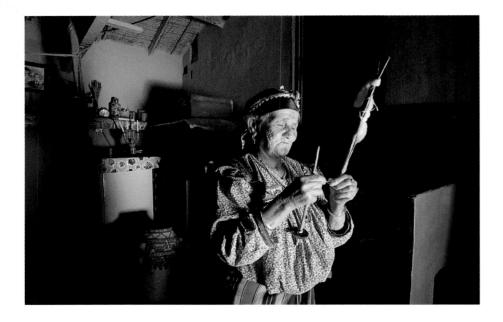
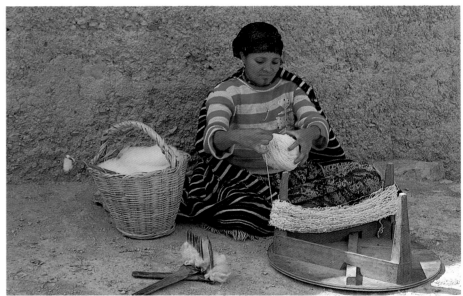
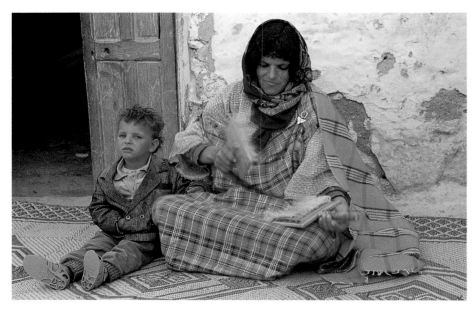
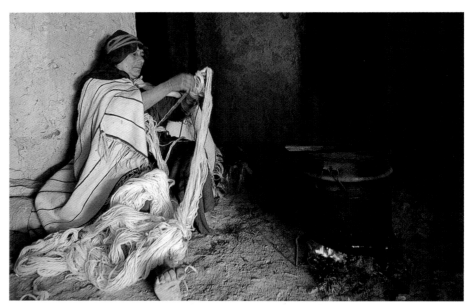
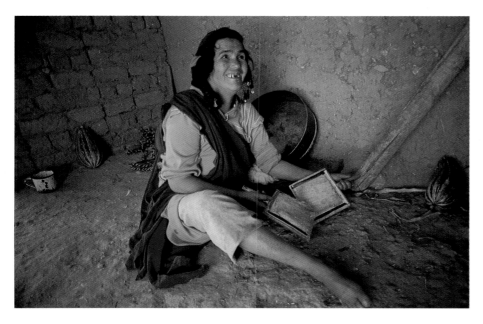
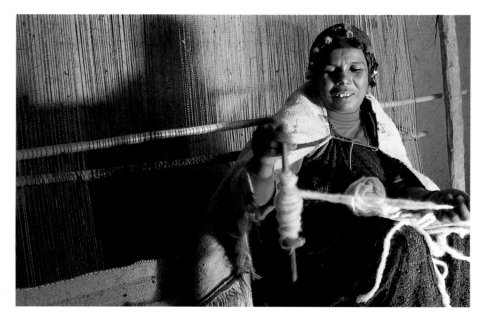

Opposite, top left: A Kabyle woman from the village of Ait Mesbah, Algeria. Top right: A young woman of the Ait Haddidou tribe. In the foreground are two combs used for combing raw wool made of iron spikes set in horn and mounted on wood. Center left: A troglodyte Berber cards wool in the courtyard of her home in Matmata, Tunisia.

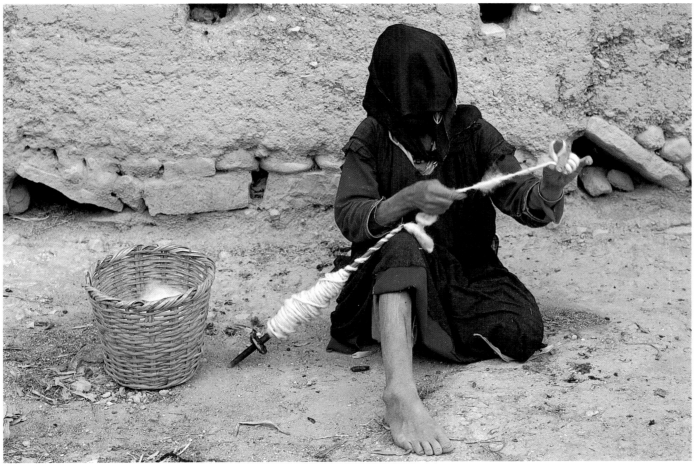

Center right: Aïcha Ouichou, an Ait Brahim woman, prepares a skein of wool for dyeing. Alamghou, eastern High Atlas, Morocco. Bottom left: Halima from the village of Bou Thrarar in the Valley of Roses uses a pair of cards with short, hooklike spikes set in leather and mounted on a square wooden bat to separate the wool into fibers. Bottom right: A woman of the Ait M'Goun tribe in the Valley of Birds, Morocco, spins wool into weft yarn.

Above: The livelihood of many Berber families in North Africa is dependent on rearing sheep and goats. Wool is the predominant fiber used for weaving.

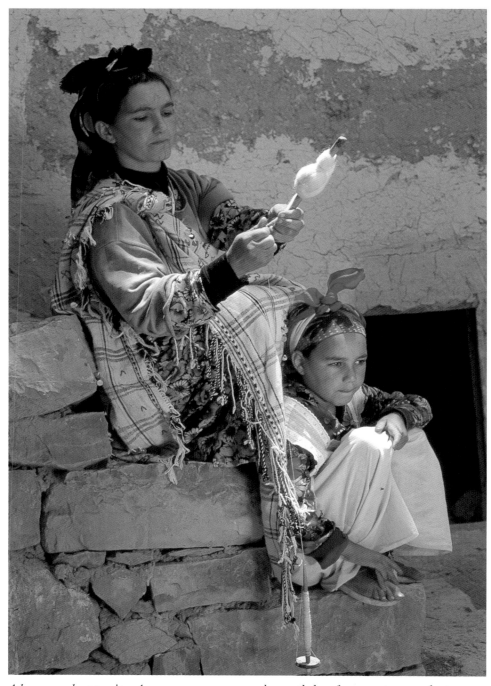

Above and opposite: A young woman of the Ait Bou Gmez tribe, village of Takhida, Morocco, uses the stone steps in the courtyard of her home so that the spindle can spin beneath her for greater comfort. Women in the Bou Gmez Valley spin a very fine yarn that is woven into exquisitely declicate shawls scattered with embroidered Berber symbols.

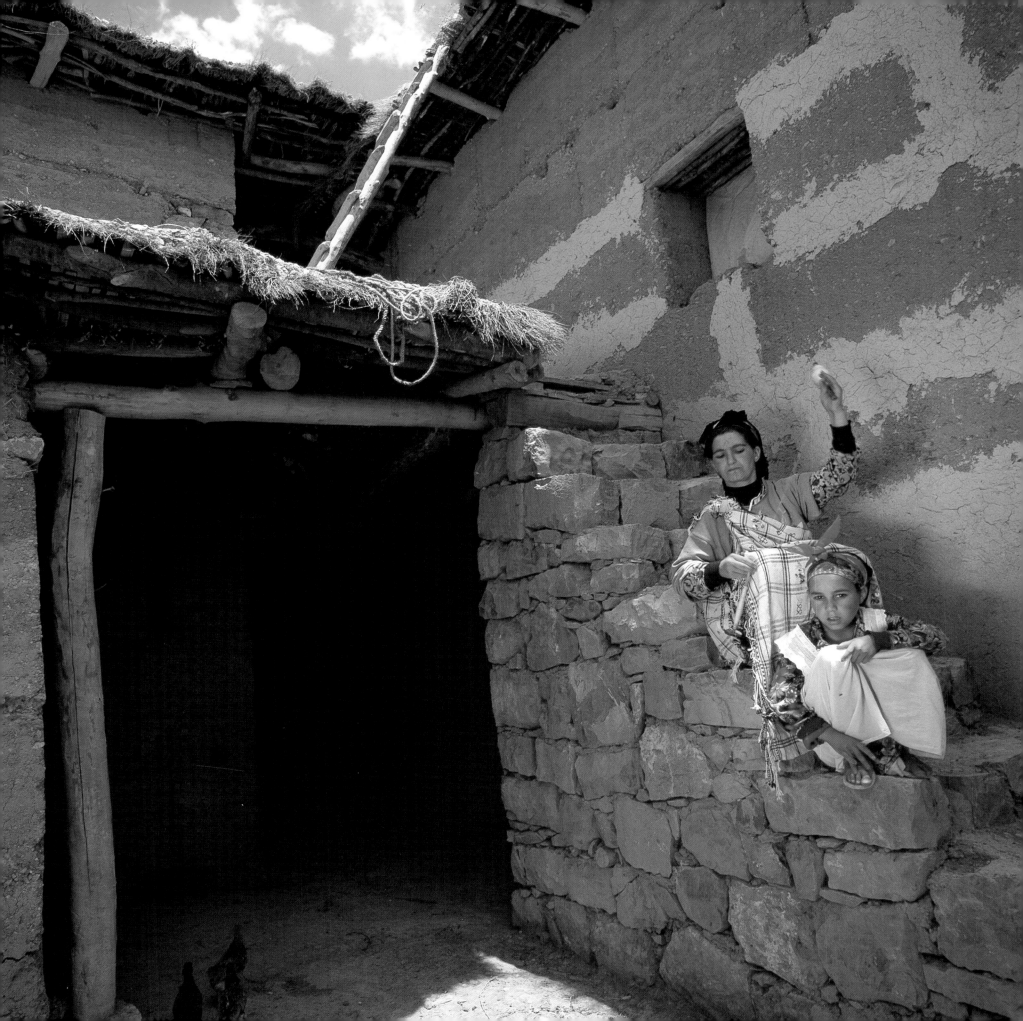

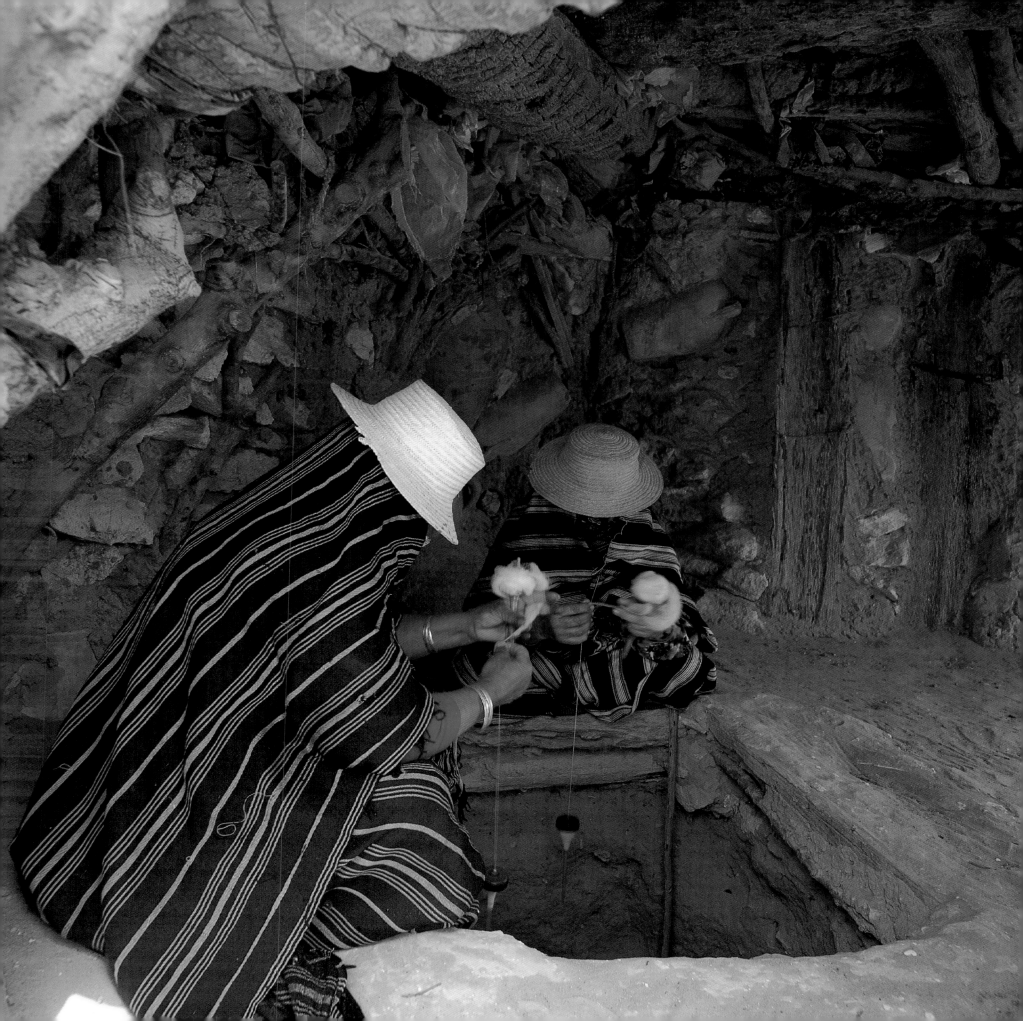

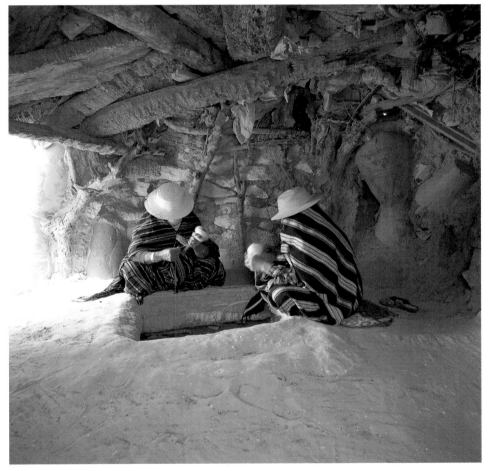

Opposite and above: Berber women from the island of Djerba, Tunisia, whose husbands insisted they not be identified, spend their afternoons spinning wool to sell at market. Although most islanders live in brick and concrete houses, a low, domelike structure is built in the courtyard, using broken pottery from the renowned Djerba pottery industry and bark from palm trees. Men are barred from entering this private space where women gather to drink tea and socialize while spinning. The spindle is dropped down into a specially built pit so that it can rise and fall like a yo-yo without requiring the spinner to keep her arms continually raised.

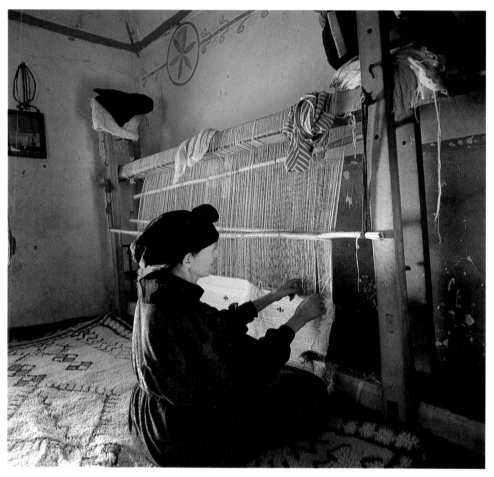

Above: Forty-year-old Hadda Ouchaou from the village of Abachkou in the Bou Gmez Valley, Morocco, makes fifty knotted carpets a year to take to market. During the long snowbound winters, she also teaches other women the art of carpetmaking. Hadda adheres strictly to local traditions by using only natural hues obtained from plants and walnut leaves as dyes, and Berber symbols as decoration.

Opposite: A single-heddle loom set up in the kitchen of the home of Loho Ousouha in Msemrir, in the High Atlas Mountains, Morocco

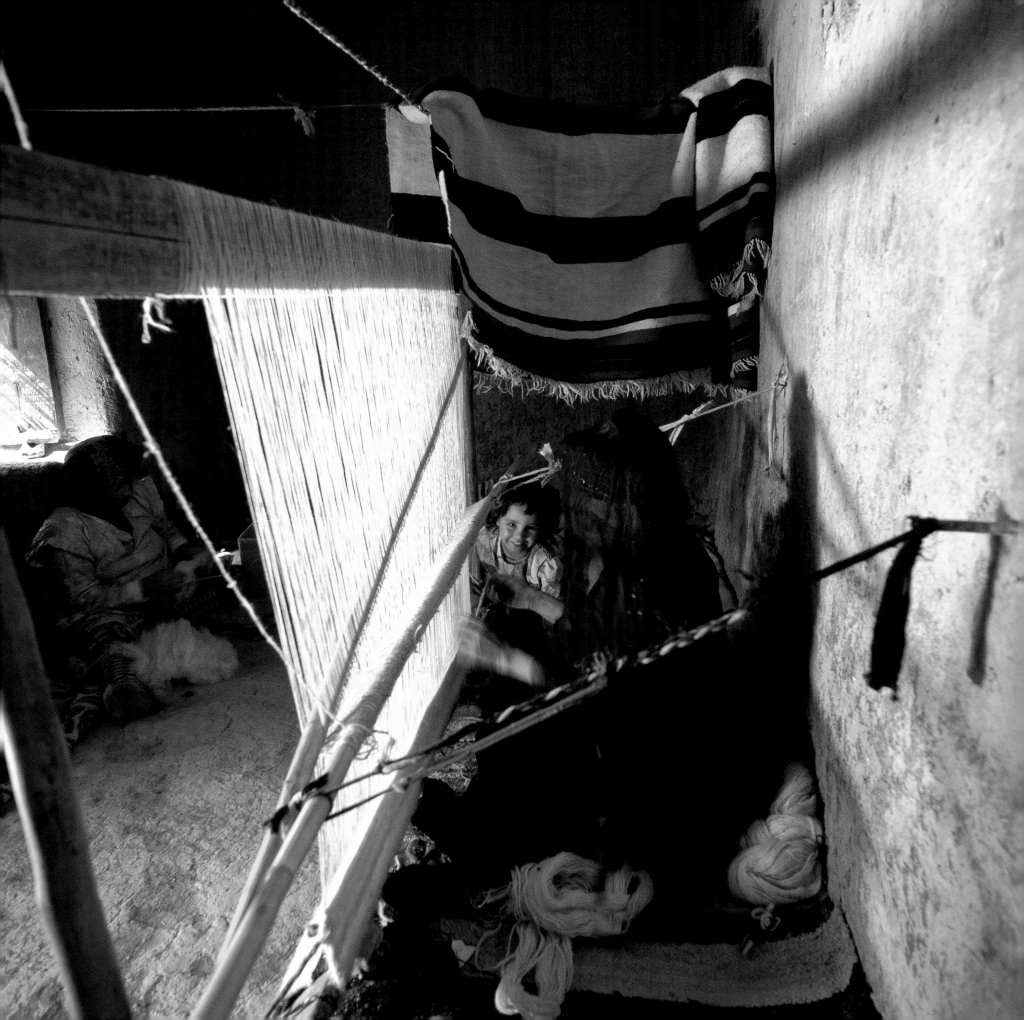

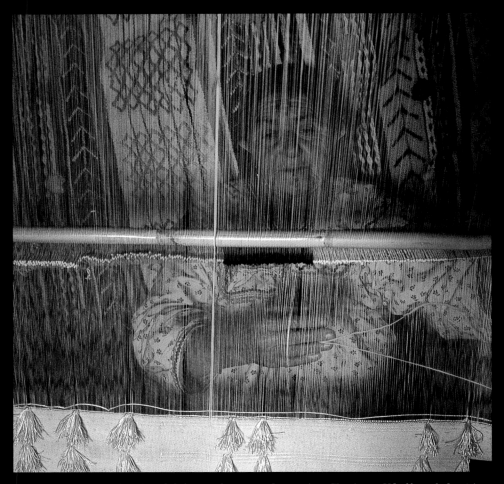

Above: Messaouda Hendel from the village of Taourirt-Khelf in the Great Kabylia, Algeria, weaves a woolen blanket. Pulling down the shed with one hand, she uses the other to insert a length of weft yarn.

Opposite: Fatima Khella of the Ait Brahim tribe weaves a handira *of broad black stripes divided by fine white and maroon threads, proper to her tribe. Alamghou, in the High Atlas Mountains, Morocco*

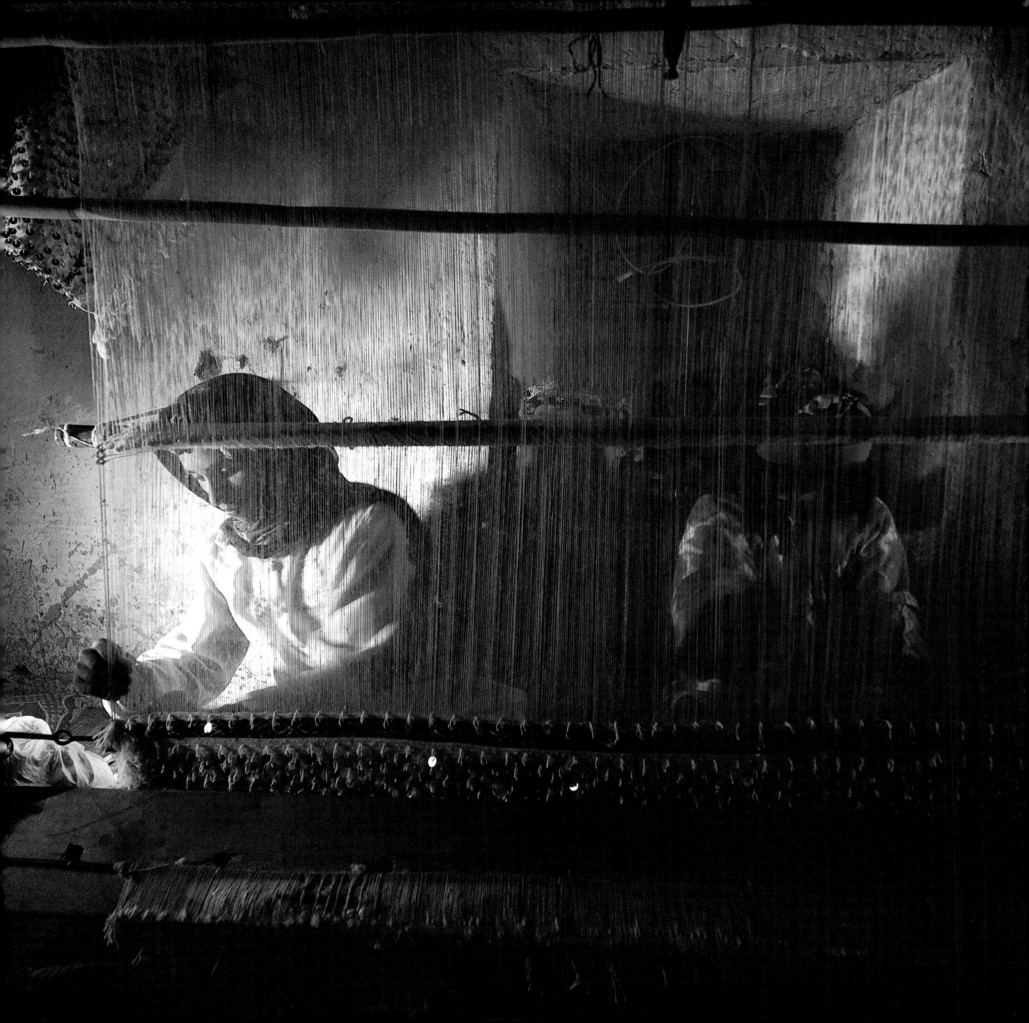

MOTIFS

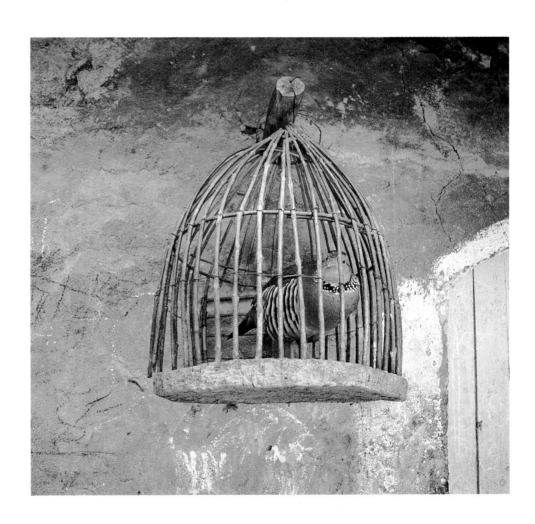

THE BERBER LANGUAGE has been fragmented by time and distance, but the language of symbols remains. Dialects differ, but the symbols that Berbers use in their jewelry, pottery, weavings, and even tattoo into their flesh are the same in the valleys of Algeria's Kabylia ranges, on the peaks of Morocco's High Atlas, and in the deserts of Tunisia.

For most Berbers today, the symbols are, above all, decorative patterns that are unique to their own culture. But for the elderly, the superstitious, and the traditional, they also serve a vital purpose: they are protectors against the evil eye, bringers of good luck and bountiful harvests.

Often, the motifs are associated with living creatures whose qualities are for some reason desirable. In Berber culture, the partridge is considered a bird of great grace and beauty, and is thus associated with the qualities of a good wife. Its sharp eyes are also thought to be vigilant watchers against danger, and so a triangular design known as the eye of the partridge is often incorporated in household items as a symbolic guardian against evil fortune.

Although they have been extinct in North Africa since the beginning of this century, lions once prowled the Berber lands and were admired for their strength and majesty. Hence, the lion's paw remains a popular motif, especially in weaving.

The human hand, often highly stylized, is perhaps the most popular motif of all. Most Berbers today say the five-part pattern represents the hand of Fatima, the prophet Muhammad's beloved daughter. In fact, the motif predates Islam, and is a visual representation of the gesture and chant "Five in your eye," swiftly made by anyone who felt they may have been victimized by someone giving them the evil eye.

Many Berber motifs are without reference to the supernatural and deal instead with the most mundane tools and chores of daily life. A pair of scissors, a rake, or a snow shovel is an image just as likely to find its way into a carpet or onto the side of an oil storage jar.

Although most Berber women are still fluent in their ancient visual language, some younger artisans have lost the meanings of the symbols they employ. While they may know every flick of thread required to weave an eye of the partridge into a carpet design, they may no longer be able to say just what the diamond shape is supposed to convey. The language of Berber motifs is in danger of joining so many of the world's other lost languages.

Previous page: The partridge, a bird of great beauty, is highly esteemed by Berbers. A husband will honor and flatter his wife by calling her "eye of the partridge," and will give her a partridge to hang at the entrance to her home. Opposite: "Tit' n-teskourt," as the eye-of-the-partridge motif is called, symbolizes a submissive and beautiful woman. It is composed of a large lozenge made up of many small black, red, and white lozenges as in this woven rug from Ait Mesbah, Algeria. Though the colors of this motif change across the Maghrib to conform with tradition and the visual vocabulary of the region, the lozenge remains constant whether woven on a rug or painted on a wall or on pottery.

Above and opposite: Details from the same bakhnoug, *a large rectangular shawl woven and worn in winter by women of the mountain regions of southern Tunisia. An isolated motif of two gazelles eating palm leaves (above) decorates the otherwise plain central section. The borders are adorned with motifs such as the scorpion sting (bell-like tassels on left), amulets (triangles), plumed amulets, and zigzag snake motifs.*

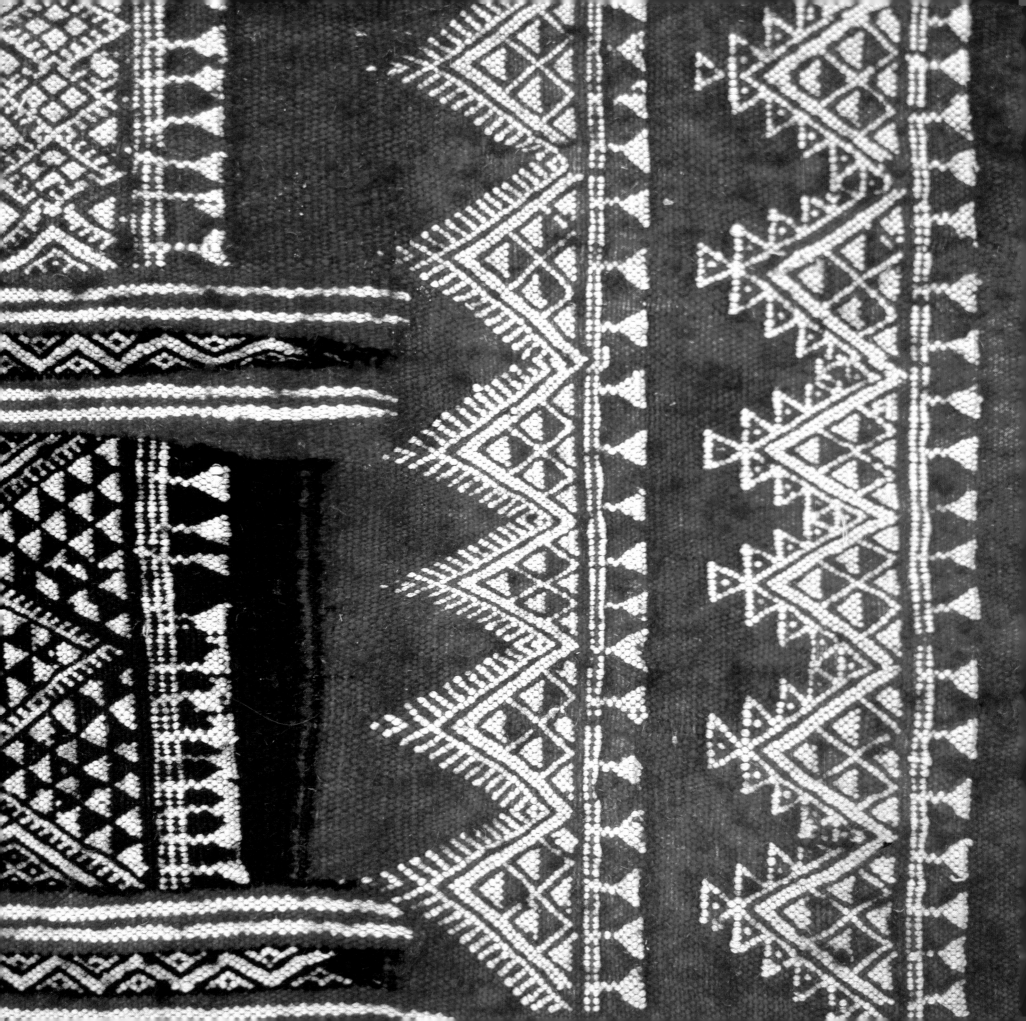

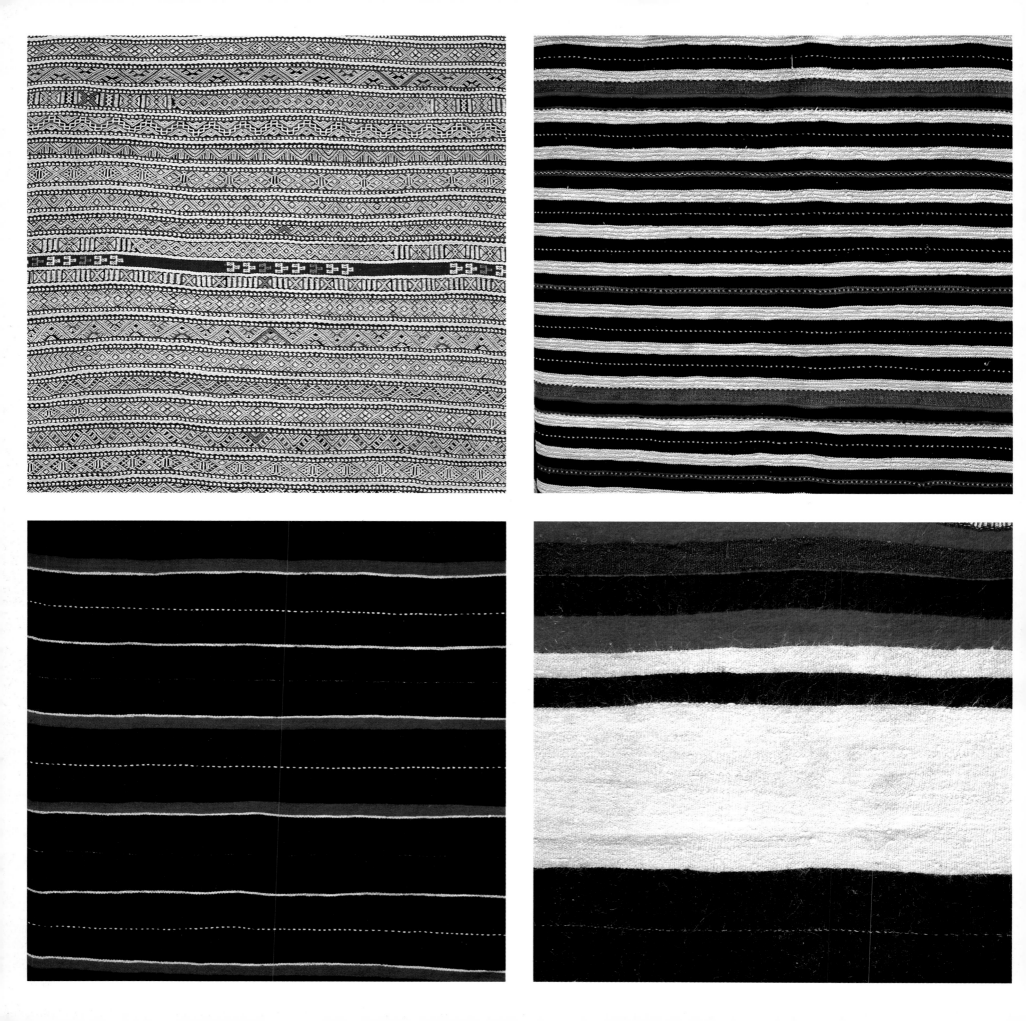

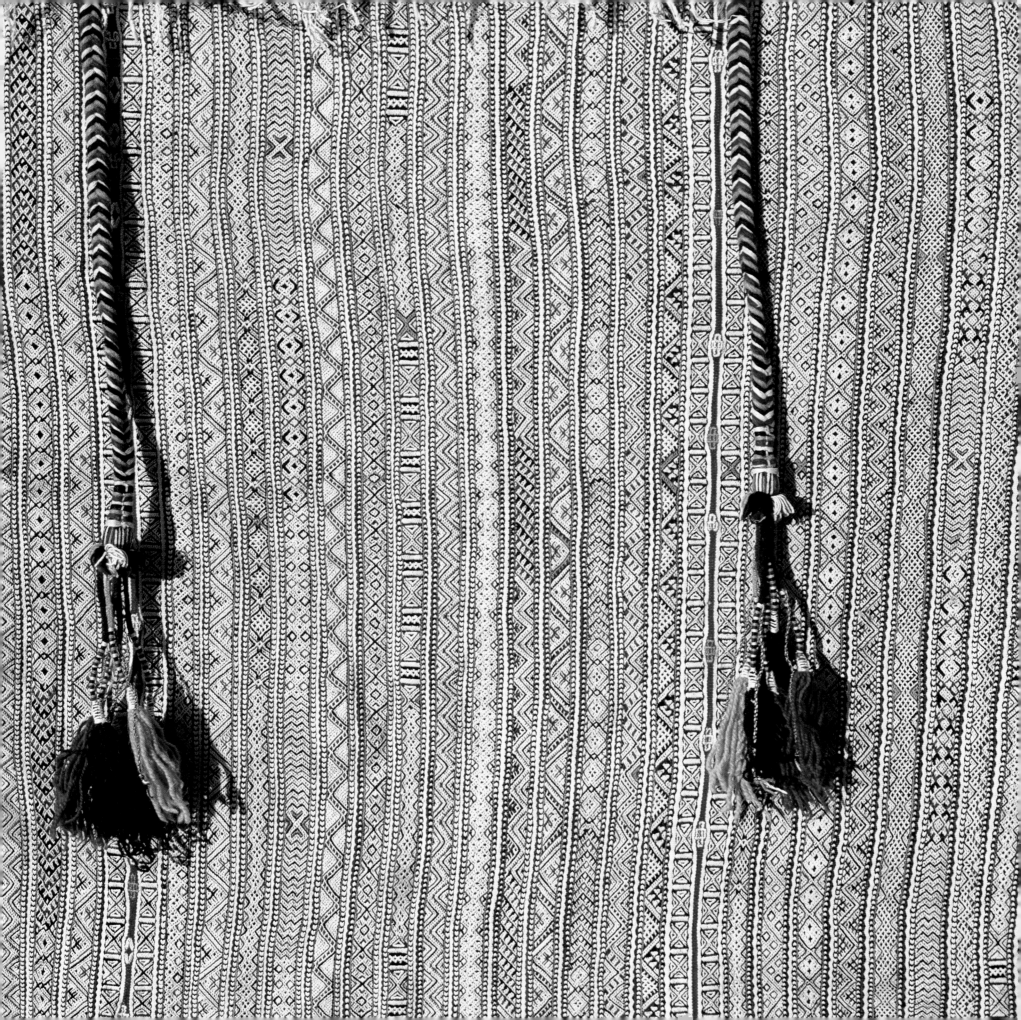

Previous pages: Details of woven woolen handiras *from Morocco. Top left: Berbers of the Middle Atlas, the Beni Ouarain, weave exquisite* handiras *decorated in complex patterns. Wool in natural earth tones is used together with narrow cotton trips to form bands of long, warm shag on the reverse. The motif in the dark stripe is derived from the wooden clips,* teyed'mt, *used to pull the weaving tight. Top right: The striking* handira *in black and white stripes countertwined with fine red—and occasionally a green stripe—worn by women of the Ait Haddidou tribe in remote reaches of the High Atlas Mountains. Bottom left: The broad black striped* handira *of the Ait Brahim tribe. Bottom right: The broad white center band of this* handira *is edged with narrow black and maroon stripes, and worn by the Ait Atta tribe. Far right: This finely woven Beni Ouarain cape from the Middle Atlas is an early piece that has been in the Driss family from Tahala for generations. Naturally dyed wool and silk have been used to create a warm shag on the reverse whereas white cotton motifs form the intricate patterns. Braided tassels are used for tying the cloak around the woman's shoulders.*

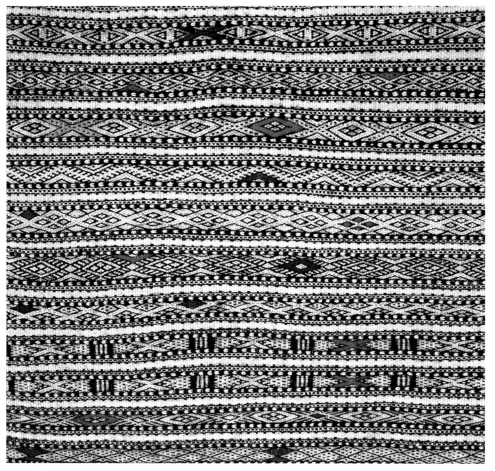

Above and opposite: Details of a handira *woven recently using both pure wool and synthetic wool. The colors are also synthetics dyes. The weaver, forty-eight-year-old Zahra Belarbi of the Beni Abedhamid tribe near El Boudriss in the Middle Atlas, says, "I learned [to weave] through my eyes . . ." Without hesitation she describes the motifs, now lost to the younger generation— and her four daughters: the* aksoul *or snow shovel (green); the zigzag road that passes by tents (in various colors); a* tashkouft *(plate, or broken plate); an* oulili *(spider sting); the* tit' n-teskourt *or eye of the partridge (blue); four small red lozenge shapes representing partridge eyes that decorate a tent; a* temchratt *or pair of shears (yellow).*

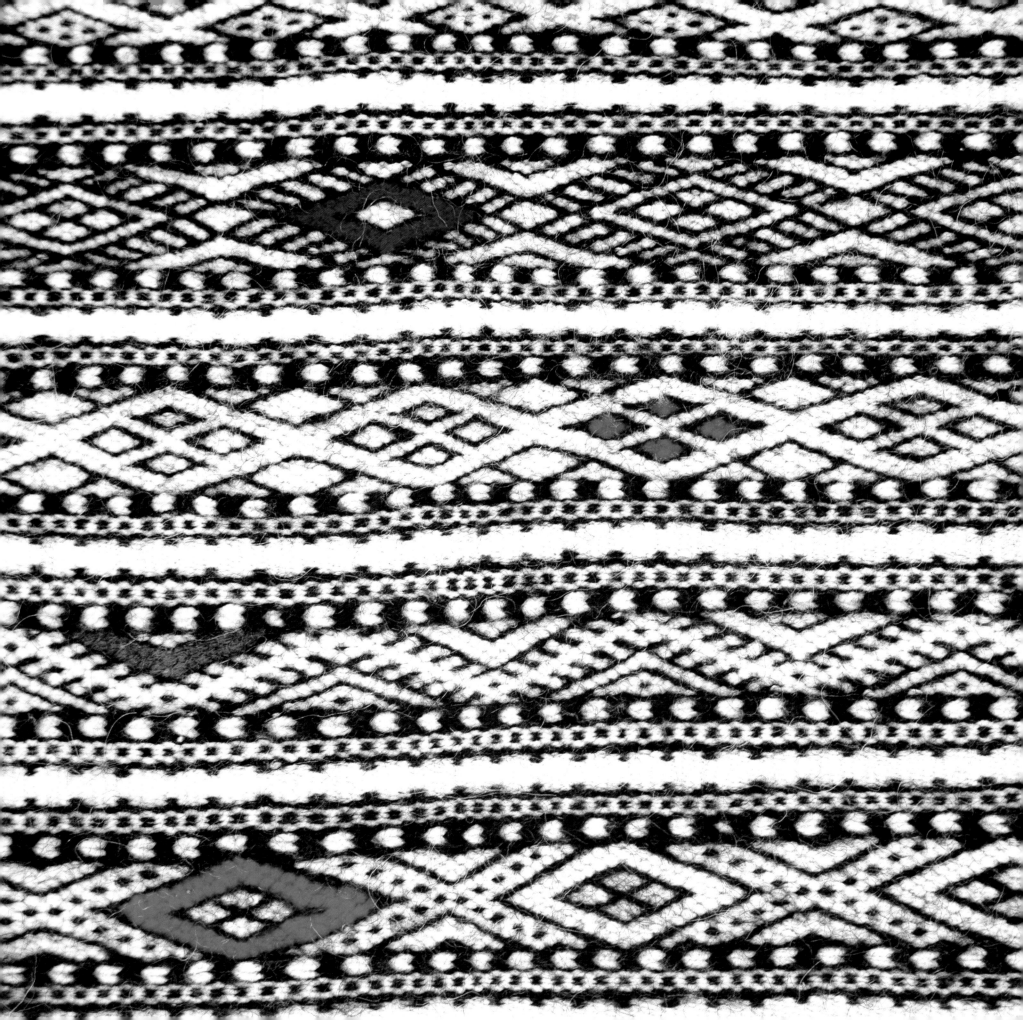

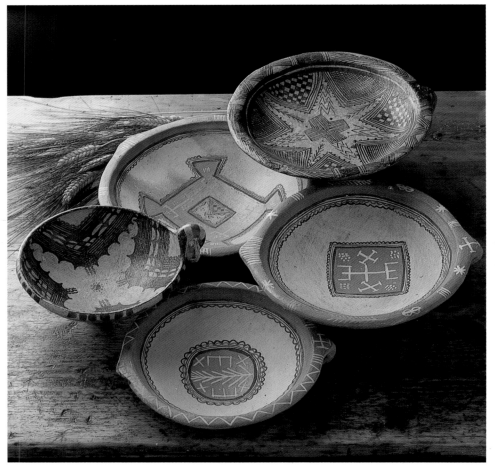

It is said that Berber women are not dreamers, nor are they possessed with lyrical imagination. Seldom do they digress from the reality of a thing or object itself. The most important point about a rug or a pot is its utilitarian quality. Plates, bowls, and drinking vessels that are used at mealtimes are generally decorated with agrarian symbols such as grains, olives, prickly pears, honeycombs, or dates—significant of bountiful crops. Storage vessels, lamps, and jars are decorated in rectilinear patterns. Choosing from a geometric repertoire, a Berber woman paints their favorite protective symbols in countless combinations: chevrons, triangles, lozenges, and quadrilateral designs, representing anything from jackal's teeth to fibulae, hawk's claws, fish-and-spine, myriopods, and the eye of the partridge.

Above and opposite: Plates from different rural communes in the Great Kabylia, Algeria

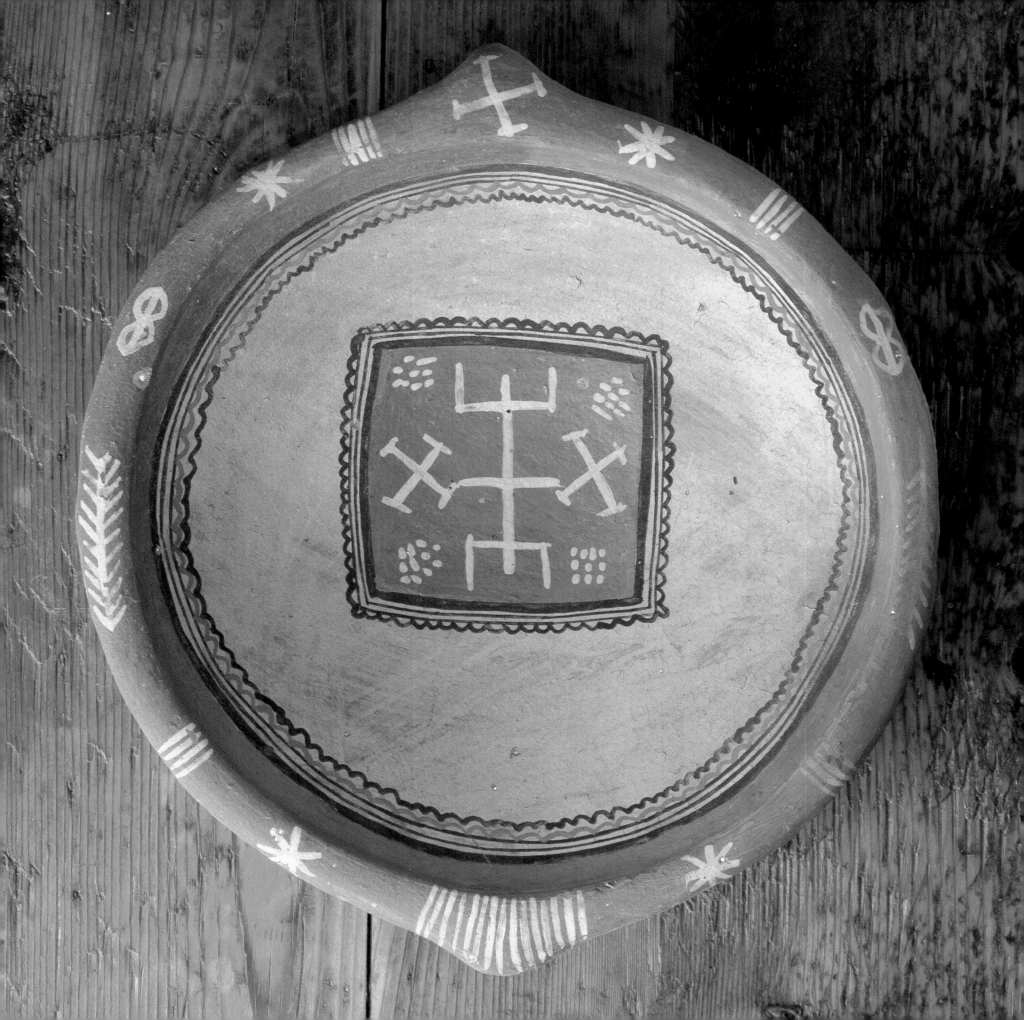

POTTERY

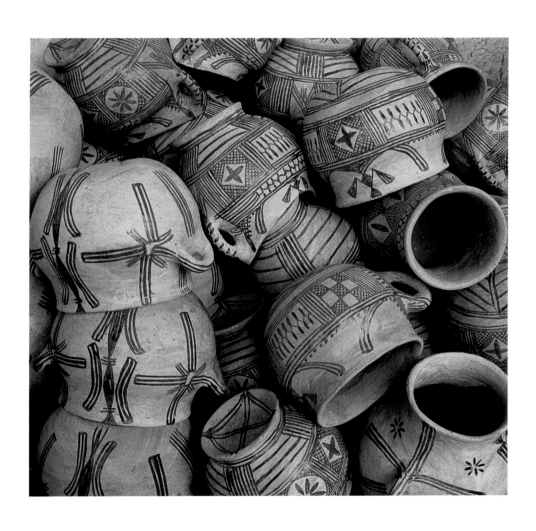

BERBER WOMEN MAKE their pottery with few tools; the most important of these is the human hand. A wooden scraper, a handful of stones for polishing, a paintbrush made of donkey tail fixed to a twig by a blob of clay—all are used at various times. But it is the female hand that does most of the work, and as a result, the pottery has the soft curves of human flesh.

Berber women's pottery is intensely practical. They make water carriers, storage jars for olive oil, drinking cups, and food platters. It is also beautiful, in the austere and subtle way of most Berber artisanry. The curvaceous shapes are always just a bit more generous than they need to be to satisfy the demands of use alone. The decoration —designs painted onto each piece before firing— draws on the Berbers' constant repertoire of symbols, yet is intensely idiosyncratic to each maker and unique to each piece. Pottery patterns are not only traditional, but used to be hereditary within each village. These days, many potters play with the old visual vocabulary, with a few emerging as true artists who work only on commission.

The beauty of the widemouthed cups or ovoid oil bottles makes it impossible to watch a typical firing without a wistful pang, for more than half the objects will almost certainly be destroyed by the inexact methods still in use. Berber women place the pots in dome-shaped ovens or open pits, then lay on top whatever scarce fuel they can scavenge: bark, leaves, olive pits, goat dung. The fire starts at the top of the pile of fuel and slowly burns down. The firing is judged completed when the flames have died and the ashes cooled.

Berber women are proud of the utility of their work, and quick to point out that a piece may have more uses than meet a stranger's eye. A water jar, for example, not only carries water but also serves as camouflage for a young woman who wants to meet with a young man. Because fetching water is women's work, lone men are not supposed to be at a spring or well unless they are travelers suffering an acute thirst, in which case they must drink and not linger. A woman walking with a water bottle may not be heading for the spring at all, but the bottle—the lovely slender bottle she carries so gracefully—gives her a reason to be out, away from the gaze of the ever-watchful parental eye.

Preceding page and opposite: Tamimount Benamar, fifty years old, from the remote village of Tamazint in the Rif Mountains of Morocco, learned the art of pottery and decoration from her grandmother. She has been making pots for thirty years, under the stern watchful eye of her husband, who transports them by mule down the mountain each week to sell at the souk.

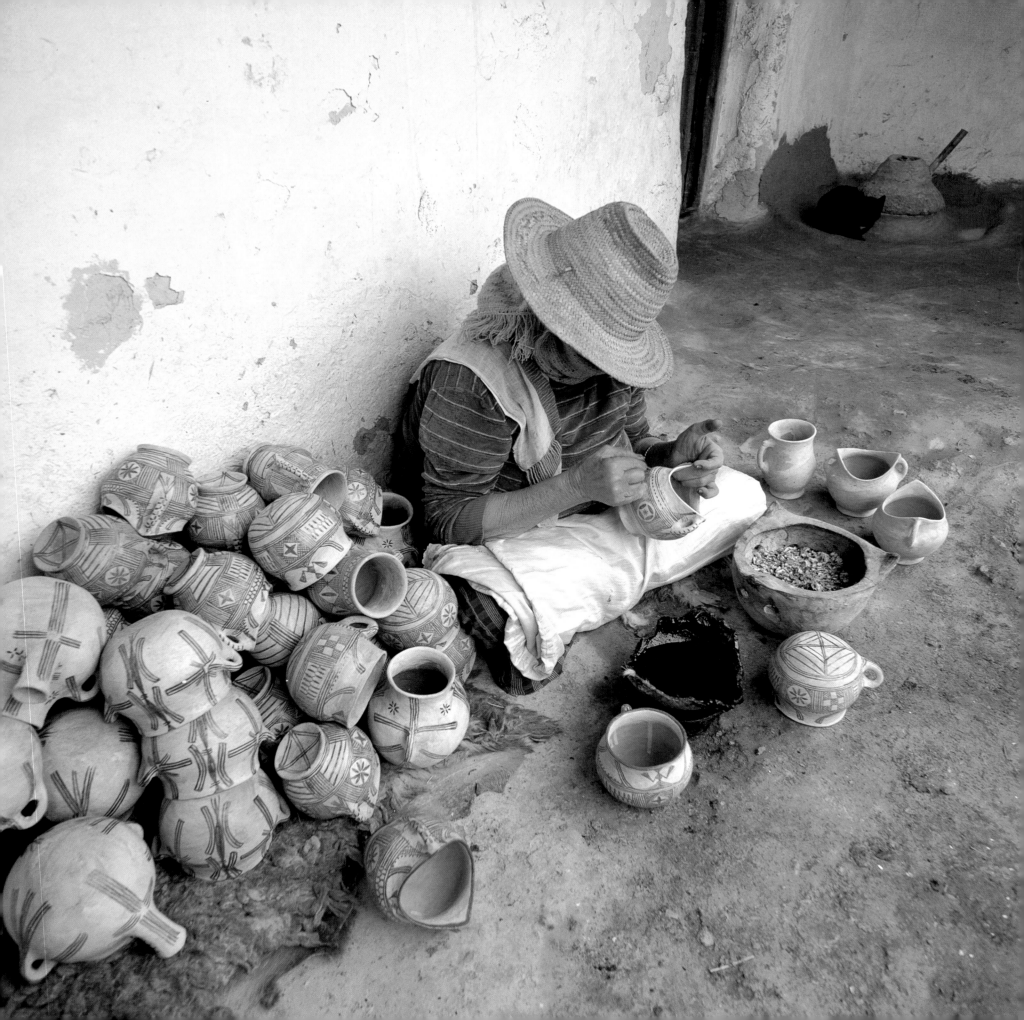

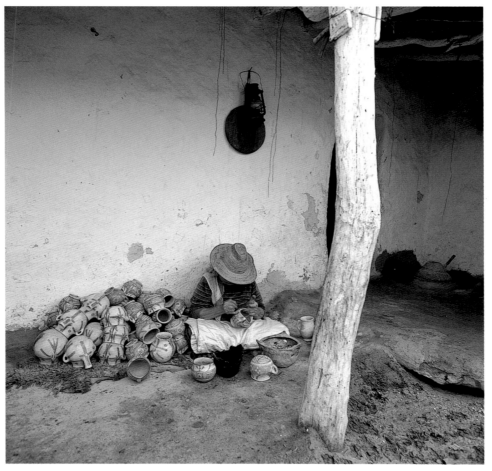

Above: Tamimount Benamar's husband allows no male visitors in close proximity to the womenfolk and their working space. He also makes sure that neither discussion nor photographs reveal the secrets of their family's small industry, which produces on average thirty pots a week, a mule's load. Tamazint, Morocco

Opposite: Tamimount adds a decoration to a tarsaste *(milk pot) with curved lips to facilitate drinking. A dye made from the crushed leaves of a local plant* (fadis) *is applied with a brush made of goat hair set in clay and dried above a brazier of coals.*

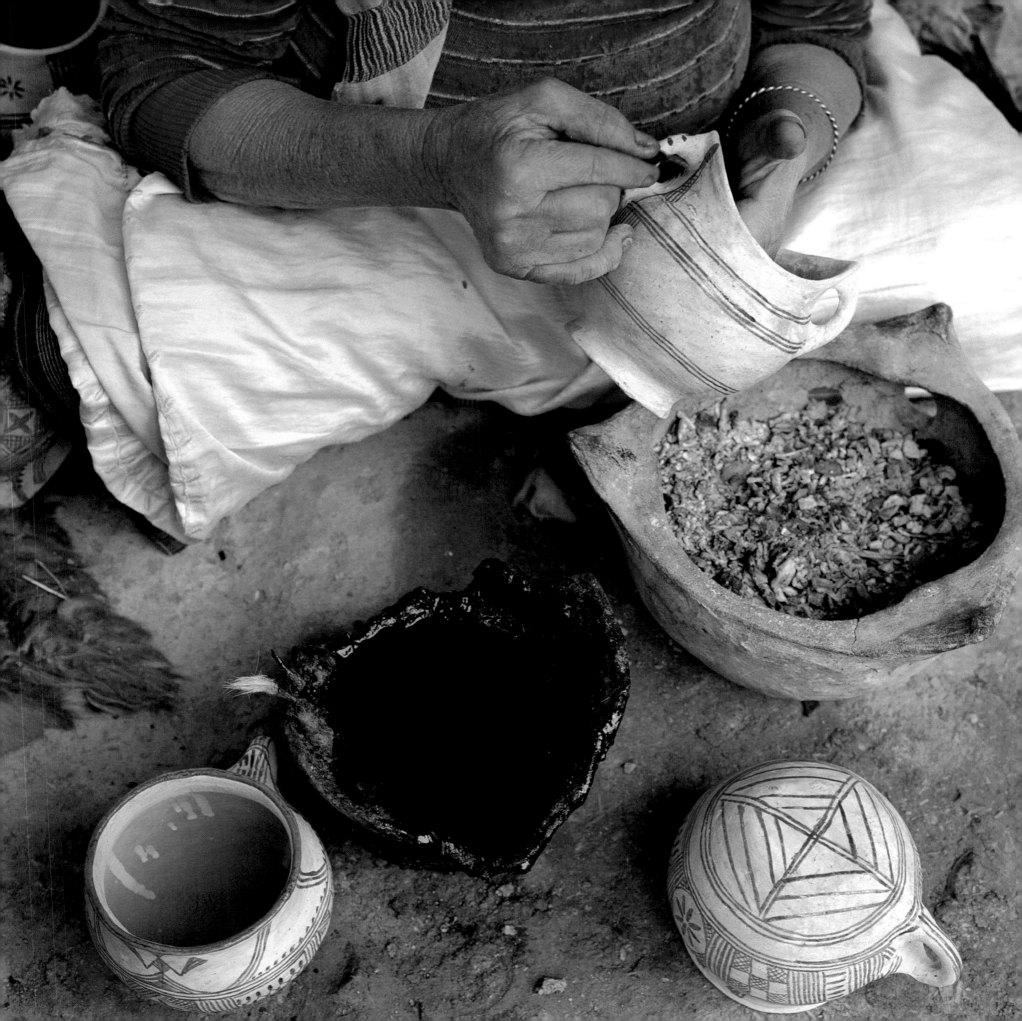

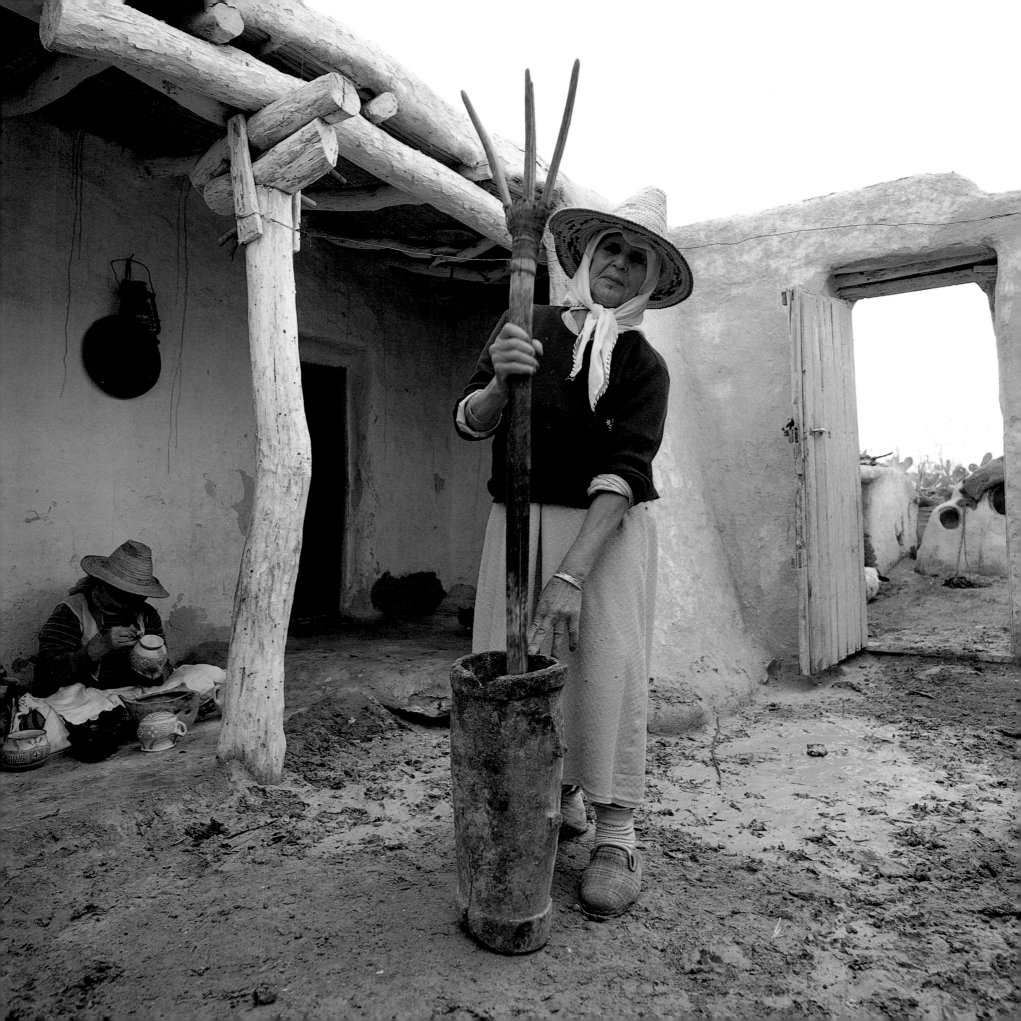

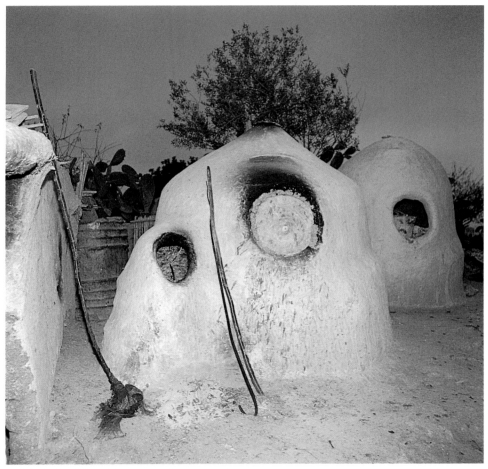

Above: Clay ovens are found throughout the Rif Mountains. The ovens are used mostly for firing pottery, but also for cooking on festive occasions.

Opposite: Fatiha Benamar helps her sister-in-law by crushing dried leaves of the fadis *plant, which are then boiled to produce a yellow-green dye that turns black on firing.*

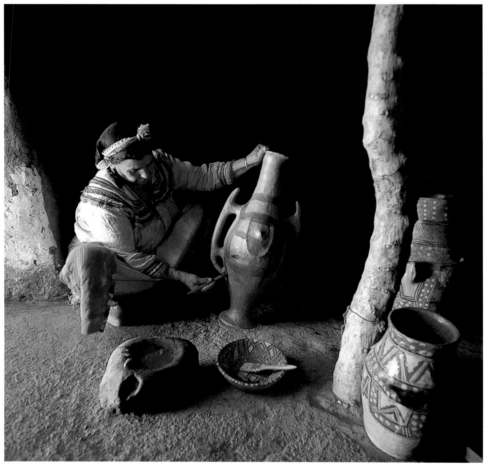

Above: Rif Mountains, Morocco. Opposite: The Berbers of the Kabylia and Aurès mountains still model and design their pots according to traditions dating back to ancient Roman times. European plastics and alternative materials have not apparently yet replaced traditional domestic utensils to the extent they have in neighboring countries. The classic amphora has been adapted to suit the needs of the Kabyle women for carrying fresh water. The long handles can be reached over the shoulder and are held in place on their backs with the conical base tucked into their broad waistband. Ouadhia, Algeria

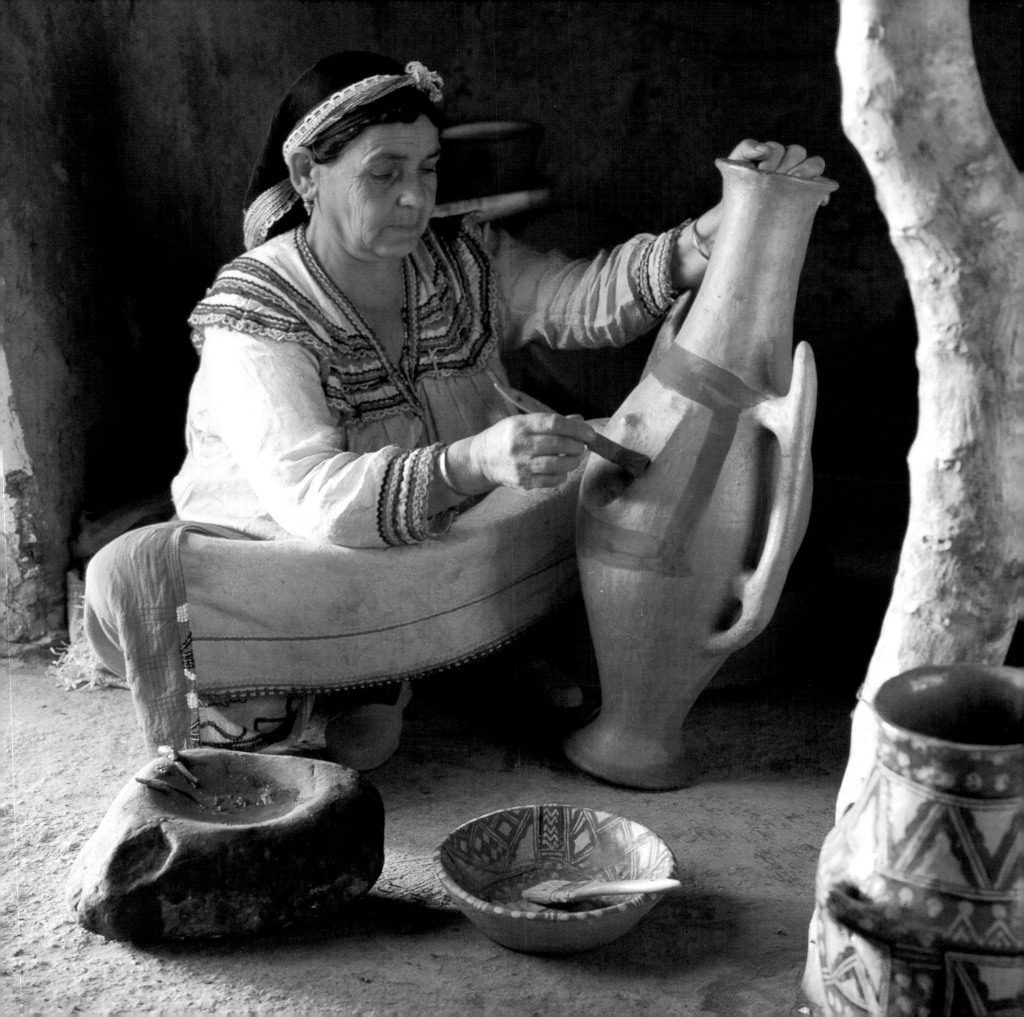

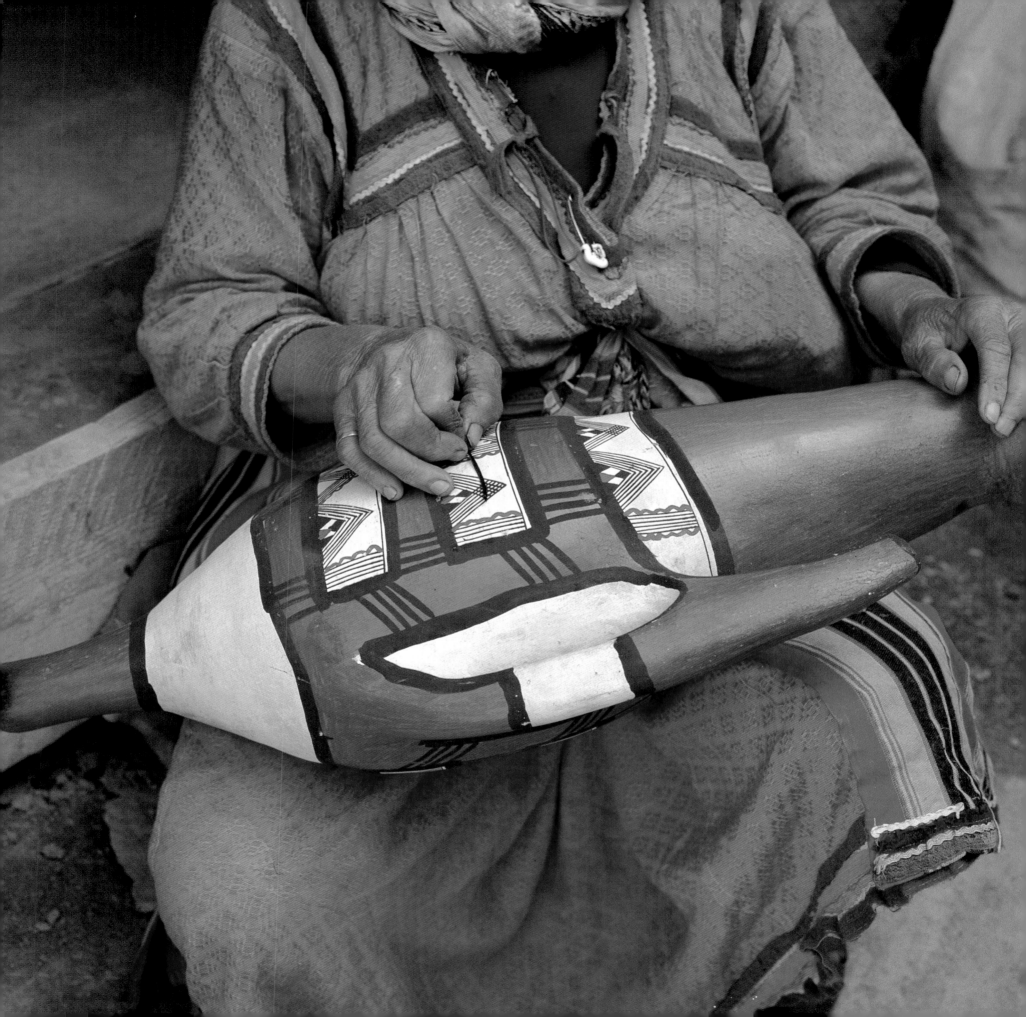

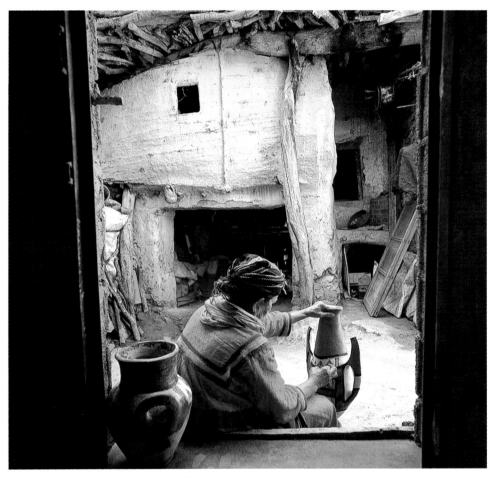

*Above and opposite: One of the last
of the older generation of Kabyle
potters from Agouni-Guerhane (her
son did not wish her to be identified)
continues to mold traditional
amphoras and large storage jars
and skillfully decorates the curved
surfaces with geometric and
rectilinear designs.*

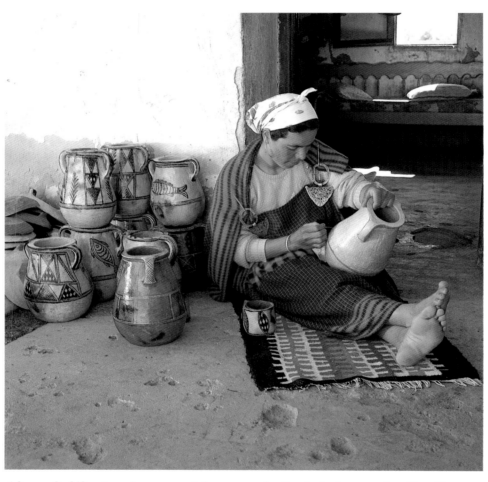

Above: Sabiha Ayari, twenty-eight, from Ermilla in the Sejenane district of Tunisia, close to the Algerian border, wears a triangular fibula from which many Berber decorations are derived. Sabiha claims her motifs originate in merghoum *(a long woven fabric from Tunisia used to cover the walls of a room). Opposite, top left: Aïcha Lamaallam, sixty-five, from Beni Fougal, an isolated village in the Rif Mountains in Morocco. Top right: A Kabyle woman from the town of Maatka, which dominates the Boghni river and valley. Bottom left: Rebah Ayari, mother of Sabiha, above, is about to decorate a platter with motifs from nature—a honeycomb, an olive branch, and kernels of wheat—symbols frequently used by potters in this region. Bottom right: Khaddouj Aharrouch, from the rural community of Rouadi, in the Rif Mountains, has specialized in making various shapes and sizes of clay braziers, which are rapidly being replaced by gas burners.*

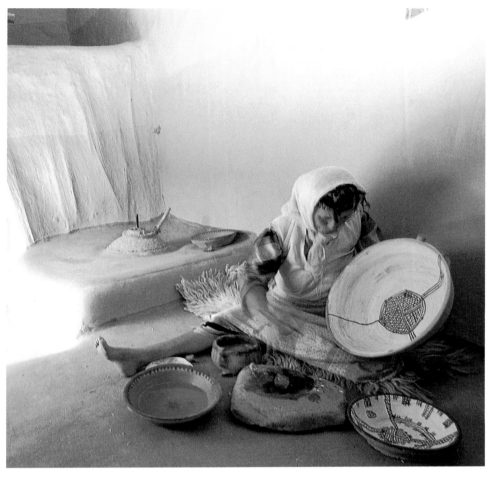
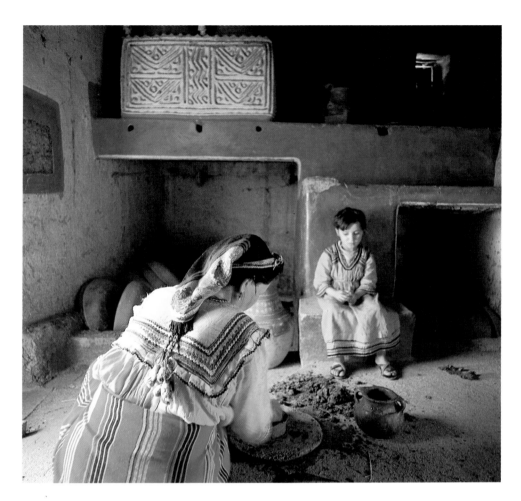
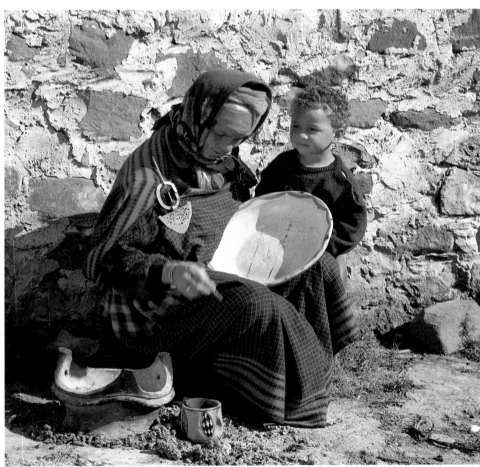
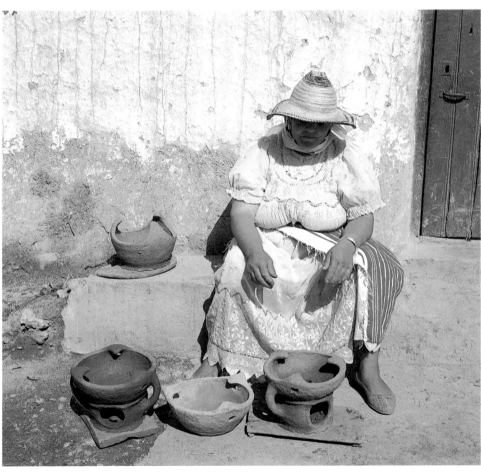

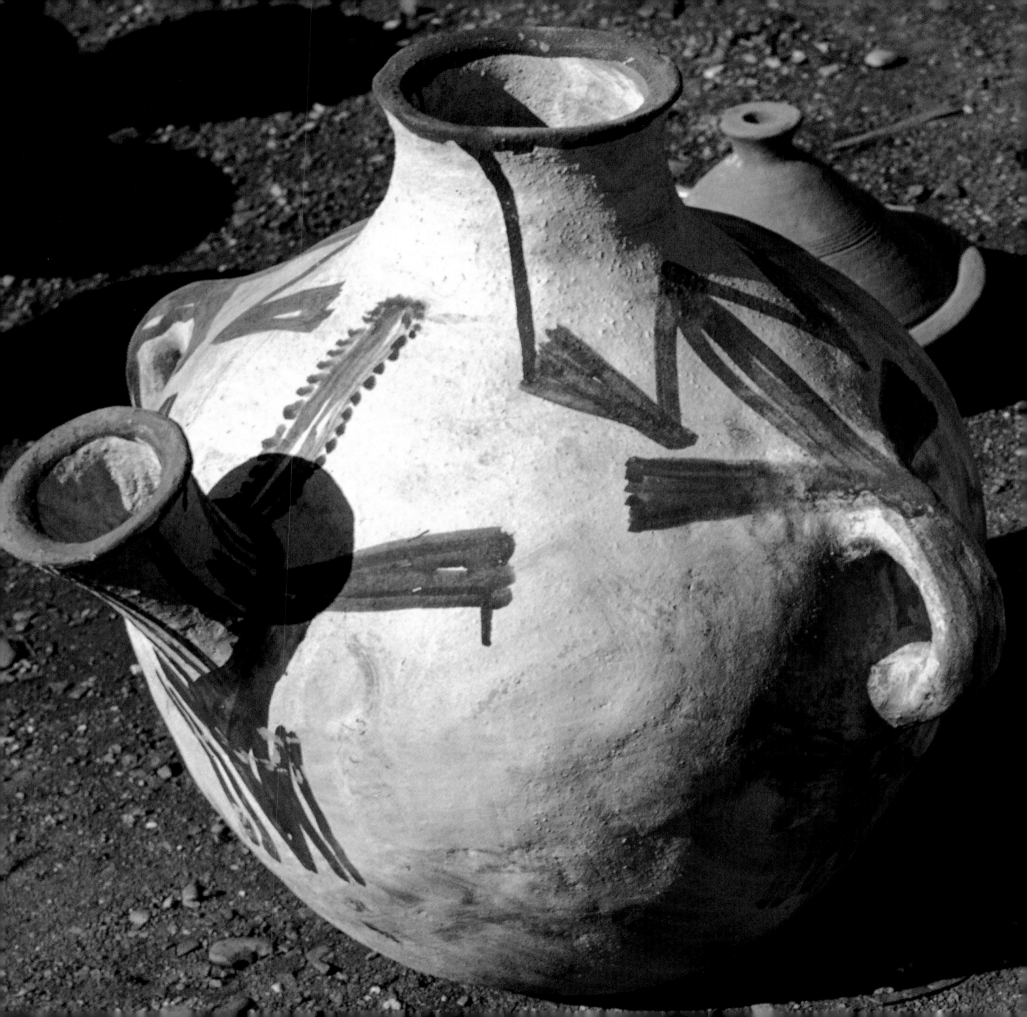

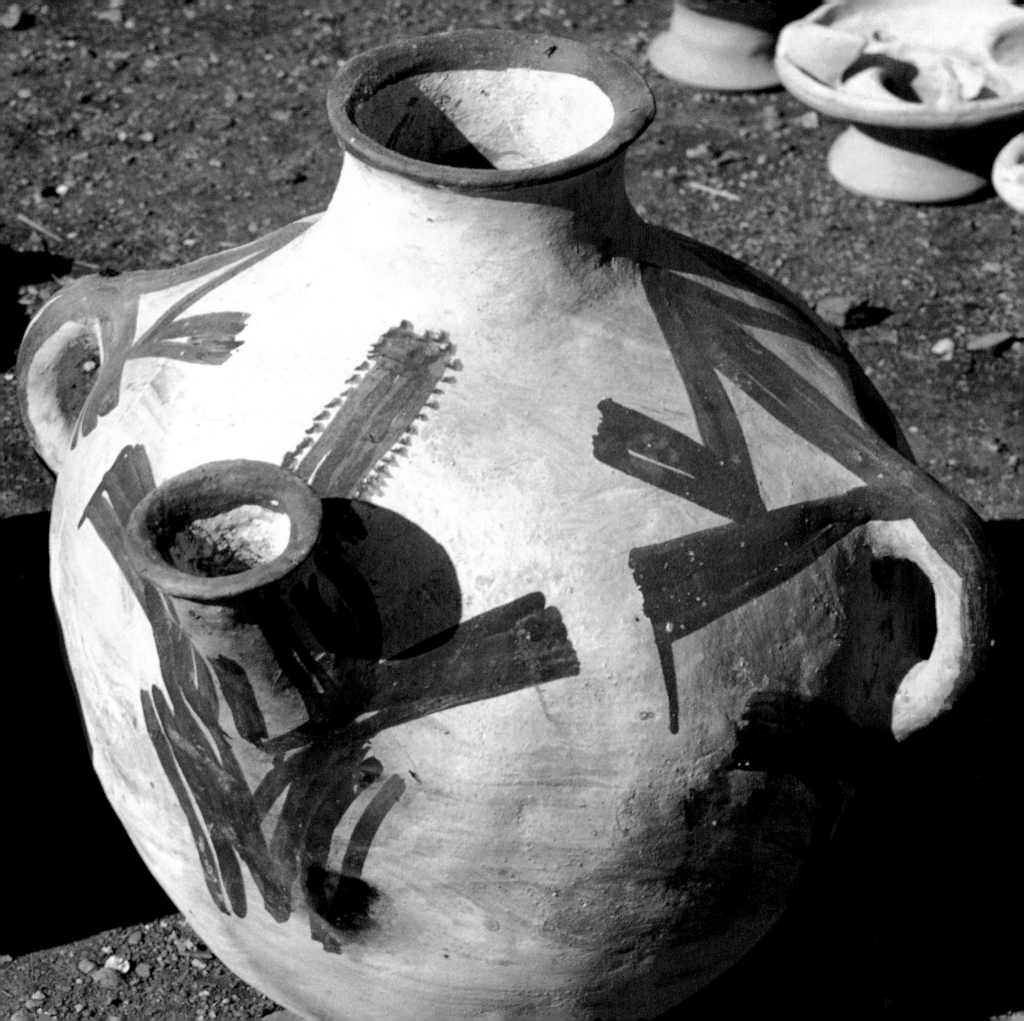

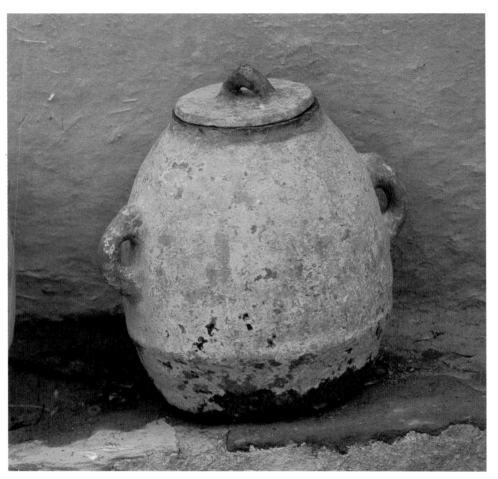

Above, opposite, and following pages: Large water containers are used by women for fetching, carrying, and storing water. Rural community of Beni Frassen, in the plains between the Rif and Middle Atlas mountains, Morocco

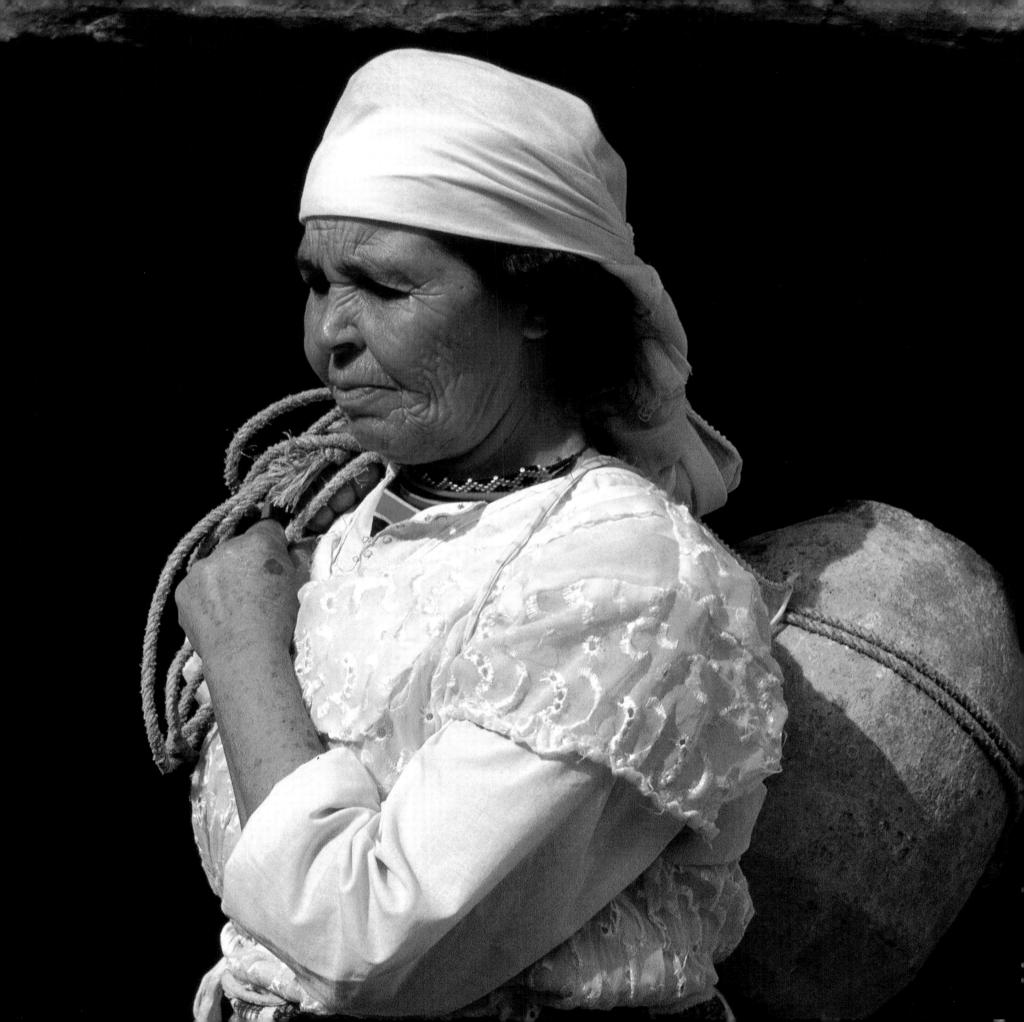

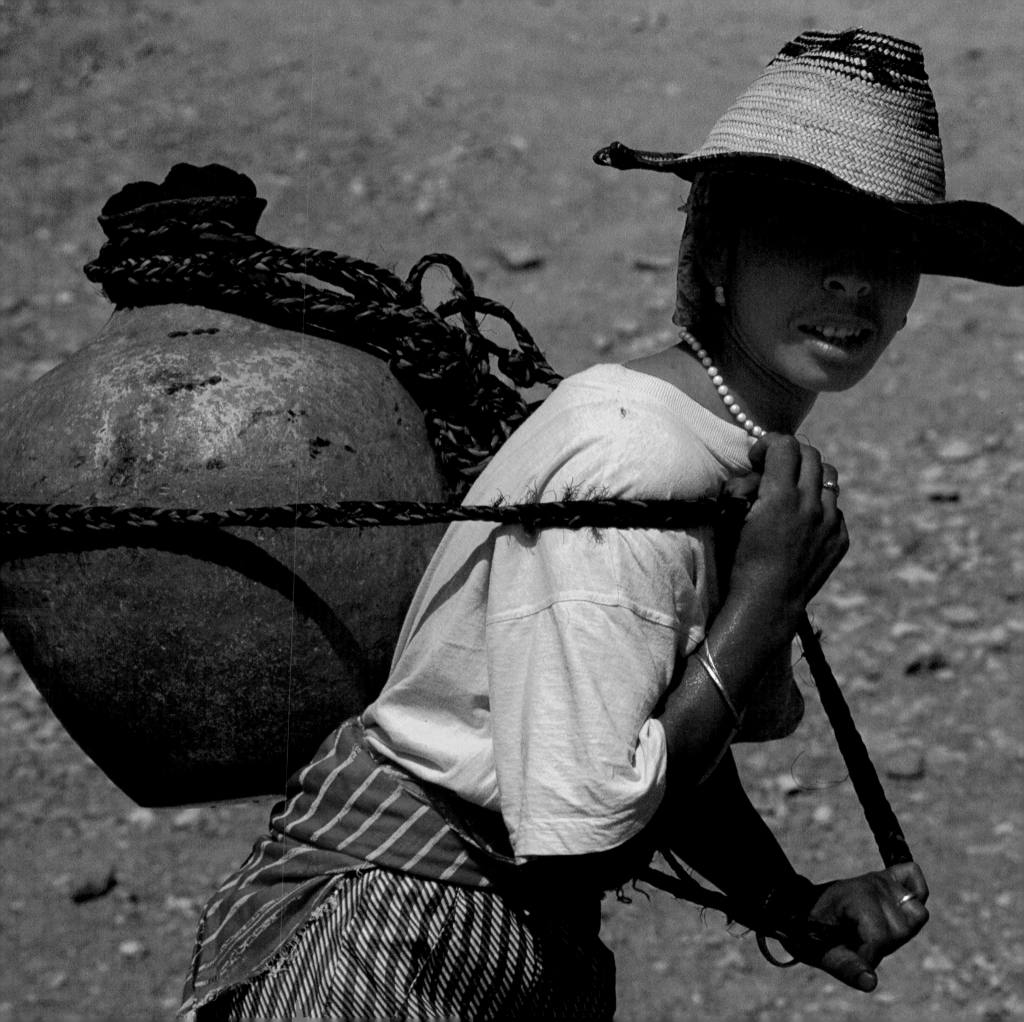

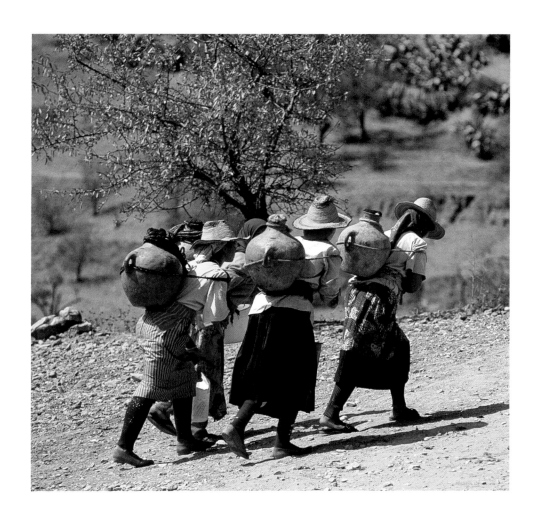

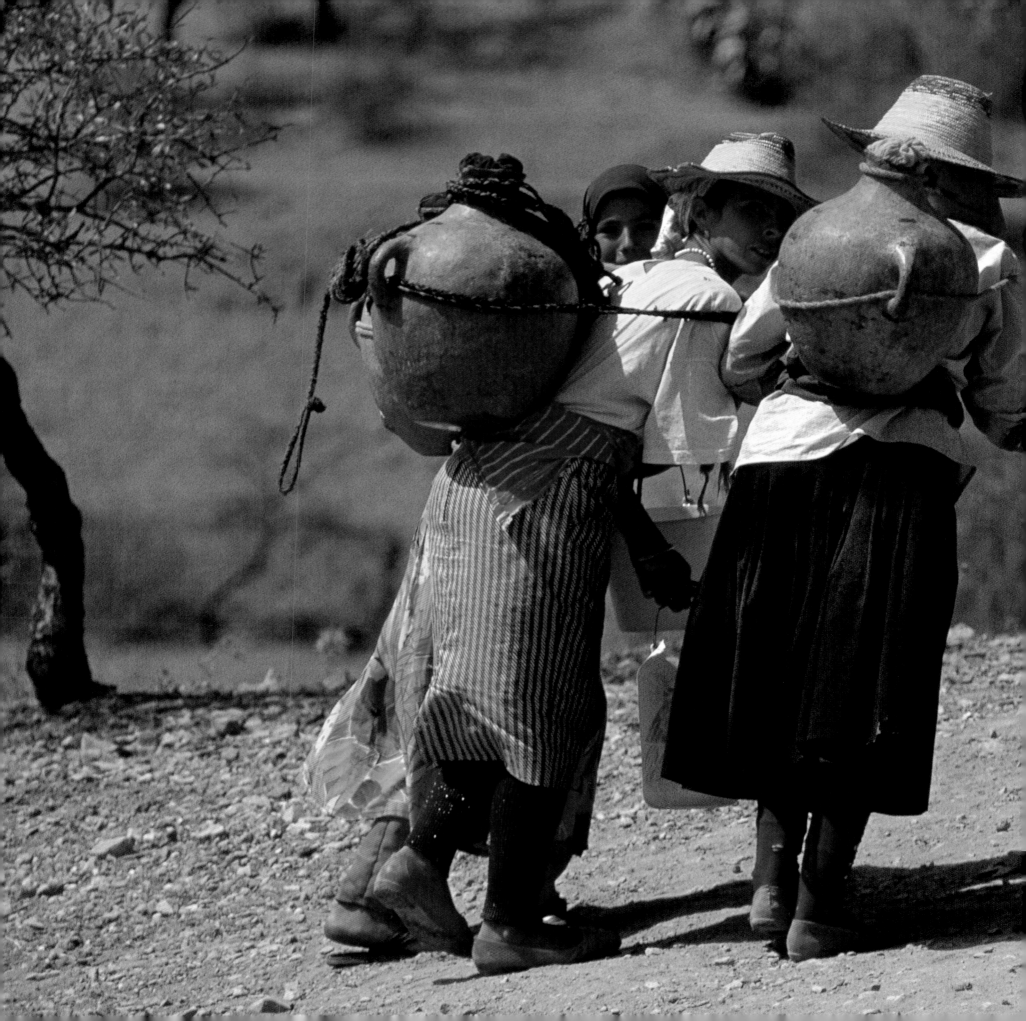

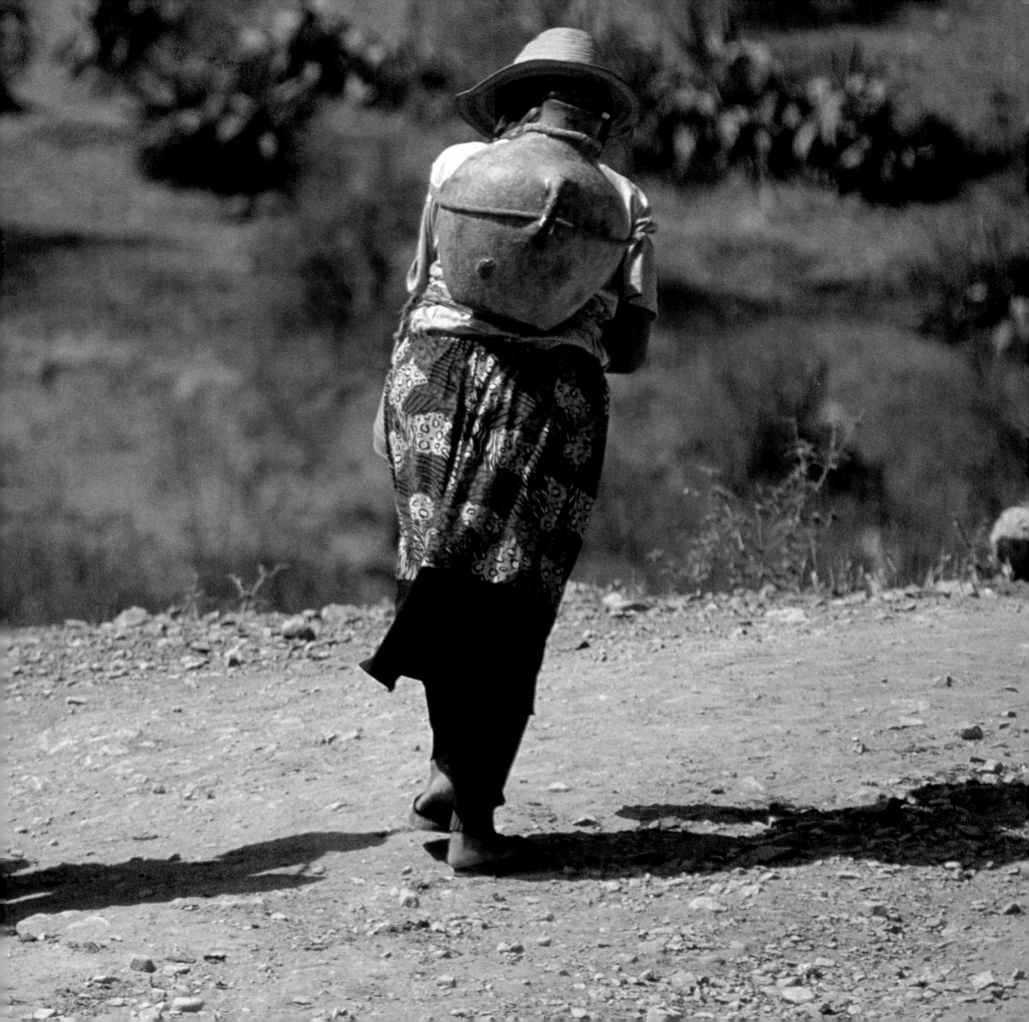

*Above, opposite, and following
pages: In an almost reckless journey
in the Rif Mountains in Morocco, we
stumbled across Beni Amar with a
population of close to one thousand,
where the tiny houses seemed them-
selves to have been made by potters'
hands. Fatima Bint Lehsen, sixty,
dignified, proud, and brimming with
enthusiasm, eagerly shares the art*

*of pottery. Sadly, her painstaking
work is no longer appreciated
because of the demand for more
functional and commerically made
vessels. In the inner courtyard of her
humble dwelling, Fatima sets about
decorating a large* couscous *plate.
She always works with a clay snake
nearby to ward off evil spirits that
may jeopardize the firing of her pots.*

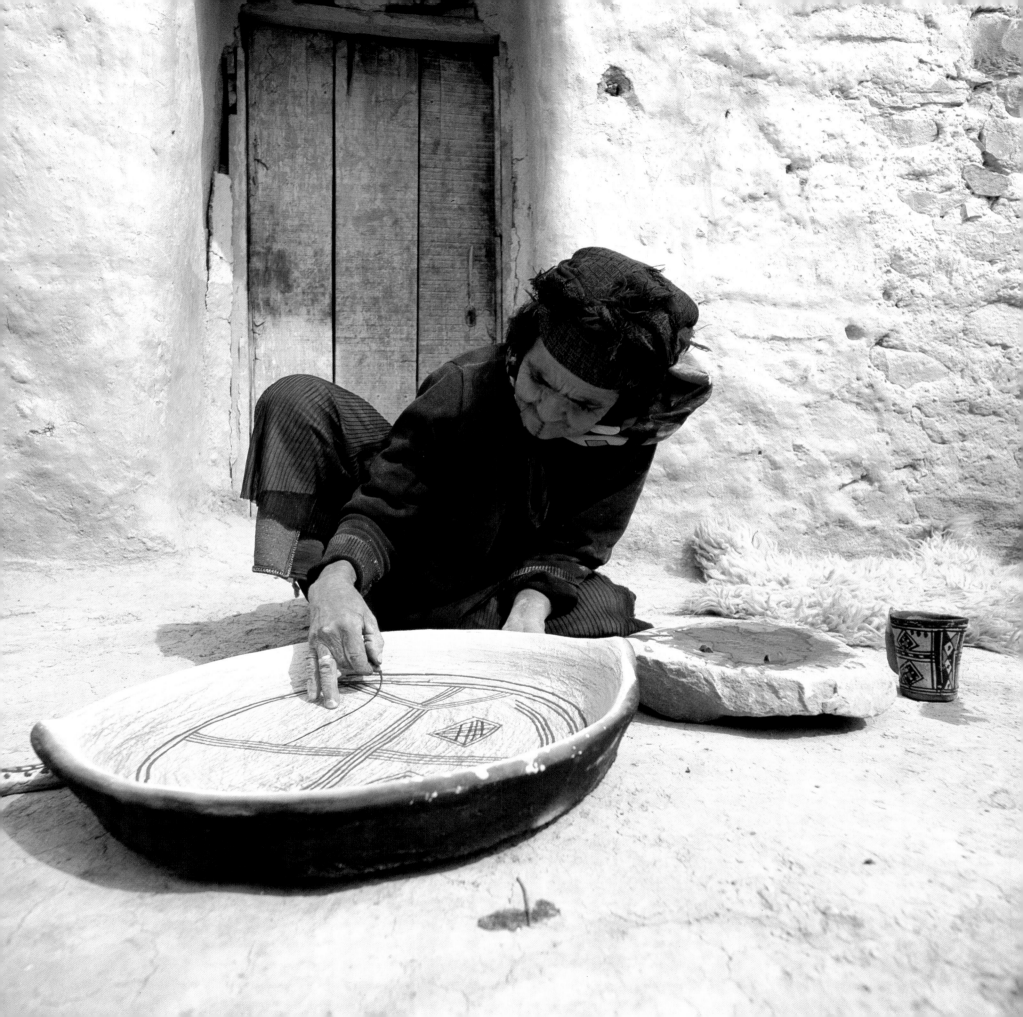

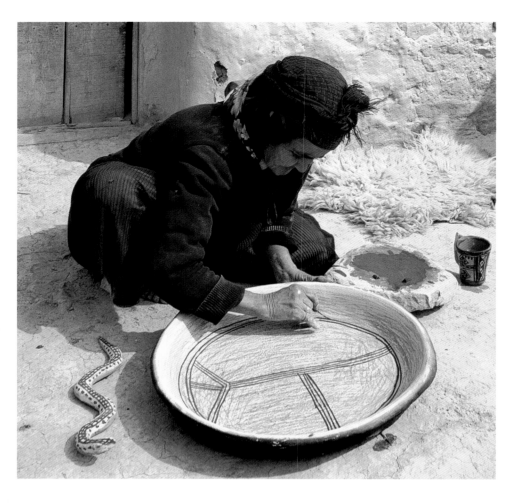
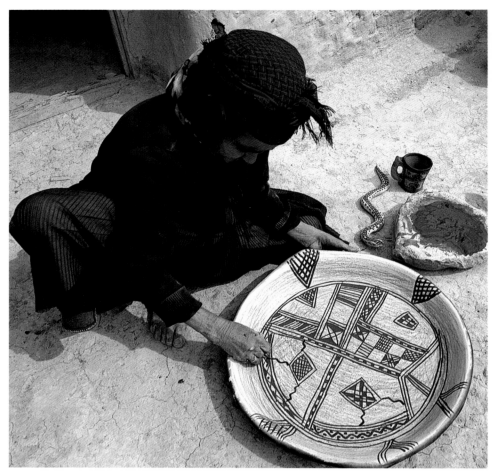
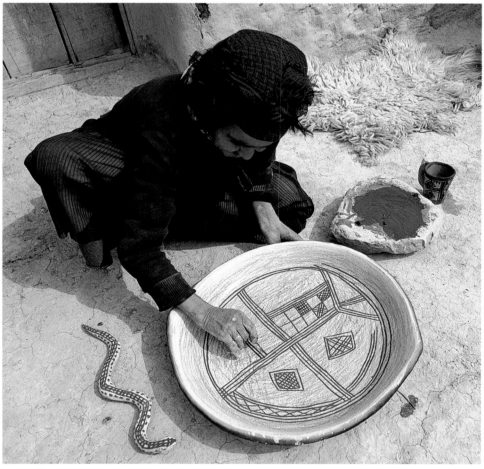
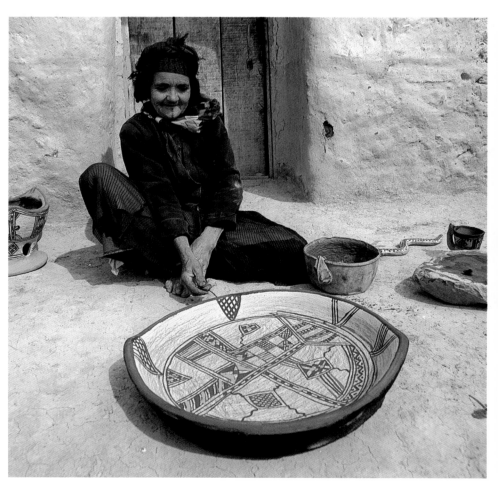

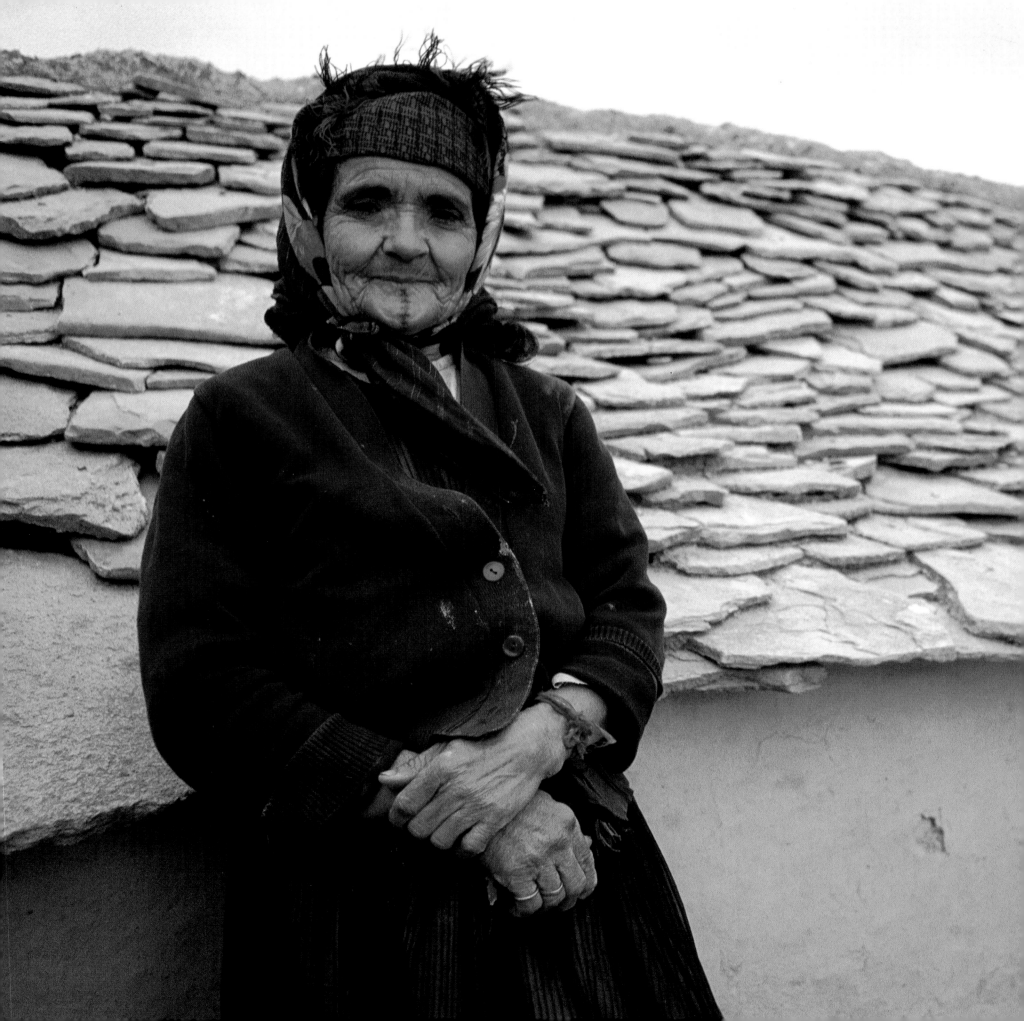

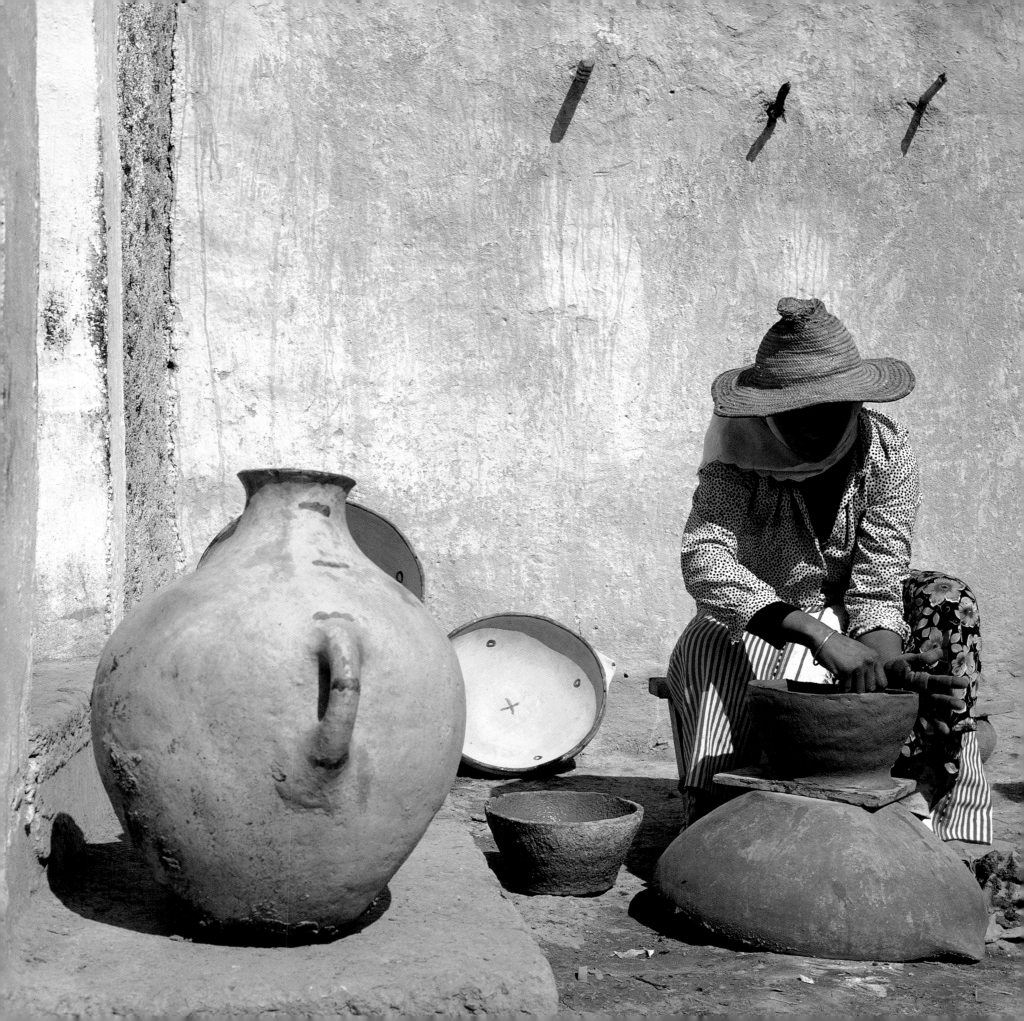

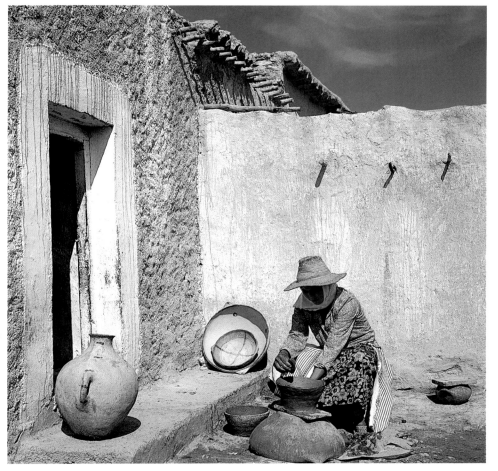

Above and opposite: Habiba
Iabkrimane makes ten pieces of
pottery a week to sell at a local
souk. Purity of form and simple
decorative elements give these
everyday water jars on unrivaled
classic beauty. These water jars
closely resemble those from the
mountain hamlet of Bieder, just
inside the Algerian border, which
are now only seen in museums.
Rouadi, Morocco

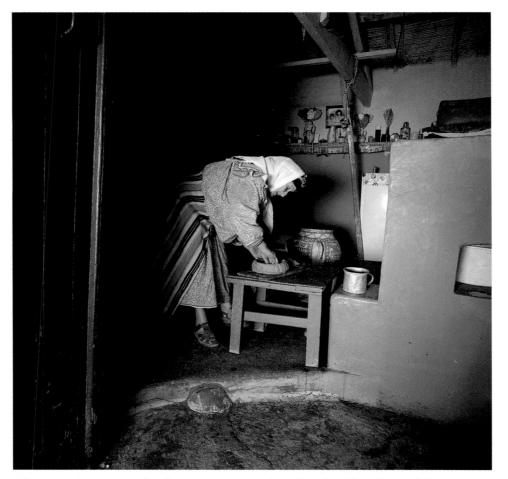

Above and opposite: In the remote Village of Ait Mesbah beneath the imposing Djurdjura Mountains of the Great Kabylia, this potter describes her work: "Pots are like us villagers. Just as a woman from one village wears a certain color dress or headscarf or a particular fouta *(striped fabric worn as a wraparound), so too can her pottery be identified." The large storage jar is painted with ocher-red flowing lines and dots in contrast to the black geometric motifs that recall feminine jewelry and evoke fertility of the earth. Both are symbols of protection.*

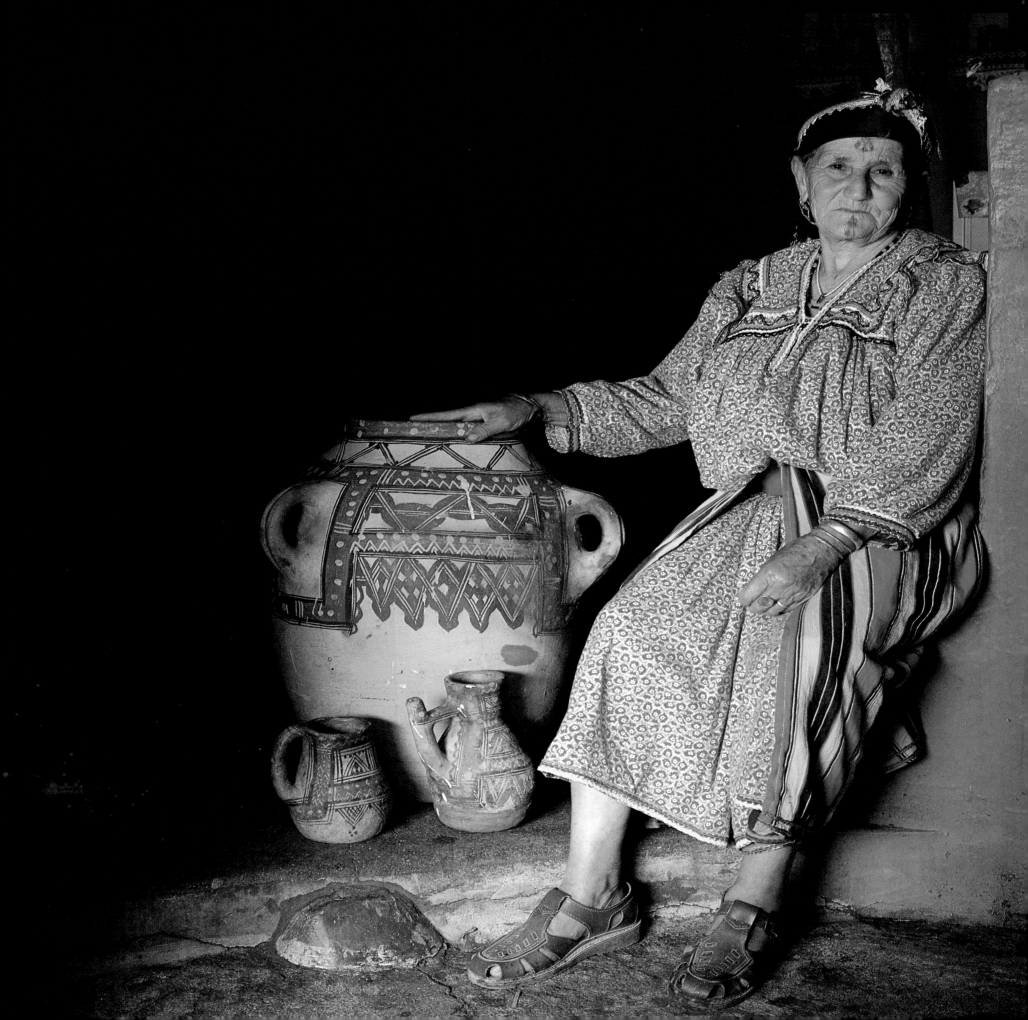

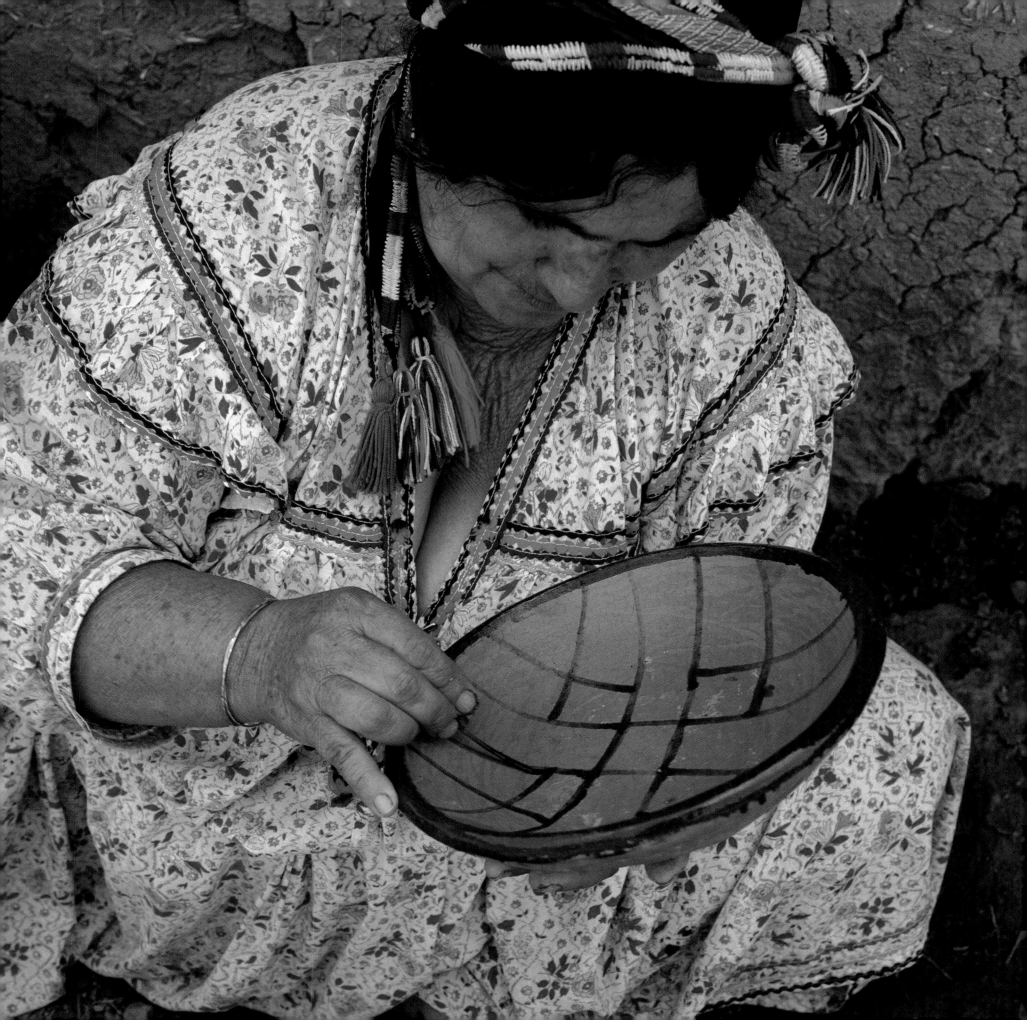

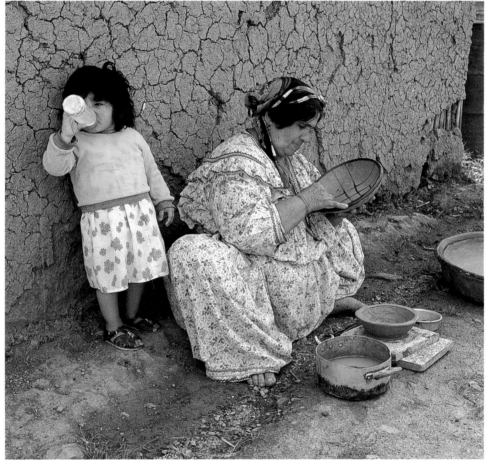

Above and opposite: Saadia Kanane from Bou-nouh is one of the last women potters in this Kabylia village once renowned for its beautiful painted pottery. Numerous small industries have developed with male potters turning out highly glazed items using wheels and electric or gas kilns. Resting her little finger on the edge of a bowl, Saadia adds a simple crisscross decoration representing a honeycomb. The goat-tail brush is always used lengthwise so that it can curve with the rounded surface that is being decorated.

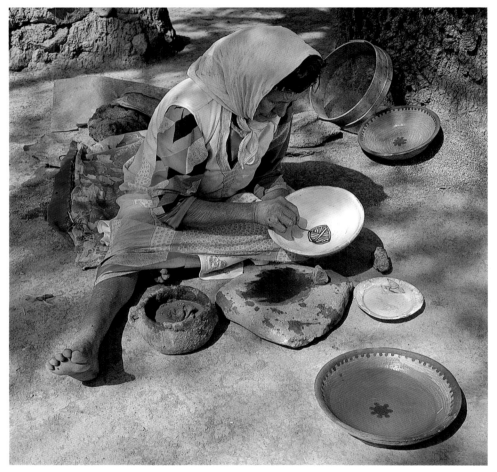

Above and opposite: Aïcha Lamaallam from the hamlet of Beni Fougal in the Rif Mountains, Morocco, was taught pottery by Fatima Bint Lehsen. She uses a brown color obtained from grinding a soft stone (assiou) *found in the woods, against a large hard rock that serves as a palette. Red earth* (sfira) *and white lime* (biada) *are later added with a brush made of* goat hair (khattata). *While she worked, Aïcha provided a running commentary on her motifs—a belt with a buckle interspersed with symbols derived from nature.*

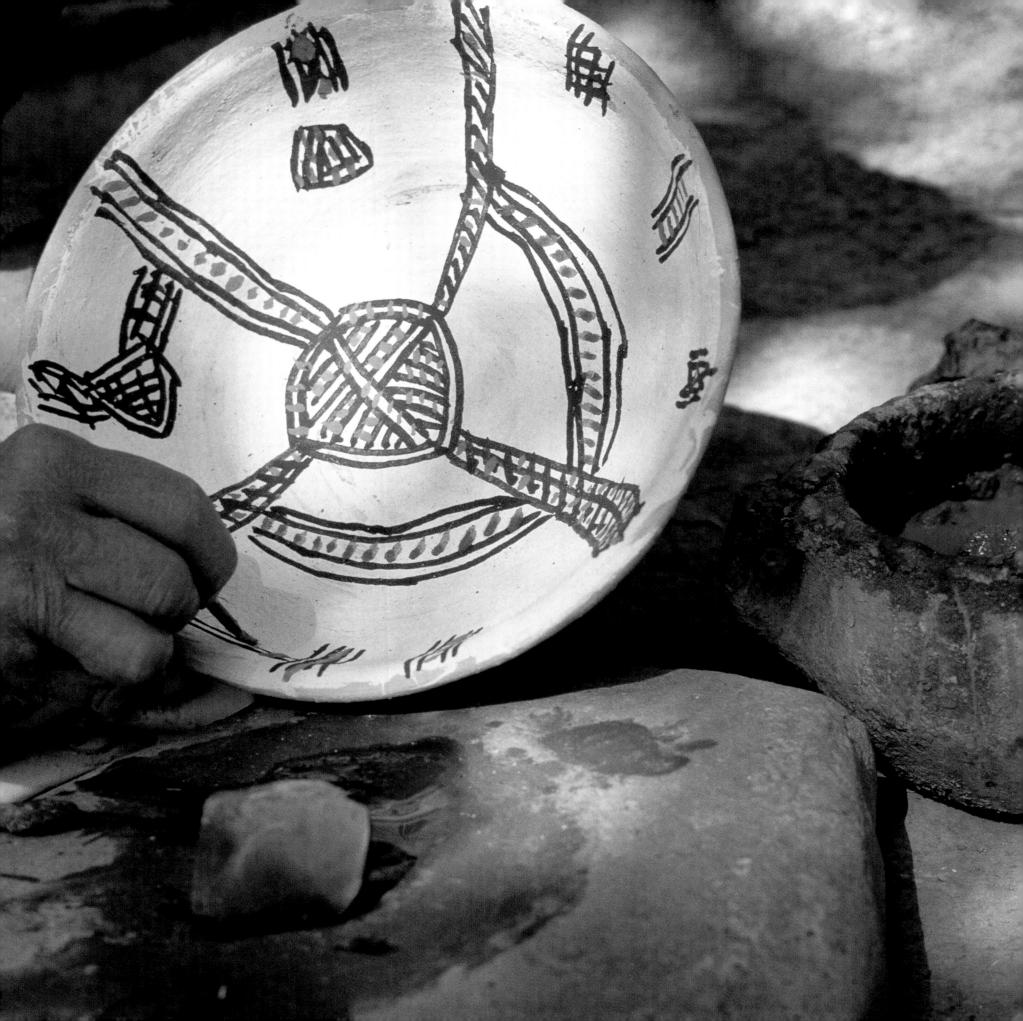

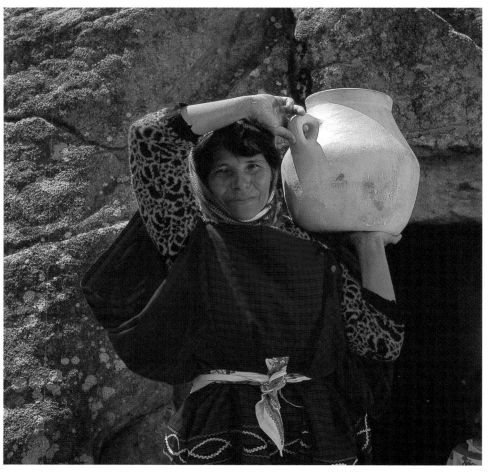

Above and opposite: Jemah Saidani is from a rural settlement near Sejenane, Tunisia, renowned for its women potters. Recognition has brought economic relief but has also endangered the traditional craft because of increased quantity demands with little regard for the time required to produce the pottery. Jemah is one of the few exceptions. Not only has she adapted her *creative skills to a more modern and refined style, but she still uses the same techniques and materials that have survived for centuries. Her motifs are derived from nature;* chehda, *honeycomb, and* boul thor, *the tracks of oxen pulling a plough.*

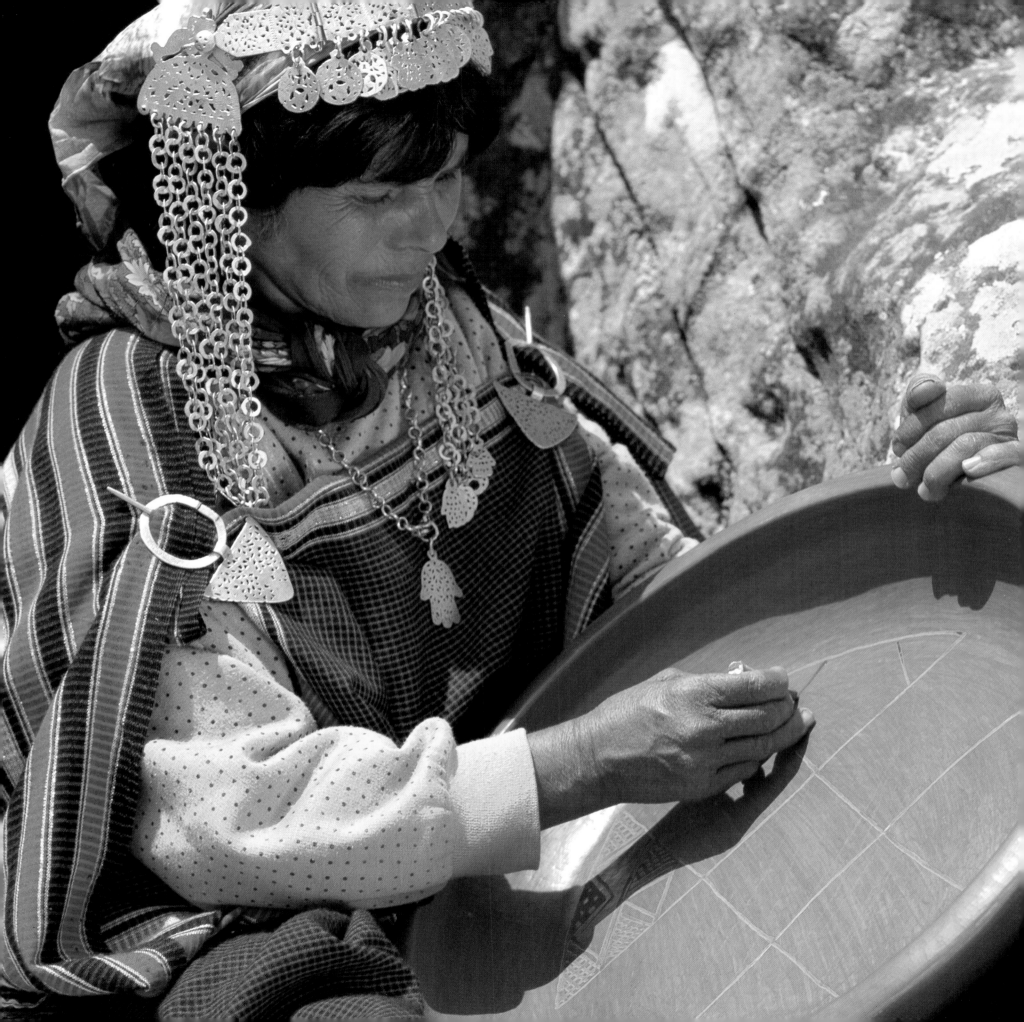

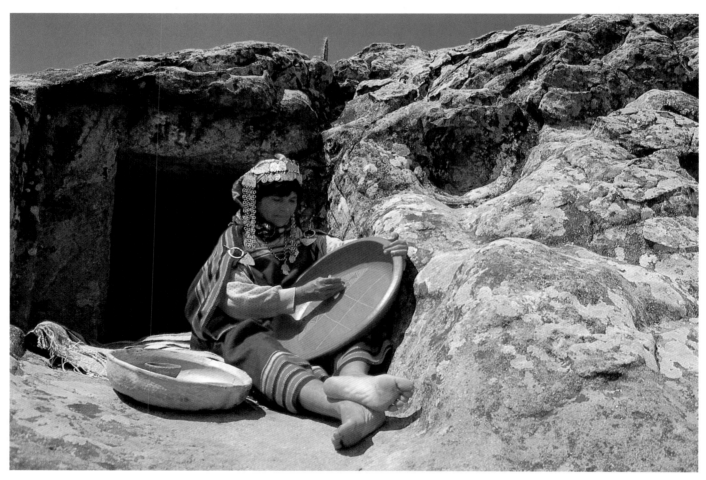

Above: Jemah Saidani decorates a large plate at her home near Sejenane, Tunisia. Opposite: Clay is abundant throughout North Africa. Its quality varies from place to place as do methods of firing and decorating of pottery. Motifs are applied after the first firing and after the surface has been rubbed smooth with a stone. The use of decoration largely depends on the existence of indigenous pigments in the surrounding area. Women improvise their own tools to apply pigment—a switch of goat hair set into a lump of clay, a stick, or more often than not, a finger.

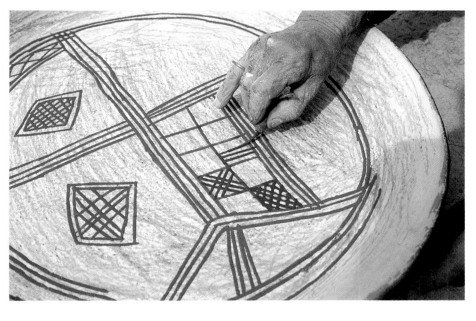
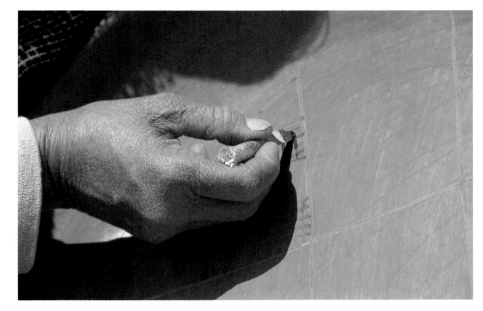
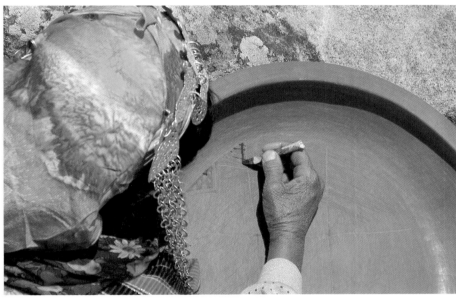
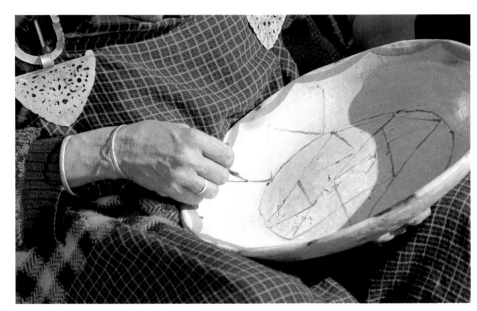
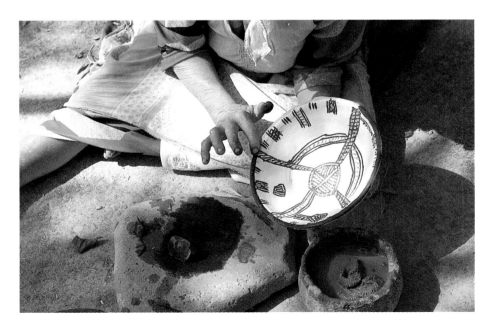
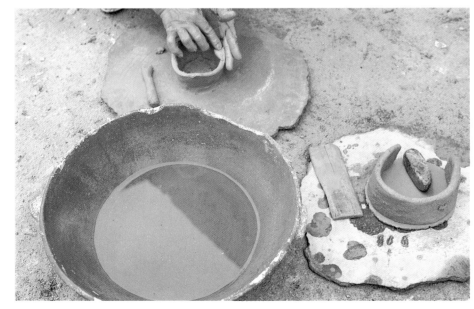

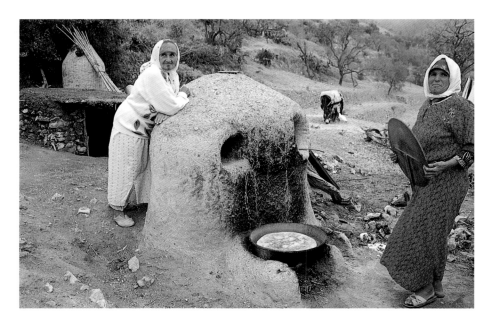
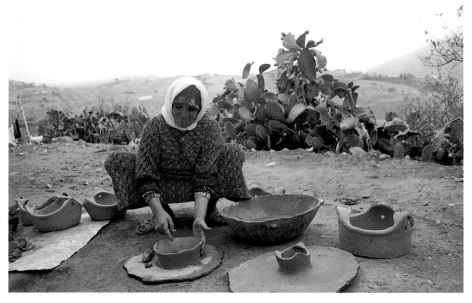
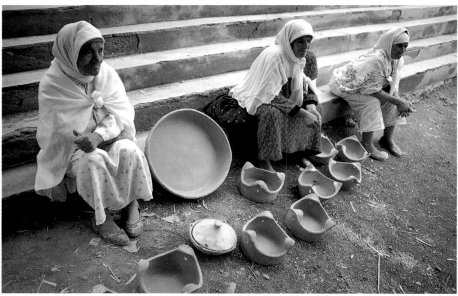
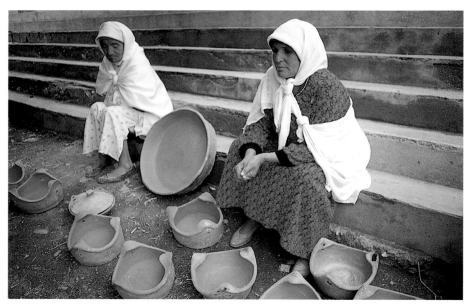
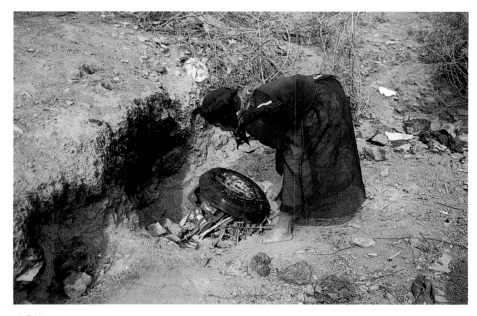
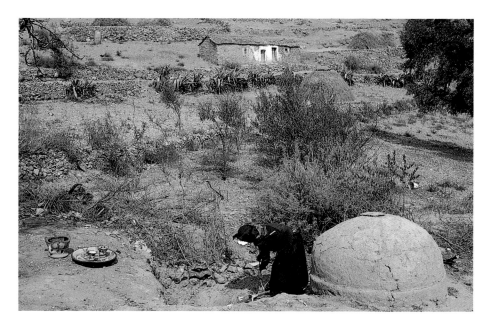

Opposite, top and center: After leaving their little hamlet in Arabaa Touarit, in the Rif Mountains, these women travel down steep trails with a muleload of their week's labor, often taking as long as six hours. It can take a whole day at the souk *to sell their few pieces—braziers, flatbread pans, and bowls (below)— in strong competition with truckloads of commercial pottery now much in demand. Zoulikha Elbarissi (wearing a red dress) and*

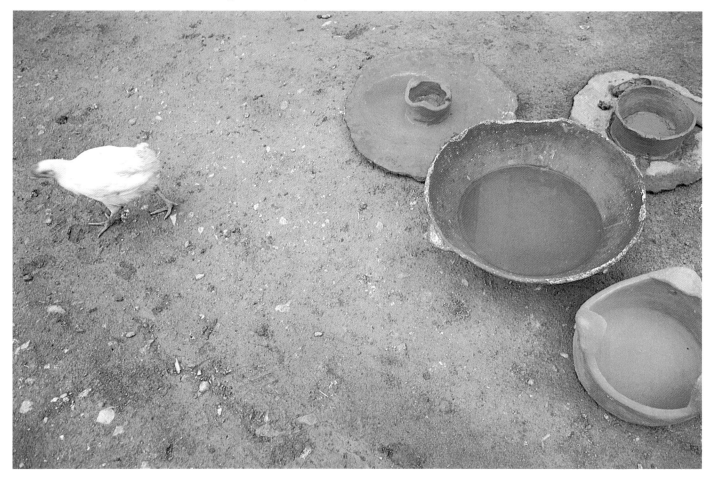

Boujemaate Aznag, at the market (center). While making a pot, Zoulikha also cooks a flatbread on an open fire in the traditional Berber way. Opposite, bottom: Fatima Lehsen, from Beni Amar in the Rif Mountains, sets about a second firing in an open pit that serves to fasten the colors on her freshly painted pottery. Scraps of wood are placed in the pit and the pieces are piled on top and covered with dried dung before the fire is lit.

PORTRAITS

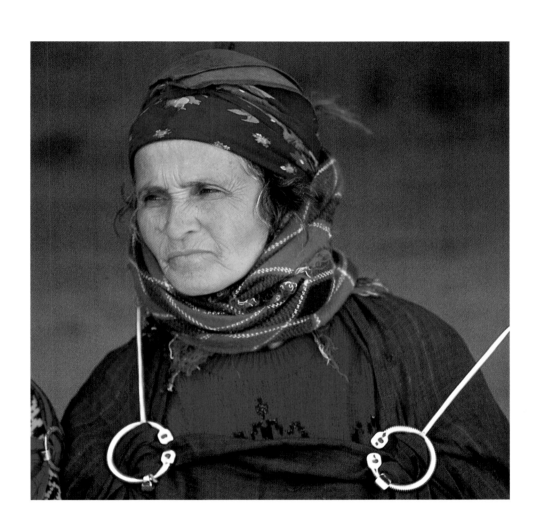

THE BERBER FACE is the face of humanity.

Berbers don't define themselves as a distinct racial type. They include among their number black-skinned *Haratins*, descendants of slave laborers and tenant farmers brought north from sub-Saharan Africa by camel traders until the middle of this century. For centuries, too, there were Jewish Berbers, although most migrated to Israel after the state was formed in 1948. There are Berbers with red hair, blond hair, and hair of every shade of brown. Eyes of green, blue, treacle amber, or molasses brown stare from faces fair-skinned or blue-black.

While most of the population of the Maghrib is of full or part Berber descent, the number still considering themselves Berber, speaking the language and conscious of a distinctive non-Arab culture, may be a little more than half the population of Morocco and a little less than half in Algeria. In Tunisia the numbers are far smaller.

Unlike many other Muslims, Berbers traditionally haven't required women to veil their faces. On the contrary, makeup and tattoos are elaborate and artistic, and often meant to carry a message to the outside world about a woman's status, tribal affiliation, and availability for marriage. For festivals, the cheeks are reddened with rouge and the eyes blackened with kohl. A triangle of black dots may be placed on the cheeks to draw the eye to a fine bone structure. Tattoos on the chin, nose, brow, or neck symbolize good fortune and prosperity, fight the evil eye, and also indicate to the experienced viewer to what region or tribe the woman likely belongs.

In recent years, some Berber women, influenced by the more conservative mores of the Arab populations among which they live, have adopted the face veil. Some who don't veil in their village hide their faces from the camera. But most Berber women remain comfortable with the gaze of the outside world, and return it with their own unflinching frankness.

Preceding page: Sahlah Saidani wears a pair of unusual silver brooches, called fibulae, with long spikes typical of the eastern region of Tunisia. They indicate a woman's status and also serve to hold her mantle in place. Opposite: The women of the Saidani family (left to right): Sahliha, twenty-five, Habiba, twenty-five, Jemah, fifty, and Sahlah, sixty-five, are all sedentary farmers. When they are not working the fertile land, they make pottery which they hand-paint and decorate with traditional symbols. Since Tunisia has become a magnet for tourists, many Berber women have sold their traditional silver jewelry and handwoven garments and opted for more European dress. Sejenane, Tunisia

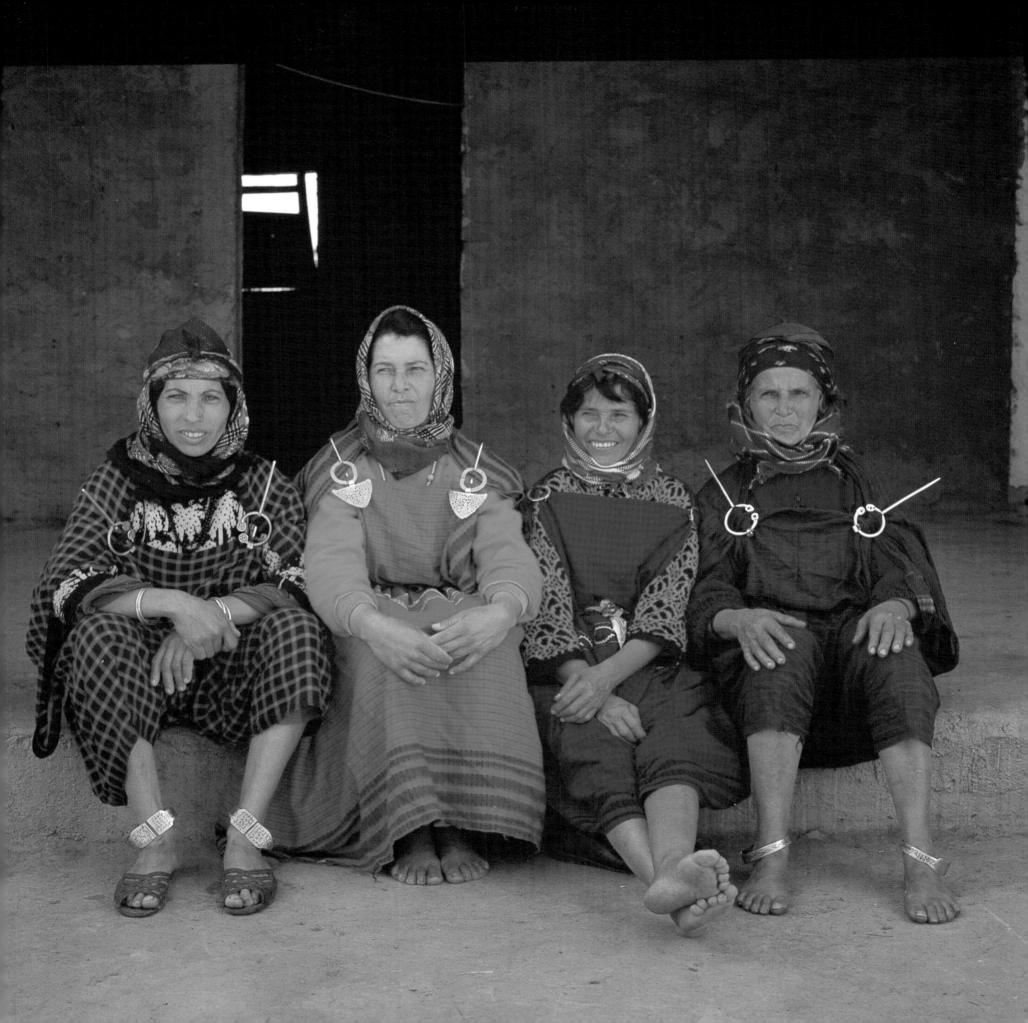

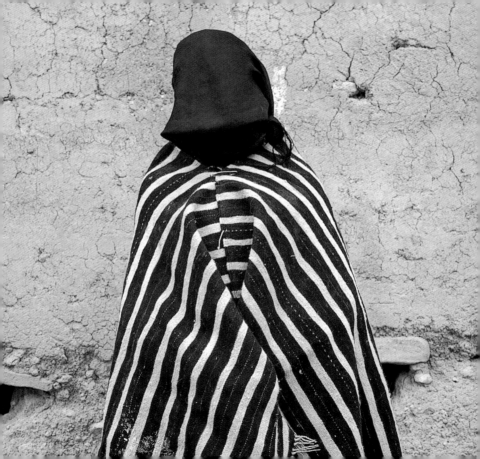

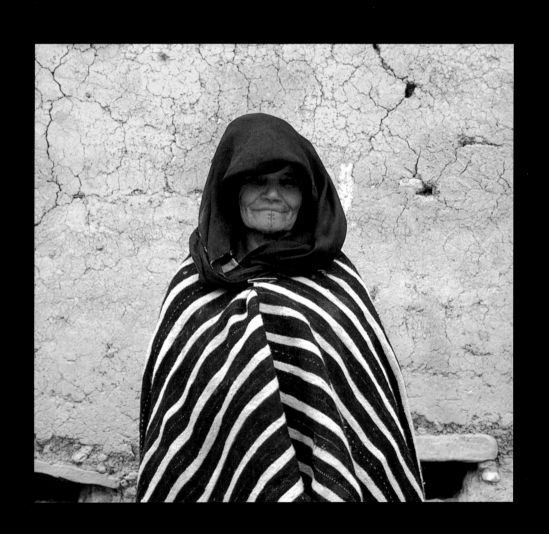

Previous pages: Aïcha Moha Ait Kaider from Tilimi in the High Atlas Mountains, Morocco, wears a distinctive black-and-white handira. *"It is my signature, it gives me sparkle," she says through the fabric that veils her face. Aïcha receives strangers with her face covered, but after we spend the day photographing her and talking to her about her life and Berber customs, she reveals her tattooed face as a gesture of friendship and trust.*

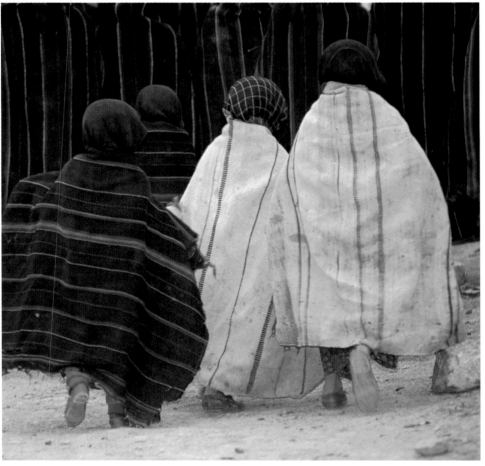

Above: Children wearing handiras, *typical of the Ait Brahim tribe, trail their parents on the way to a ceremony in the remote village of Sountate in the High Atlas Mountains, Morocco.*

Opposite: Seventeen-year-old Aïcha Hinade with her baby daughter, Fatima, and eight-year-old sister, Hennou, from Agoudal in the High Atlas Mountains. "In winter, we sit around a fire and try to keep warm and bear with the cold," says Aïcha during a break from weaving.

134

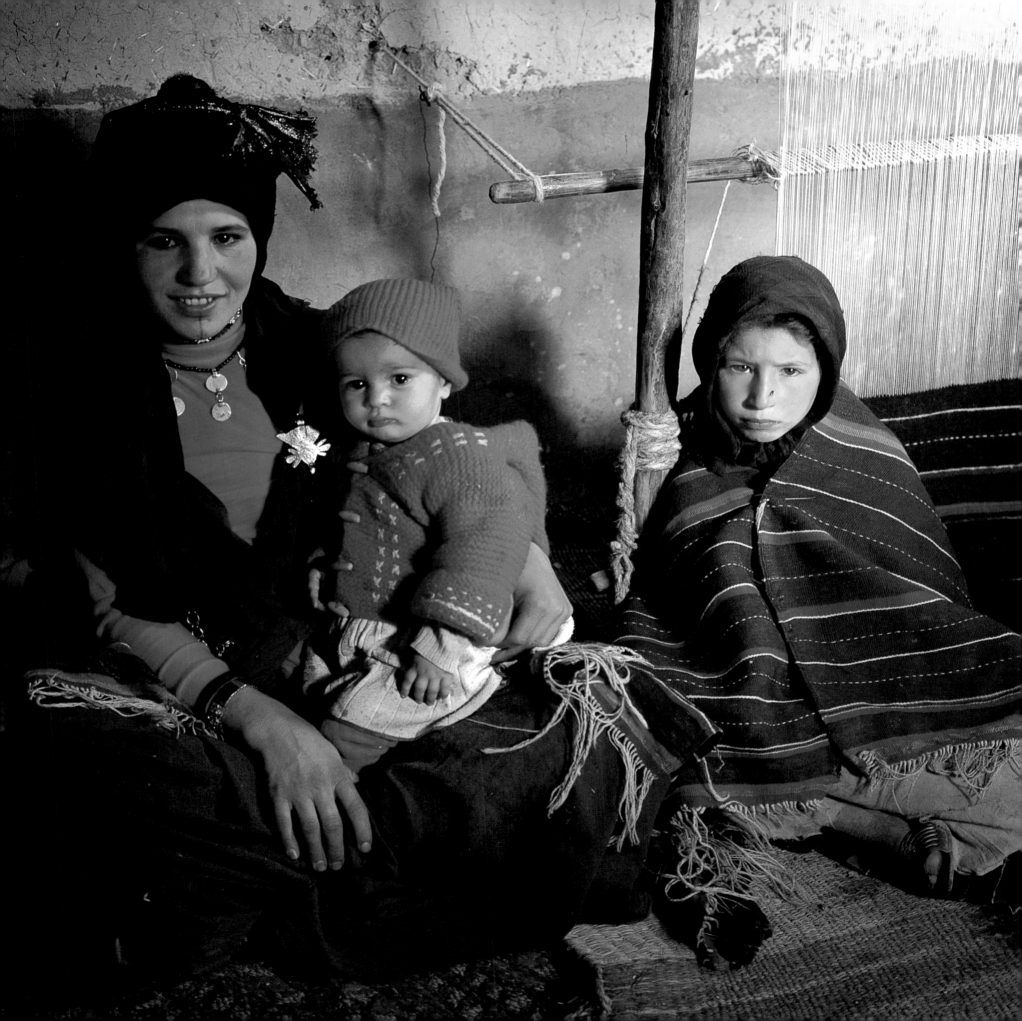

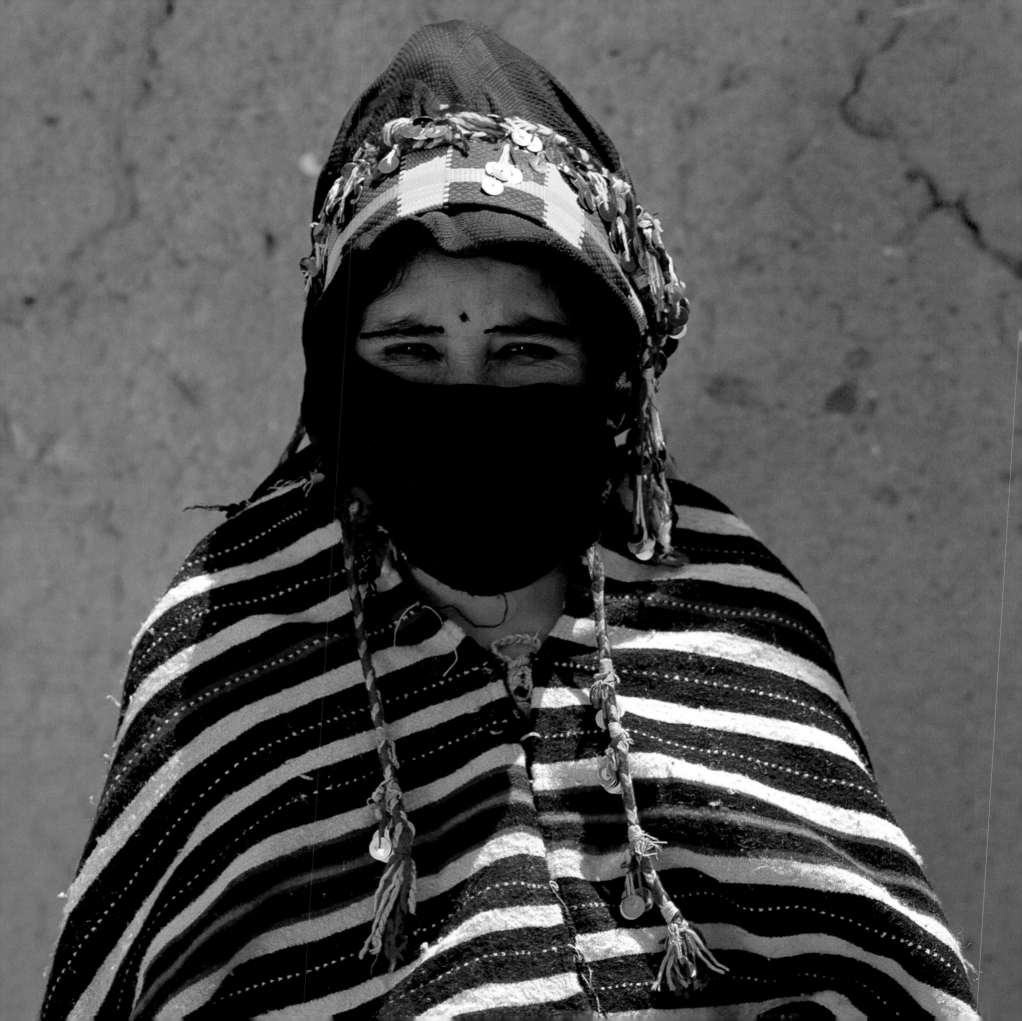

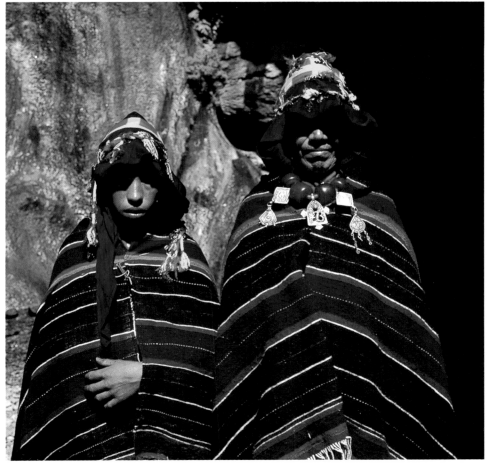

Opposite: Rabha Ben Lahsen moves about her village wearing the Ait Haddidou striped handira and purple bonnet. She keeps her face half-veiled as is customary for married women. Imilchil, Morocco

Above: Aïcha Oulrih and Rabha Ouchin of the Ait Brahim tribe, from Bouazmou near Imilchil, Morocco. Women with unveiled faces are usually divorced or widowed and partake in various festivities specifically to find a husband.

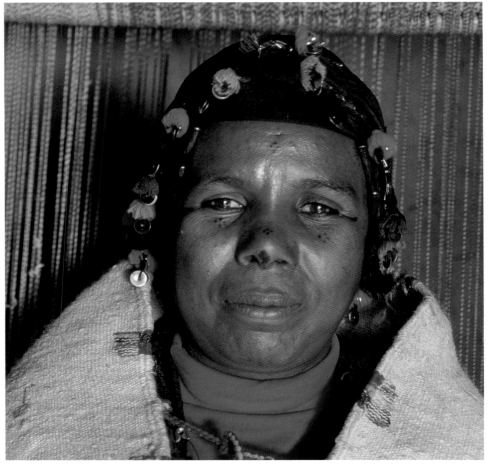

Opposite, above left: Sahliha Saidani, near Sejenane, Tunisia. Below left: Touda Ait Rahou of the M'Goun tribe from the Valley of Birds, Morocco. Above right: Mirim Ait Oumkhar, of the Ait M'Goun tribe, in front of the family cave in the Imrane Valley at the foot of the High Atlas Mountains, Morocco. Below right: A troglodyte woman in her home in the distant southern town of Matmata, Tunisia

Above: Melaid Ait Oulaid of Tarasa in the Valley of Birds, wearing a winter handira *typical of the M'Goun tribe.*

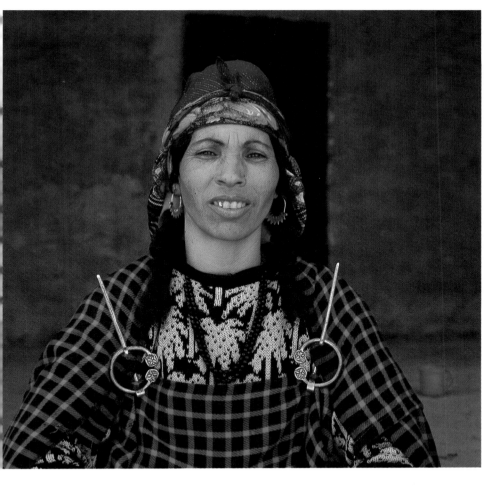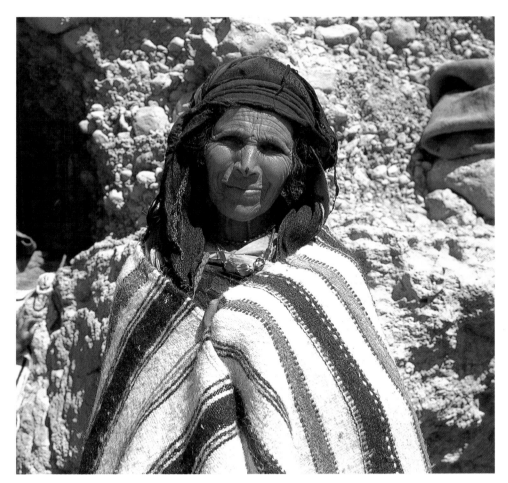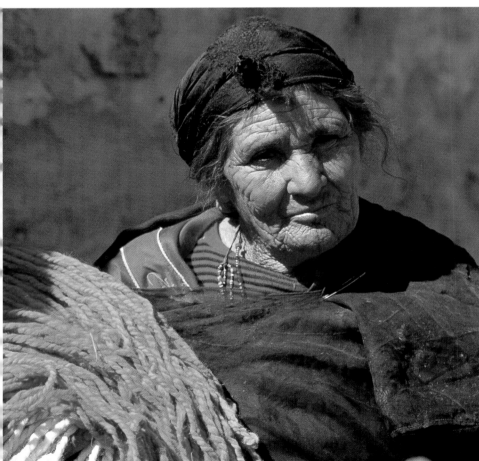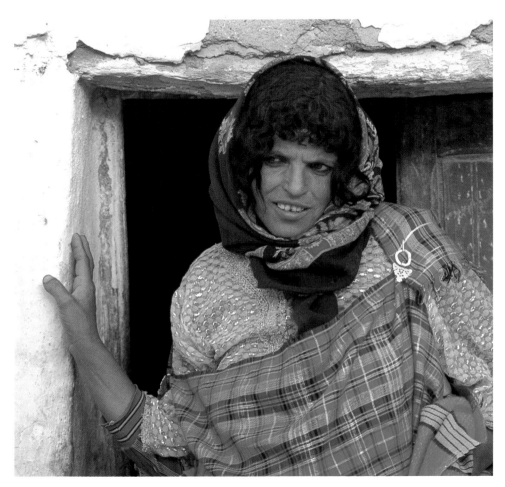

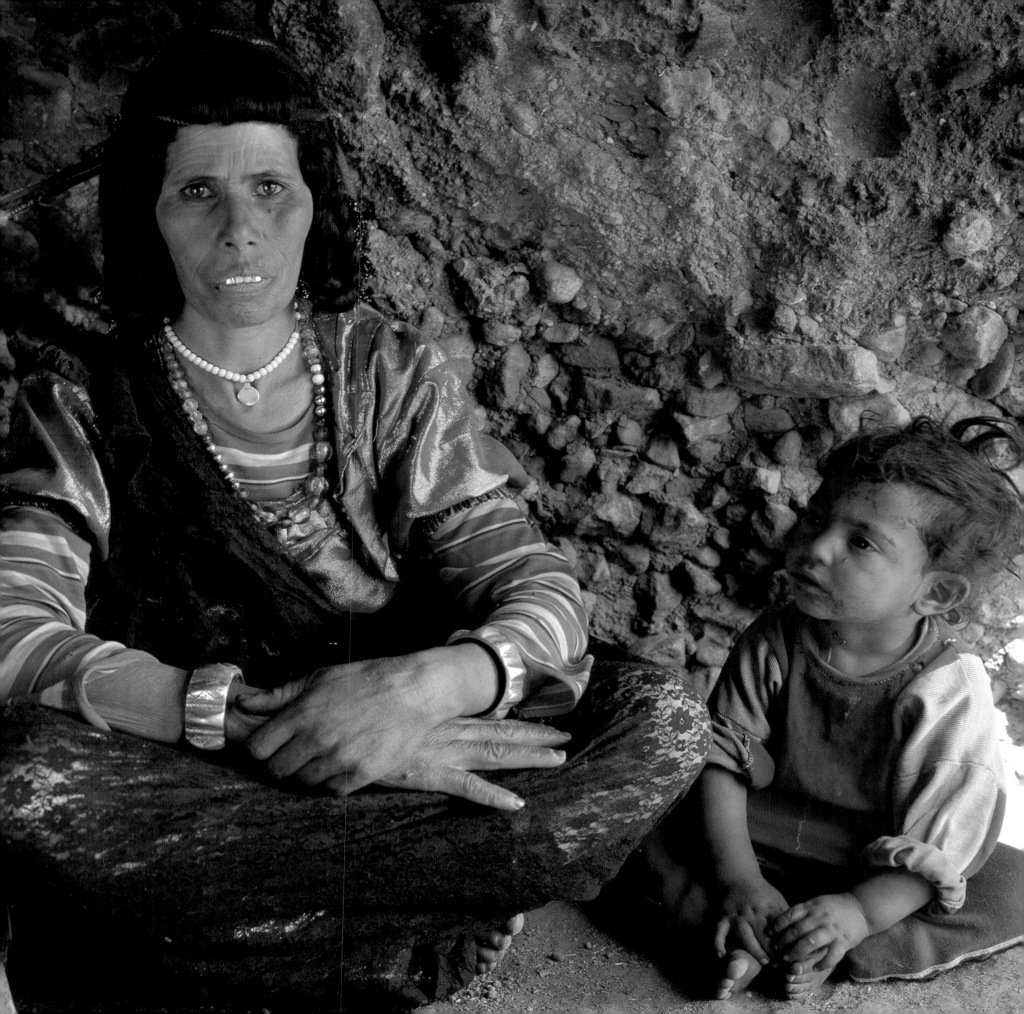

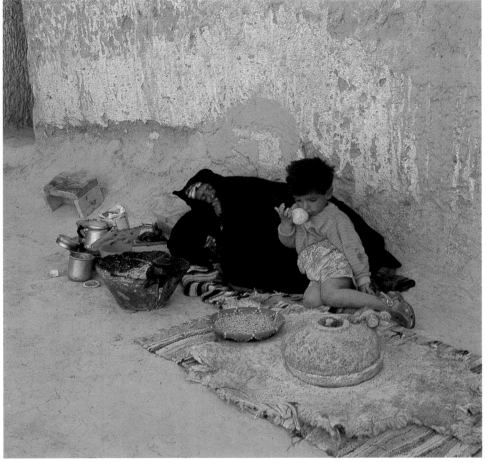

Opposite: Lho Ait Lakha of the M'Goun tribe in her cave in the Valley of Roses, Morocco

Above: Fatima Snini takes a rest in the courtyard of her underground home. Matmata, Tunisia

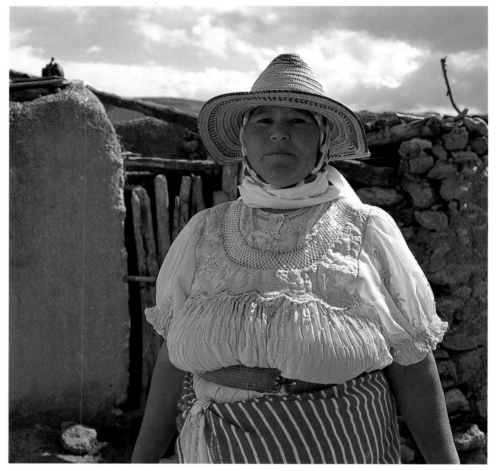

Above: Khaddouj Aharrouch from the rural community of Rouadi, high in the Rif Mountains of Morocco, has twelve children and makes a meager living selling her pots. Straw hats are peculiar to this Mediterranean coastal mountain region, and to the Berber women on the island of Djerba off the coast of Tunisia.

Opposite: Messaouda Hendel, a Kabyle Berber from the village of Taourirt-Khelf. Near Beni Yenni, Algeria

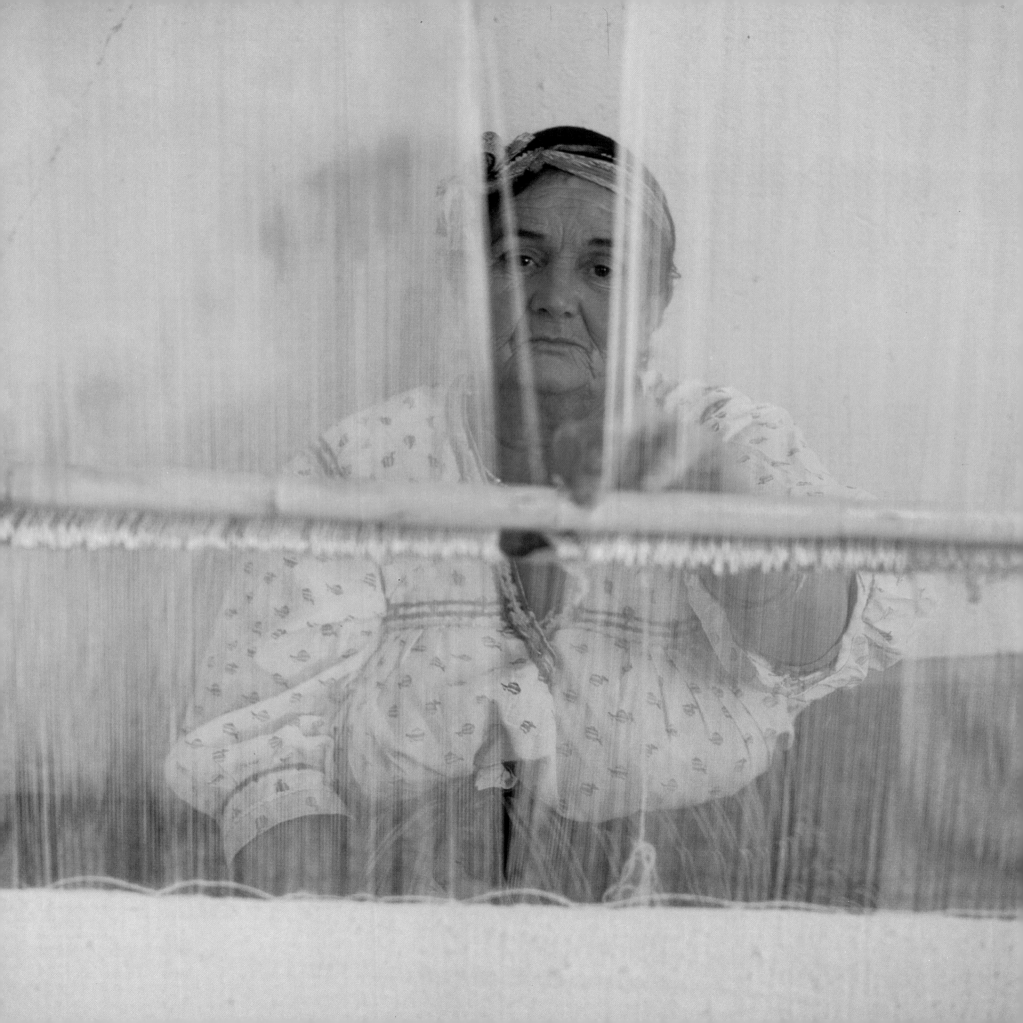

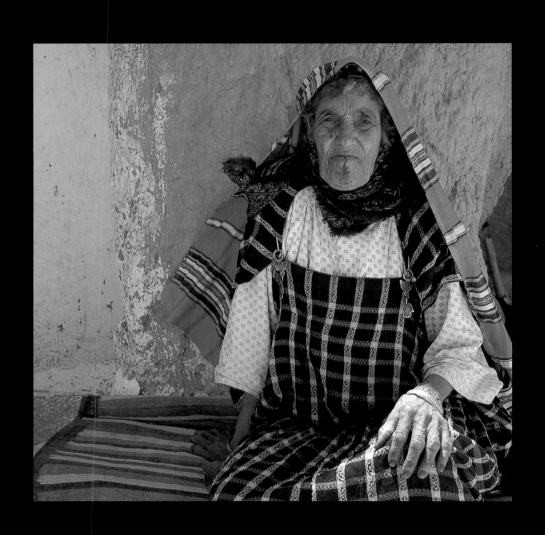

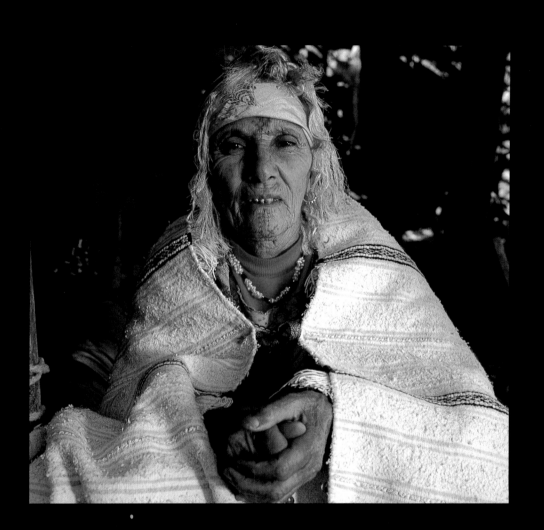

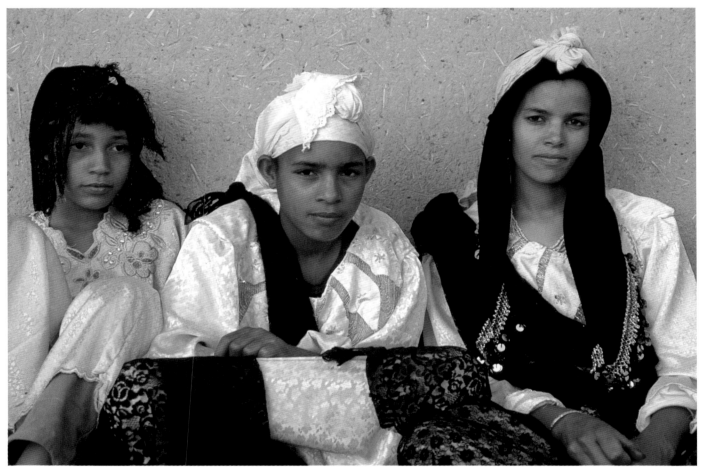

Preceding pages, left: Fatima Azouz, seventy-six, reminisces about her youth when all young women were tattooed on their chin, nose, and cheek as a sign that they were betrothed. Right: Fatima Asakawfaliba of the Beni M'Guild tribe from the Middle Atlas Mountains.

Above: Aïcha, Zohra, and Sahdia Lemnaouar from the southern town of Boumalne Dades in Morocco.

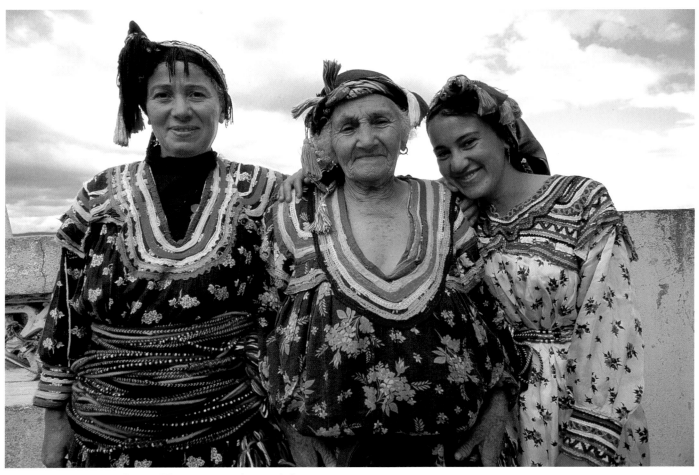

Above: Three generations of the Boukhalfa family, from Kabylia, Algeria, wearing cotton dresses elaborately decorated with colored braids and myriads of handwoven cords wrapped around their waists, typical of Kabyle women.

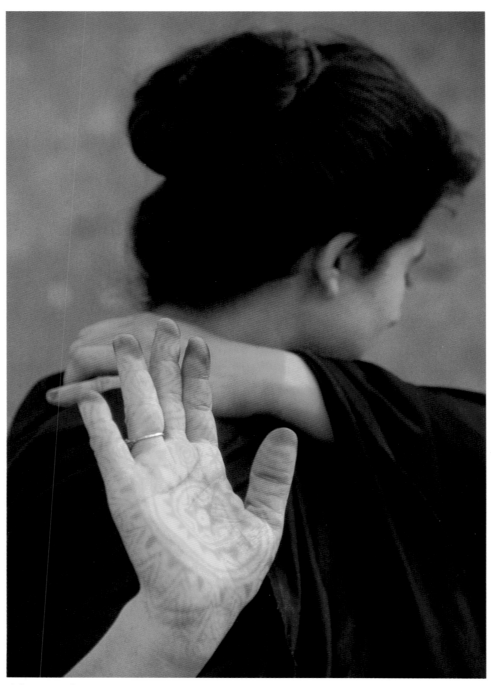

Above and opposite: Tattoos were originally believed to have magical powers. They also signified tribal identification and were integral to rites of passage. Today tattoos are no longer etched permanently but stained with henna, which is grown throughout North Africa. It is painstakingly applied to hands and feet for decorative purposes and to ward off the evil eye. Designs include intricate latticework and geometric patterns with traditional and protective symbols.

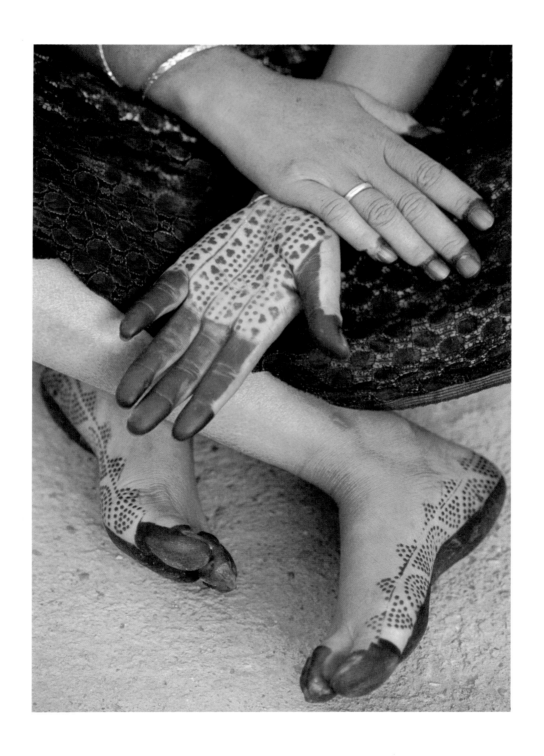

TASKS AND BURDENS

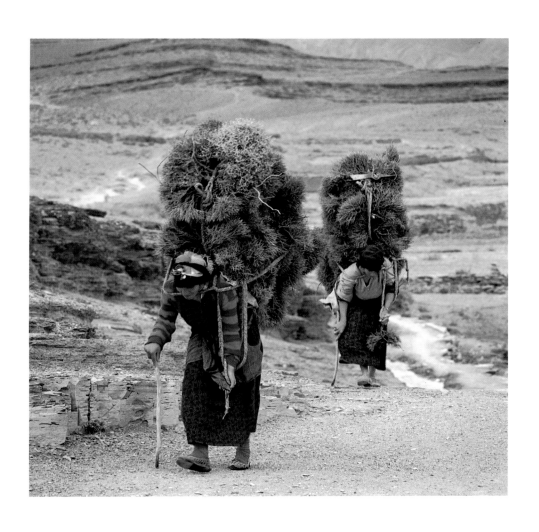

HER LABOR SUSTAINS LIFE. Without the Berber woman's daily trek through miles of mountain tracks, the isolated villages would be without fuel. Without her journeys to and from the well, there would be no water. Her gardening stocks the livestock mangers; her milking and bread making fill the family larder.

It is to women that the largest share of labor falls. Men's tasks—plowing the fields, building the dwellings, sharing the shepherding of flocks, and bringing provisions from the weekly markets— leave some room for leisure. But women's work is without respite. To her fall the constant and daily repeated duties: tending crops and harvesting, spinning and weaving, making food—and hauling almost all of life's necessities.

Of all her tasks, carrying wood is the most onerous. Few Berbers are wealthy enough to afford a mule for such work. So, at the close of the 20th century, Berber women still fill the role of beasts of burden. It is a status quo barely questioned in the remote communities, where men expect to ride whatever pack animals there may be, while slight young girls and bent old women daily haul loads many times their own body weight over difficult terrain and vast distances.

The painful work is eased by companionship. To fetch wood, women set out in groups before dawn and are climbing high into the mountains by the time the sun rises. As goats and human foraging denude the forests, the walk becomes ever longer. Few communities have the luxury anymore of burning long-lasting logs in their fireplaces. Instead, the women must work with picks to uproot thyme bushes and low, scrubby thorn shrubs.

On their return, late in the afternoon, the women sometimes sing together to distract themselves from their aching muscles.

Preceding page and opposite: Hennou Mohe and Hennou Bassou of the Ait Haddidou tribe return to their village of Moutazili near Imilchil, Morocco, carrying bundles of sagebrush and thuriferous juniper for firewood. Following pages: In the late afternoon, women walk together in their most dreaded task —gathering firewood. Their chanting reverberates against the barren hills. From a distance it is difficult to distinguish whether these "moving bushes" are carried by women or mules.

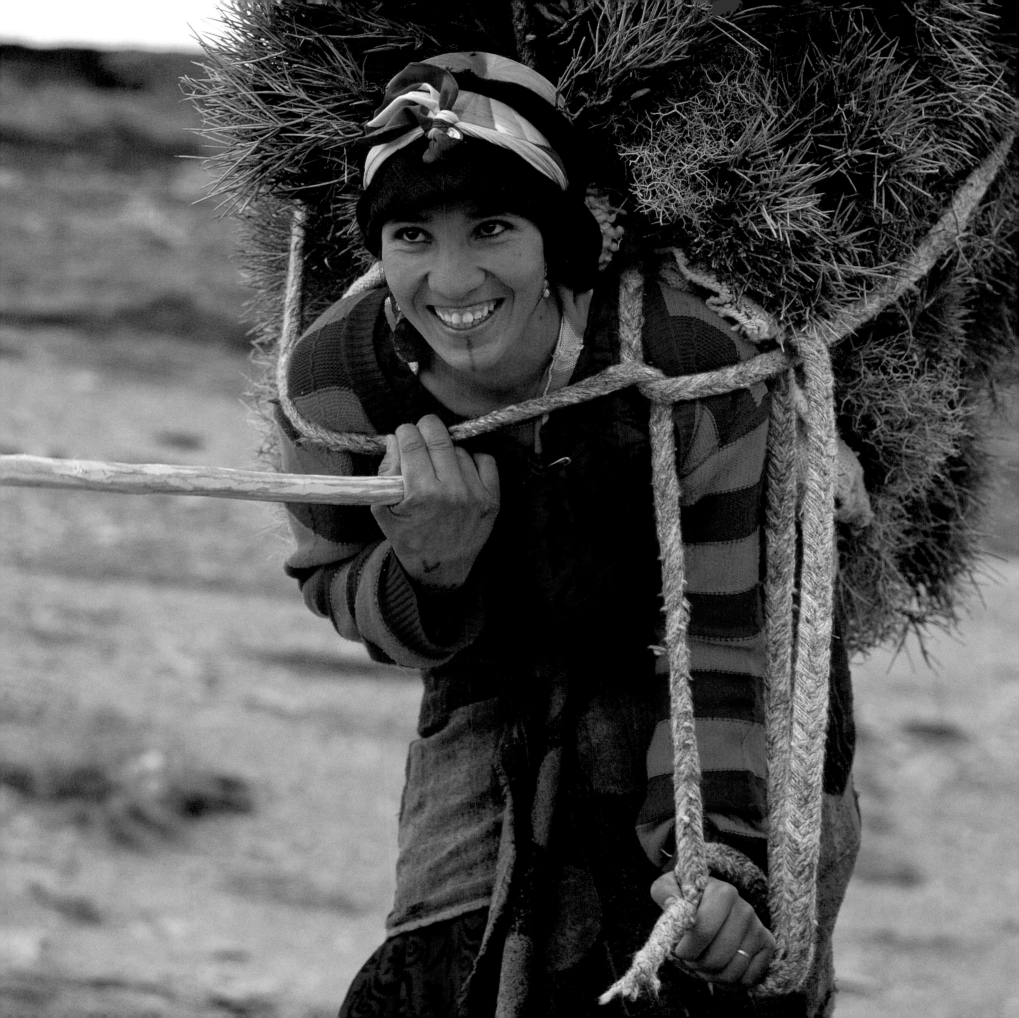

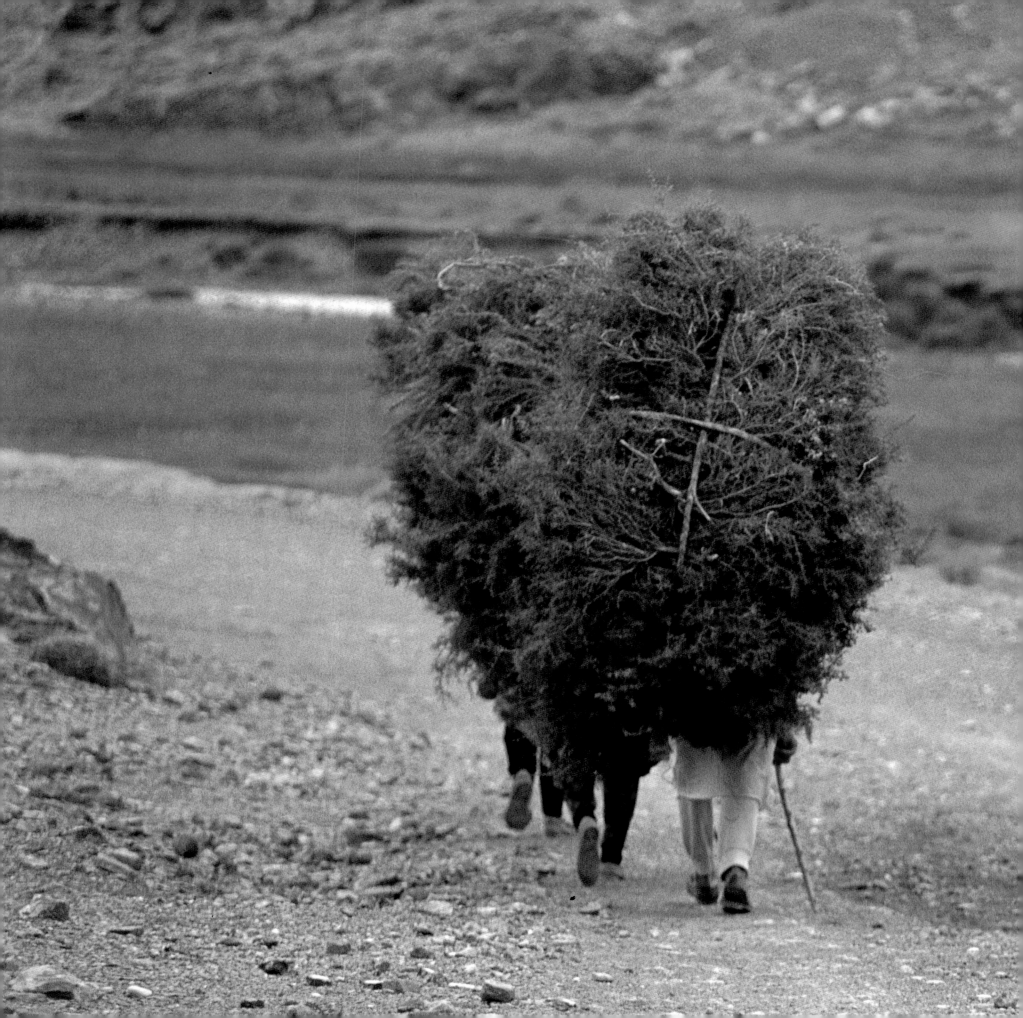

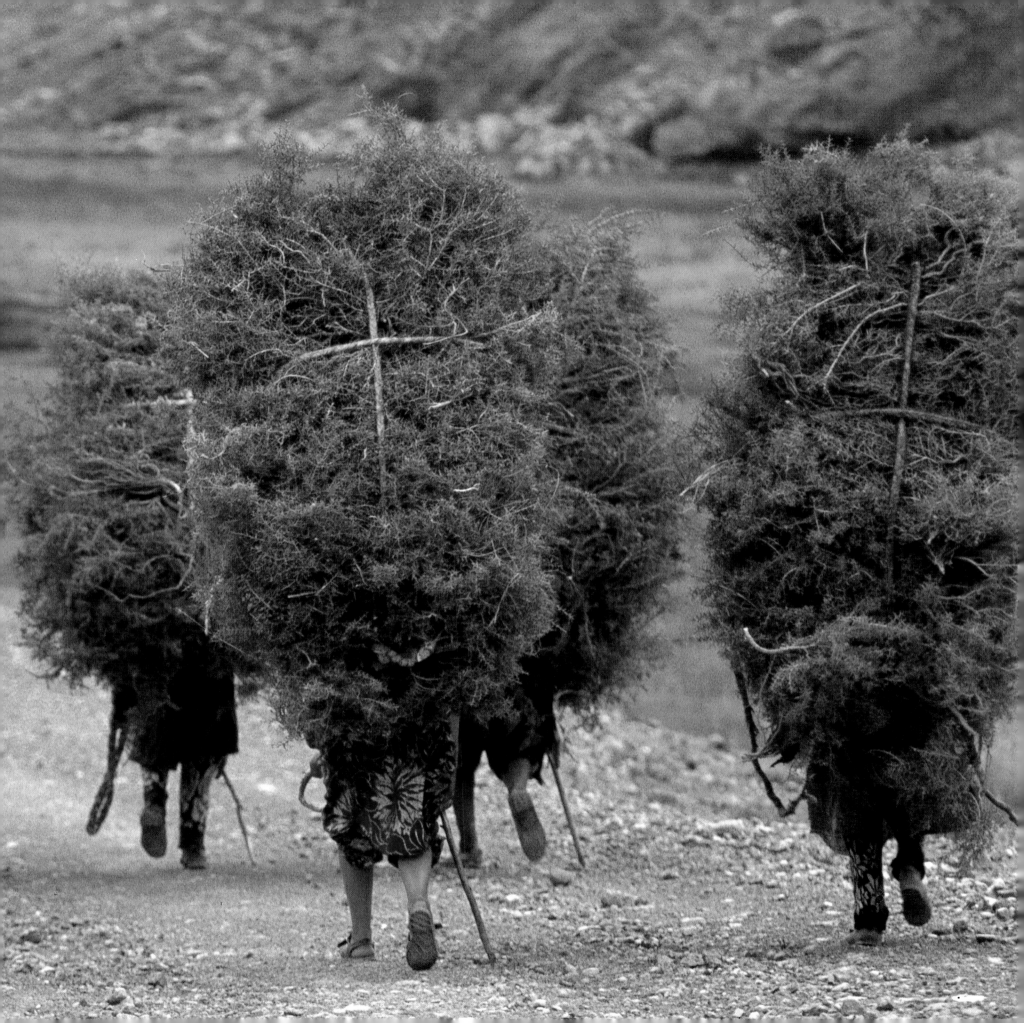

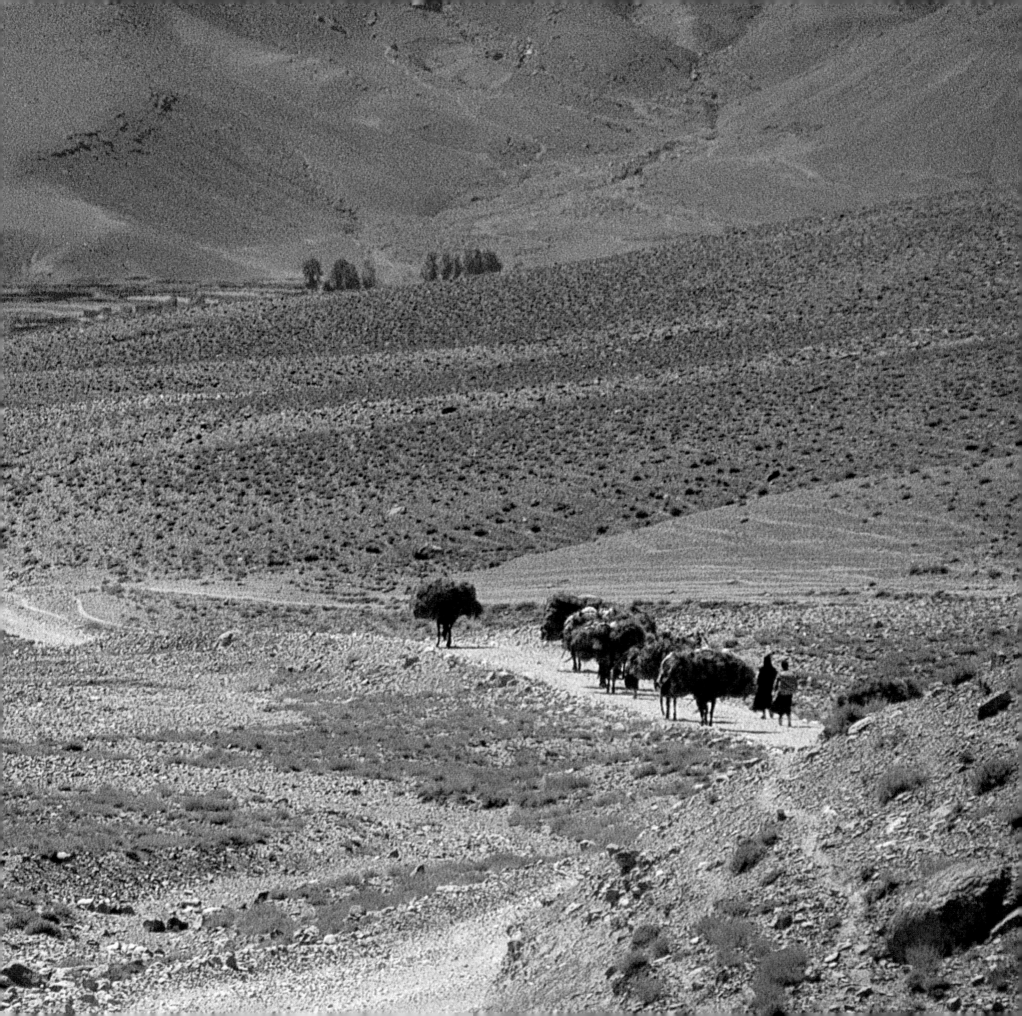

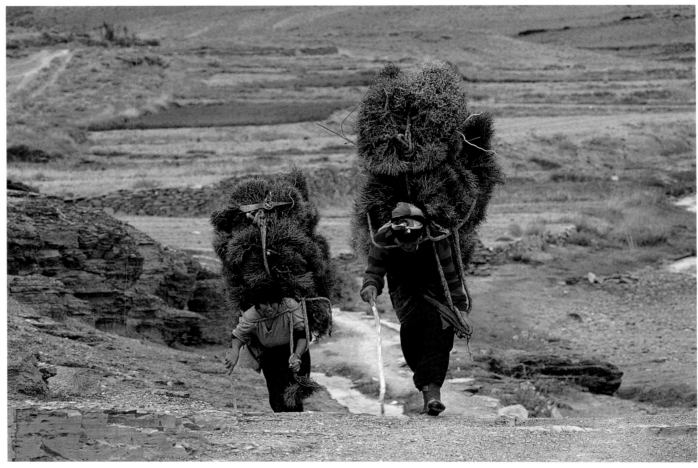

Above and opposite: It is the younger women who carry enormous loads on their backs—which they will do until they attain the status of owning a mule. As each winter passes in these snow-covered High Atlas Mountains, women will have to walk farther and farther in search of firewood. Over the centuries the mountains have been denuded of this only source of fuel. All that remains on the eroded slopes are scattered growths of juniper, sagebrush, and a stunted vegetation known by its Spanish name, matorral.

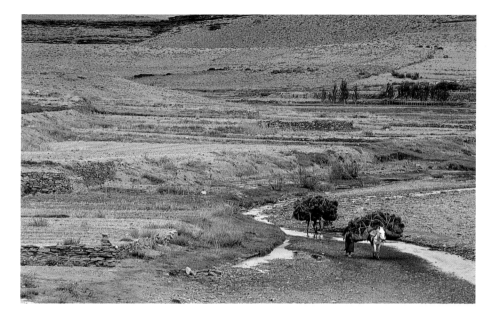 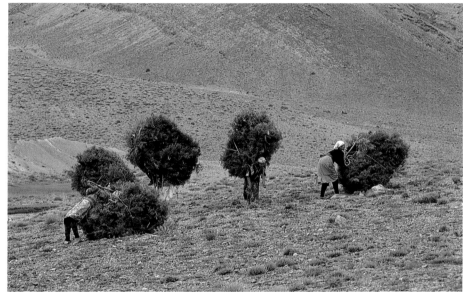

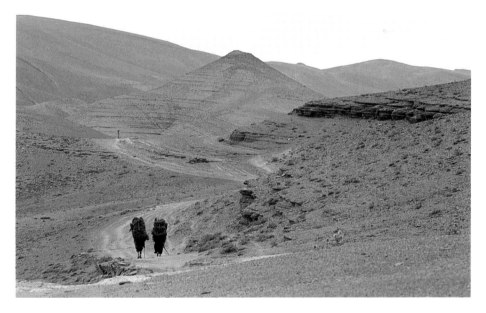 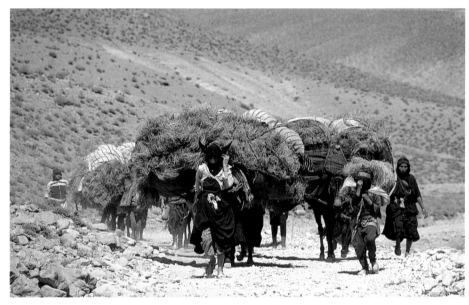

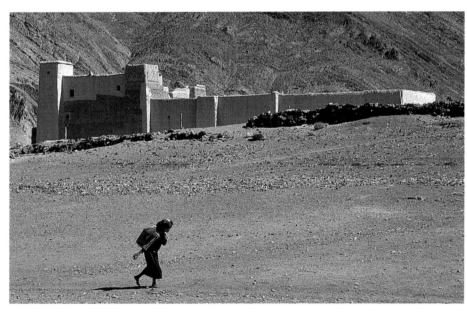 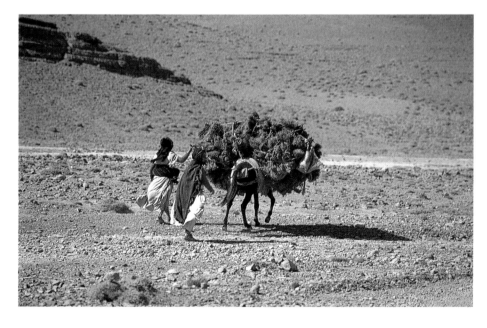

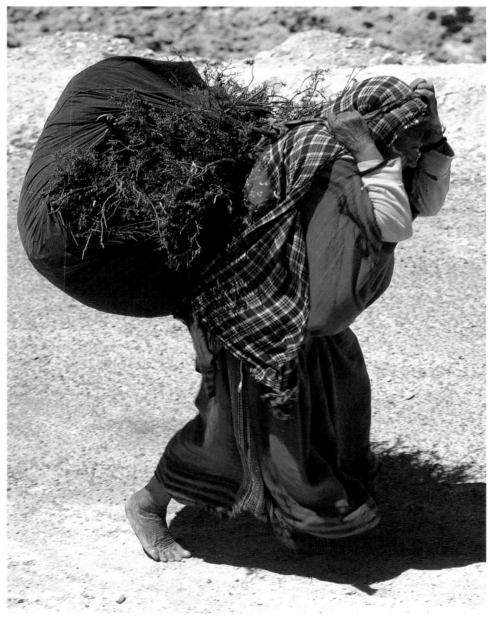

Opposite: With the aid of walking sticks, a group of women bent under the weight of hundred-pound loads return home after a twelve-hour day gathering thorny shrub for fuel in the mountains. Their bundles are held together—a pick in their midst —by a braided wool rope tied around their shoulders. An extended cord is held in one hand and used for leverage.

Above: Berber women in southern Tunisia wrap bundles of fodder for their livestock in pieces of cloth that they carry on their backs, using a braided rope to distribute the weight around their foreheads. Tarred roads throughout the country have made other forms of fuel such as liquid gas accessible to remote villages. Toujane, Tunisia

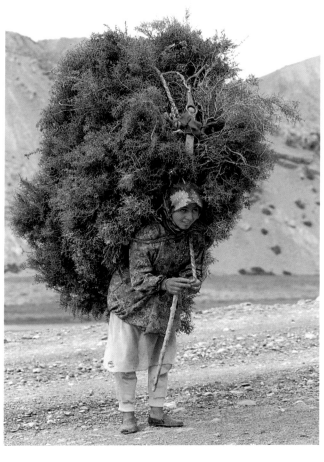
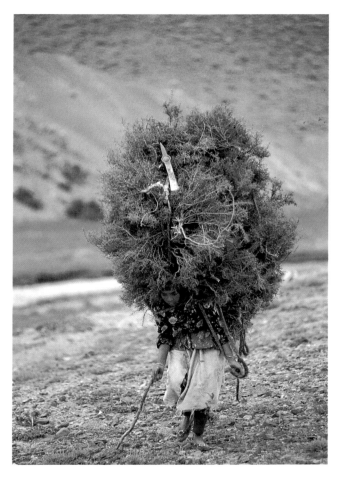
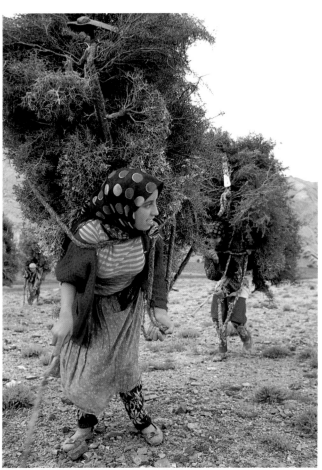
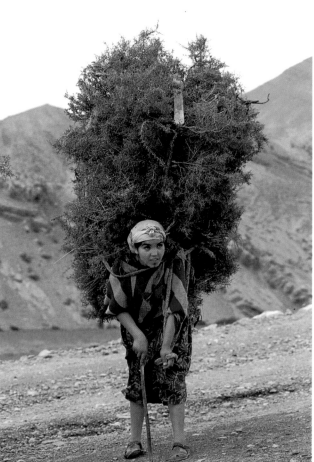

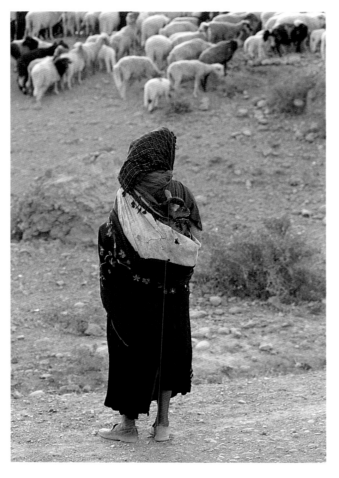
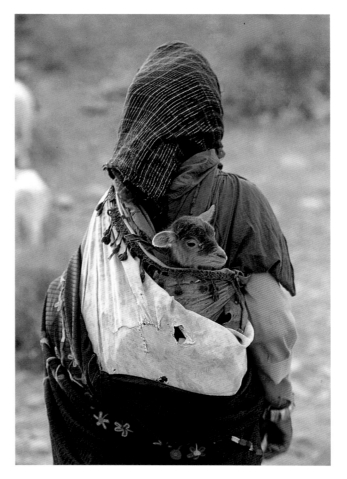
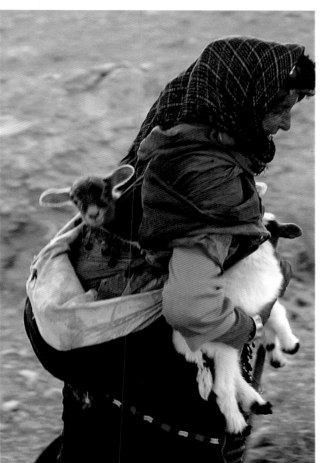
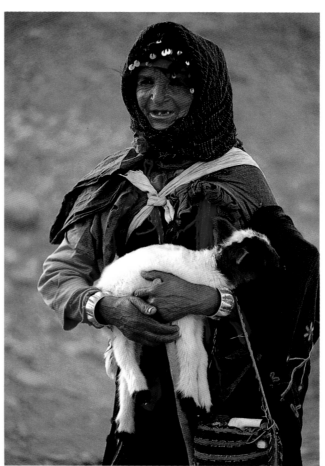

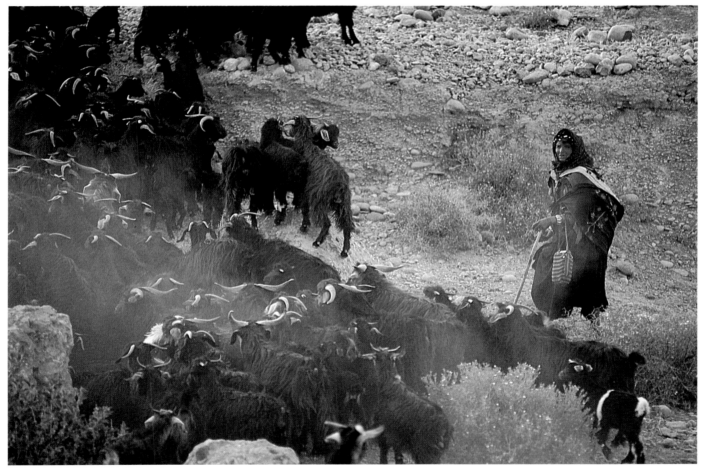

Opposite and above: A nomad woman of the Ait Atta tribe herds her sheep and goats across the plains from the pre-Saharan Sarho Mountains to greener pastures in the High Atlas. Lambs and kids tend to get crushed in the stampede and are carried and cared for like babies during the long trek. At night, a special corner under the family tent is set aside for the newborn. The men usually travel ahead with the children and the family's possessions to set up camp.

163

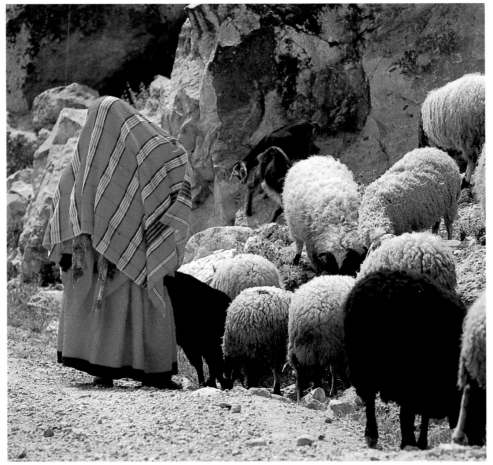

Opposite, above left: Rahma Mohna of the Ait Haddidou tribe washes wool at the river near her village of Ali Oudaoud in the High Atlas Mountains. The fleece is soaked in cold water, then beaten to emulsify the fats so they can be washed out to make the wool white. Above right: Twenty-five-year-old Halima Ayadi climbs the ancient stone steps to the roof of the family dwelling to fetch wheat stored in a woven grass basket, Toujane, Tunisia. Below right: In the same village, another Berber woman carries dried dung to her vegetable patch on the mountain slopes. Below left: Women of the Saidani family from the northern rural community of Sejenane, Tunisia, collect water twice daily in plastic containers.

Above: Veiled in a traditional striped shawl, a Tunisian woman herds her sheep on the roadside near Toujane.

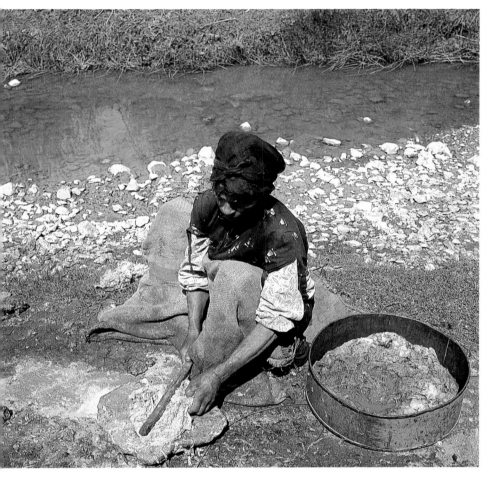
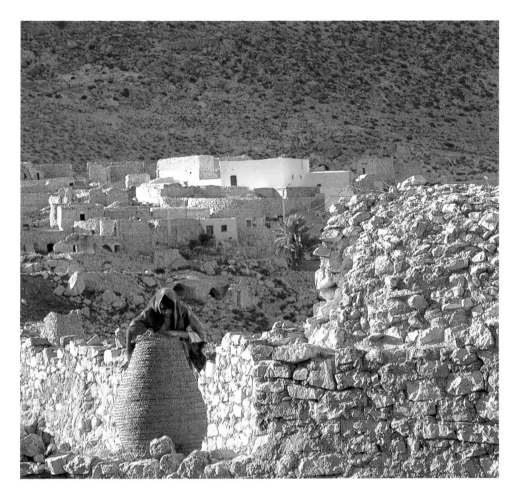
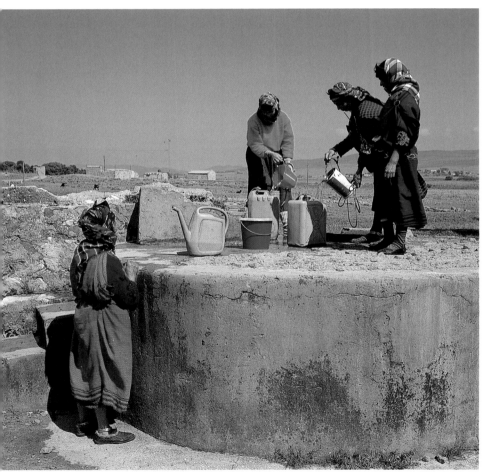
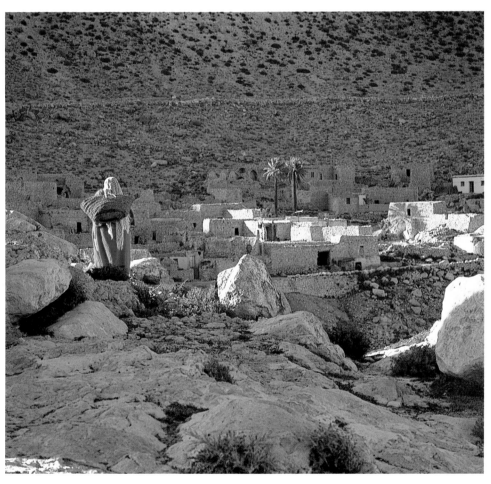

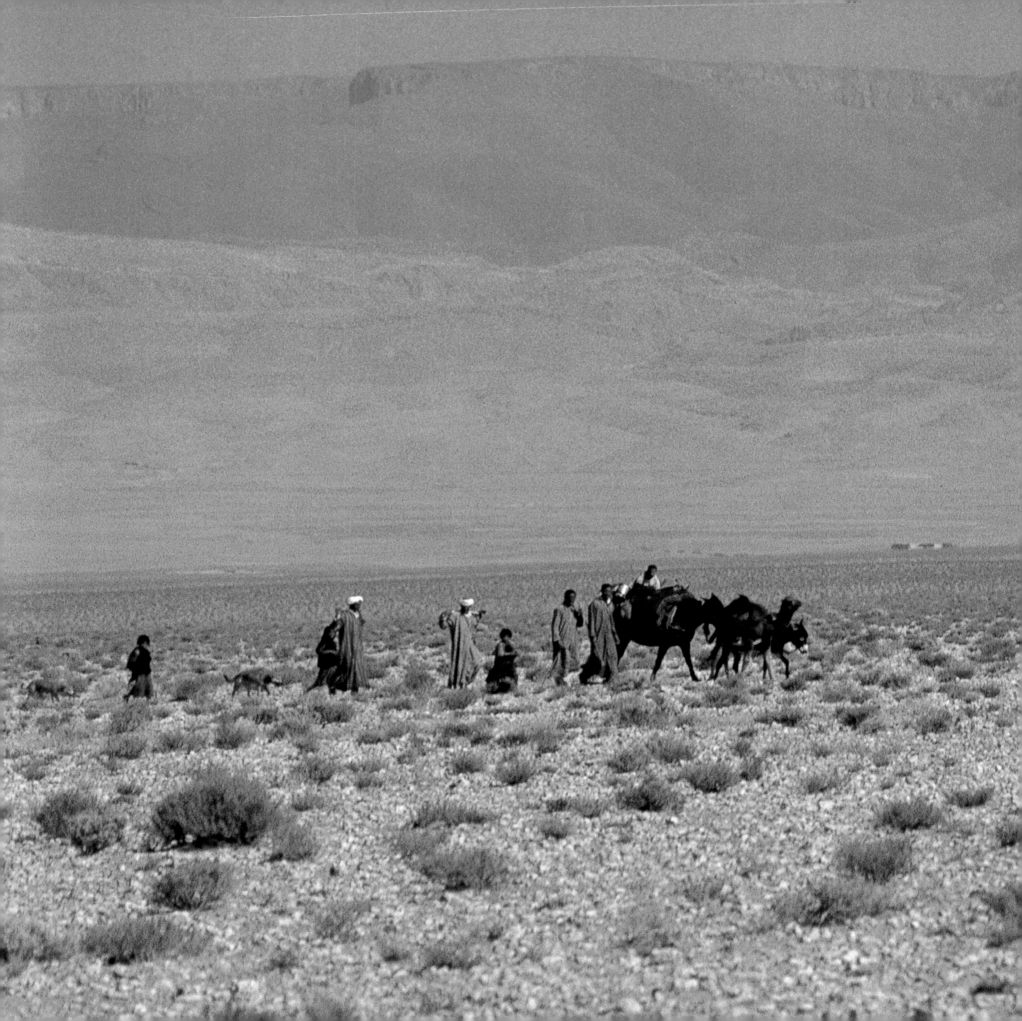

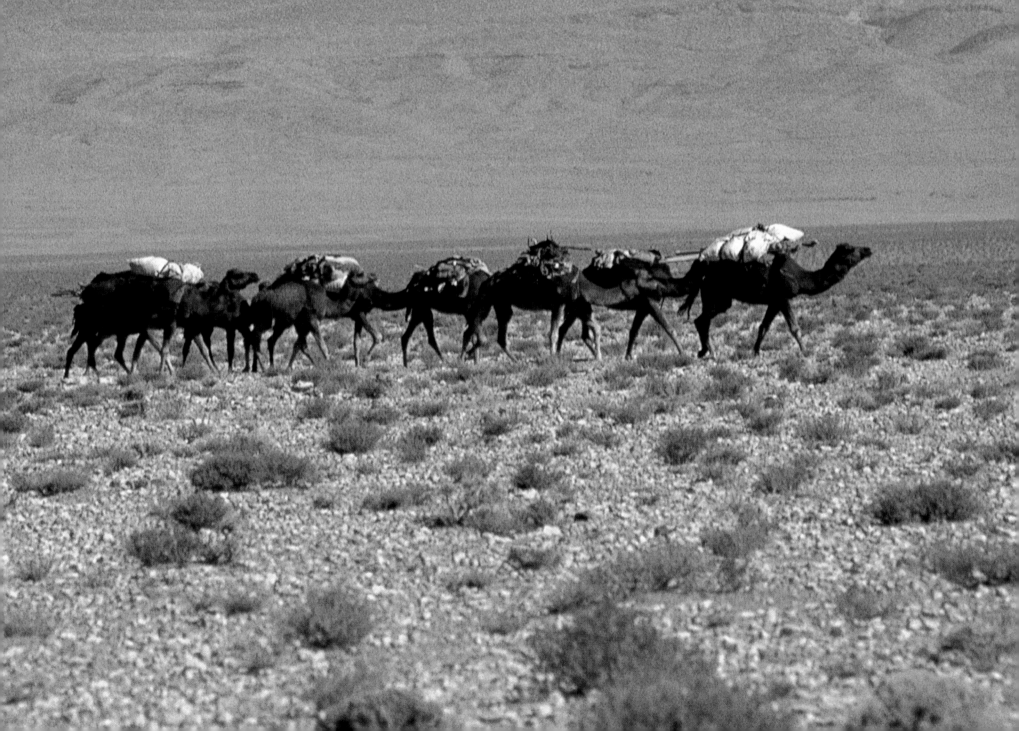

Preceding pages: Dromedaries and mules are an integral part of the Moroccan landscape and are used for transporting nomads and their goods.

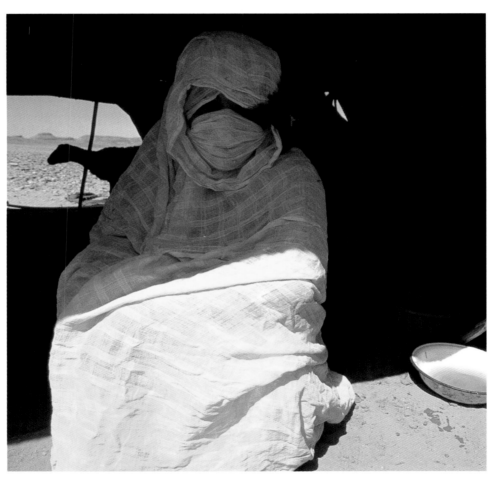

Above: On Morocco's Hammada, the stony southern plateau of the Sahara, beyond Mhamid, scattered Berber tribes live in tents and makeshift dwellings for as long as underground water can be drawn from improvised wells.

Opposite: Nomad Berber children are strapped to mules or camels along with the family possessions while on the move. Men usually take care of the children, while the women trail several days behind with the herds of sheep and goats.

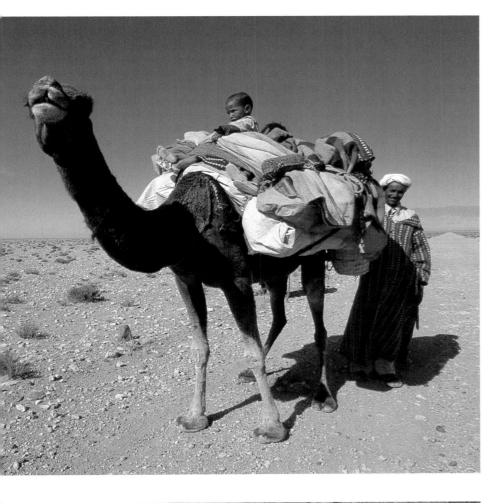
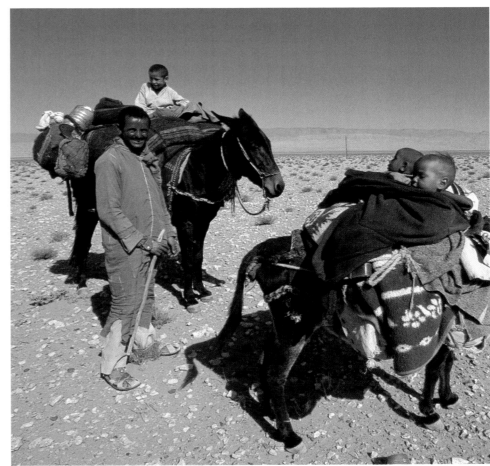
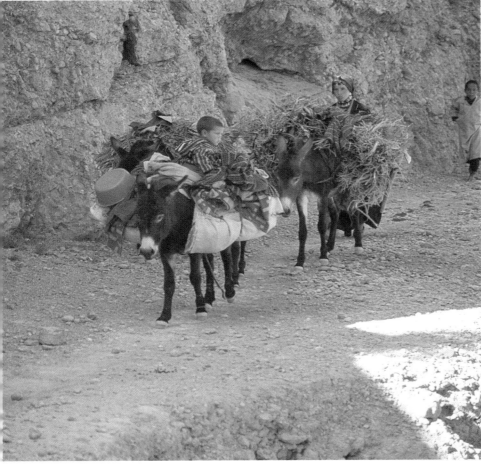
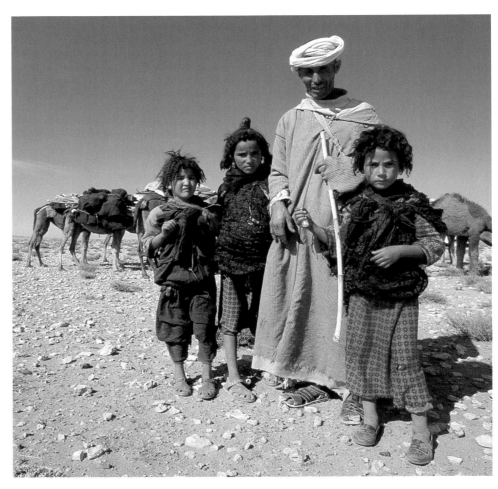

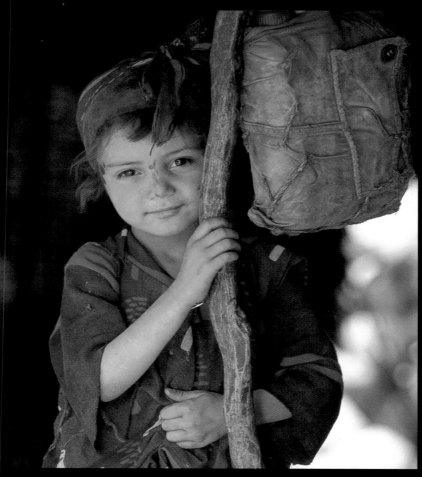

Above: Arkira, a child of the Ait Atta tribe, has lived with her parents, Yosef and Edza, in a tent in a gully of the Todra Gorge near Tamtatouch for several years.

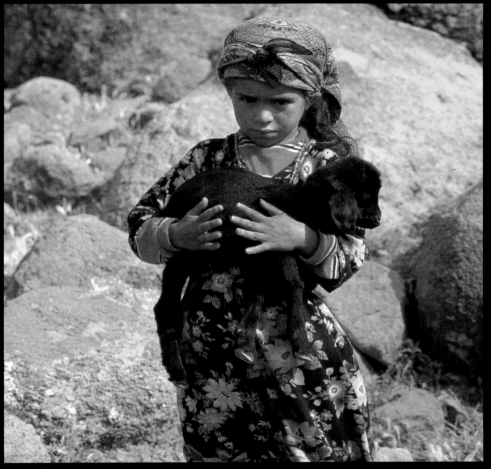

Above: Tloho Ighajamne, also of the Ait Atta tribe, is on the move with her family traveling from the pre-Saharan Sarho Mountains to the High Atlas in search of grazing for their livestock that consists of 200 sheep and goats, 10 dromedaries, and 5 donkeys.

Following pages: A nomad family on the outskirts of Boumalne Dades drives flocks to water in the Dades River before continuing into the High Atlas Mountains, Morocco.

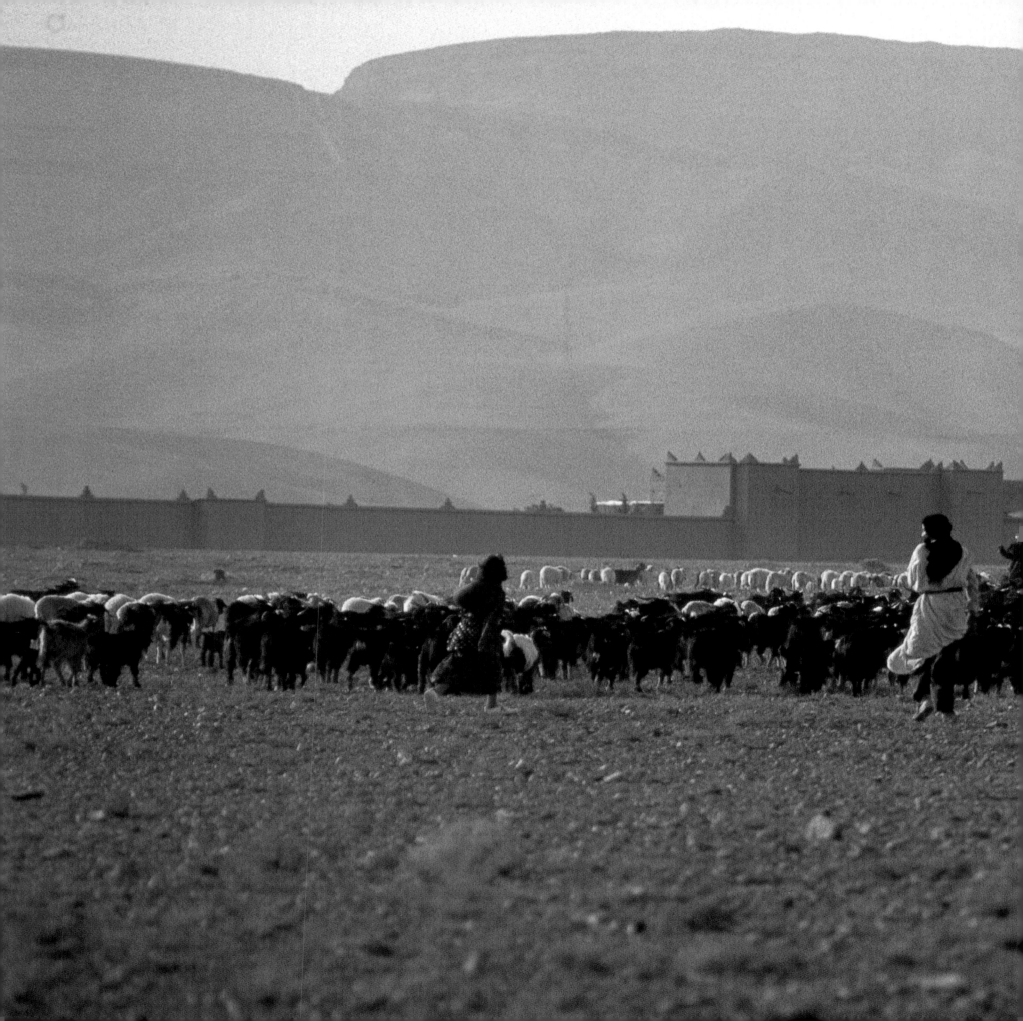

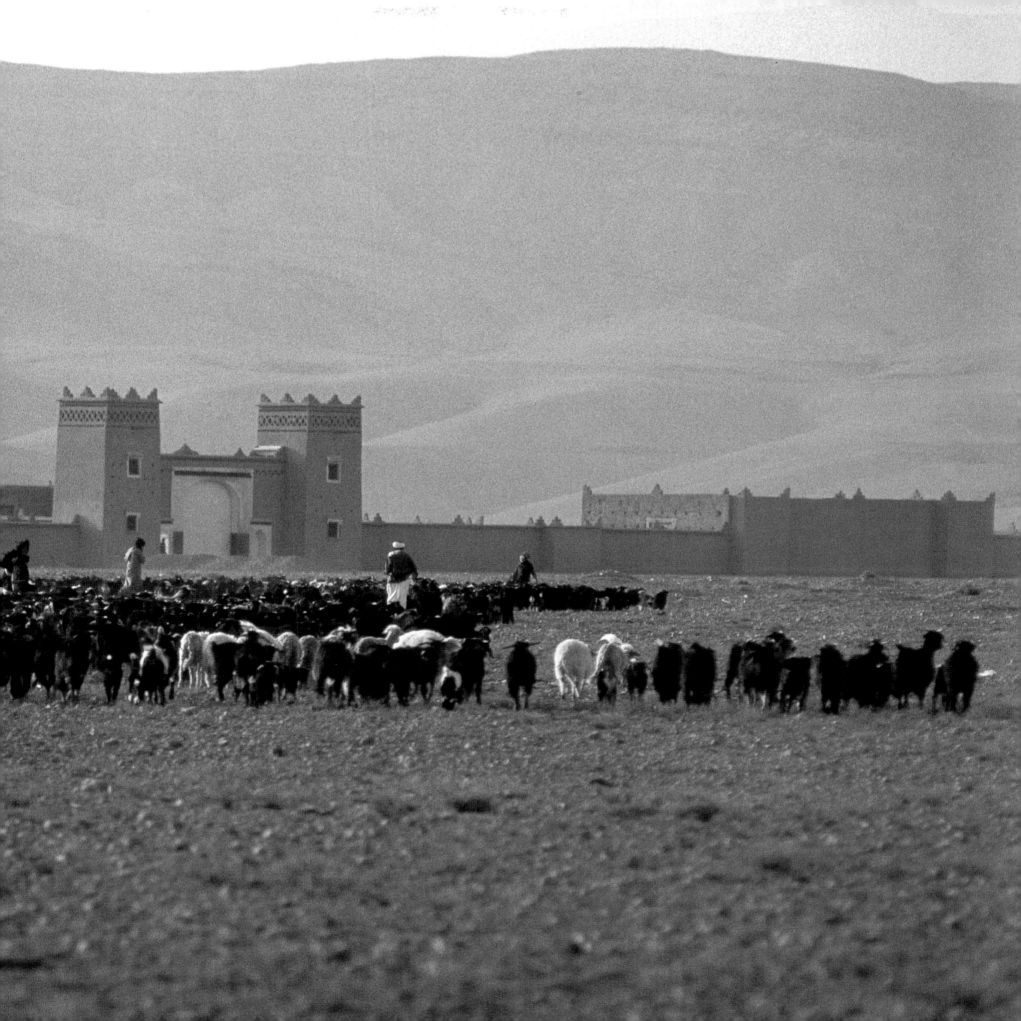

Below: Zohra Lemnaouar shakes a sheepskin of cow's milk to make butter while her younger sister steadies the forked bough. The remaining buttermilk is usually served over steaming couscous. *Boumalne Dades, Morocco*

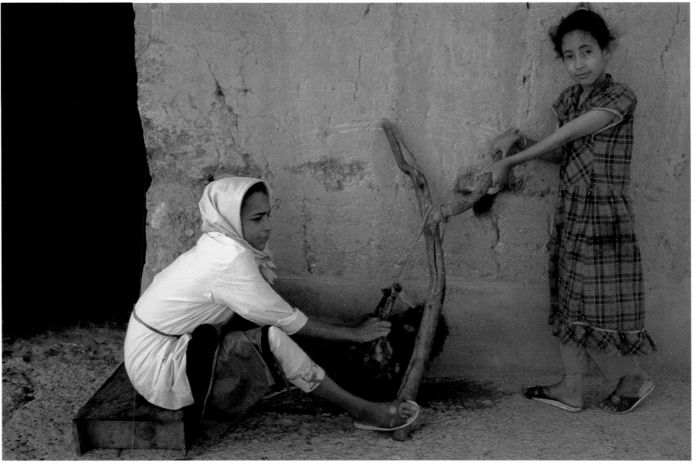

Opposite, top and bottom left: Women of the Ait M'Goun tribe wash fleece at the river. Valley of Roses, Morocco. Top right: Aïcha Lemnaouar cooks bread in the traditional clay dish in the open-hearth kitchen used for baking. Boumalne Dades, Morocco. Center left: A Berber woman from the rural community of Oued Amlil in the lower Rif Plains of Morocco bakes bread outdoors. Center right: In the Valley of Birds, at the foot of the

Sarho Mountains, Touda Rahou's daughter bakes bread in a traditional clay oven used mostly by the Ait M'Goun tribe. Bottom right: Kbira prepares mint tea over a sagebrush fire in the family cave dwelling in the Valley of Roses, Morocco. Both parents are away most of the day, either tending their flocks, walking long distances to fetch water, or going to the weekly market for provisions.

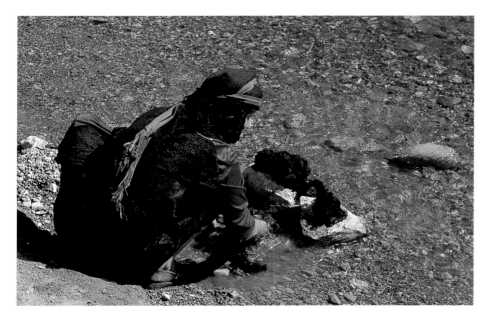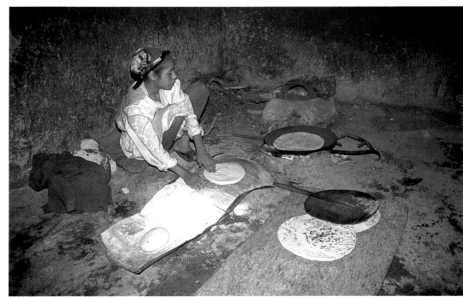

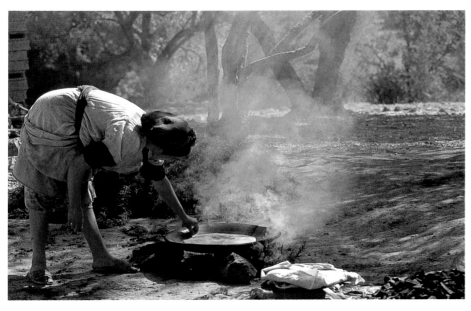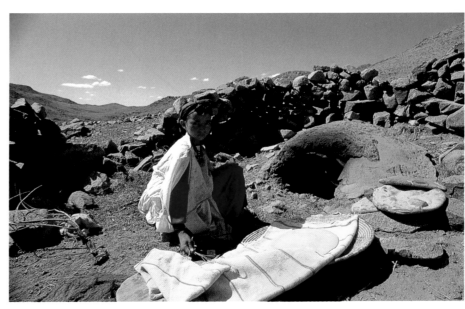

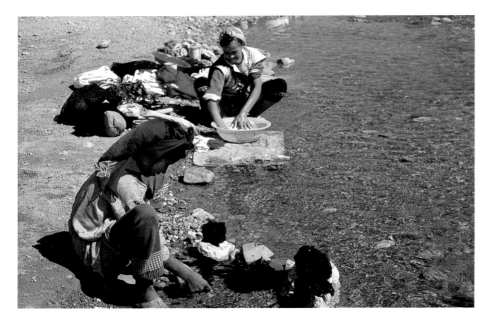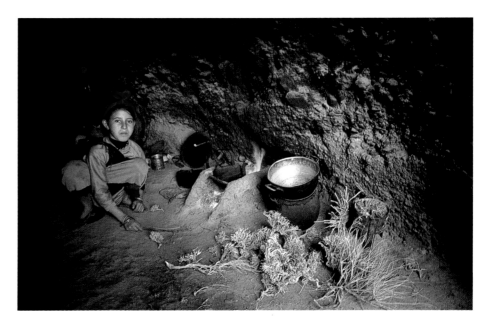

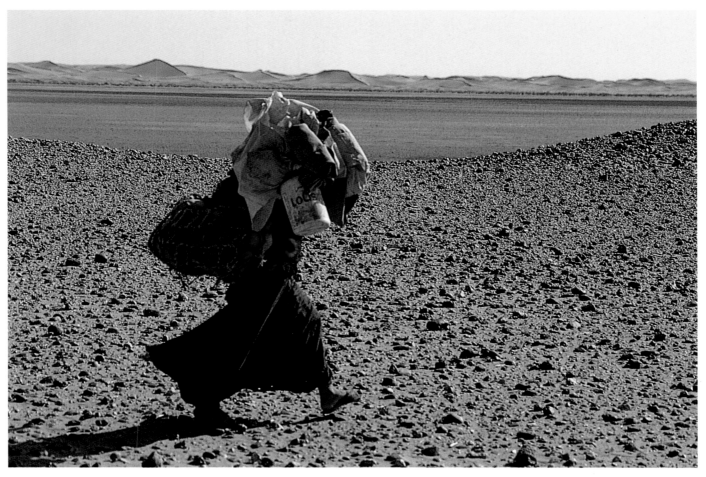

Above and opposite, bottom right: On the Hammada of the Draa River, the stony plateau of the Sahara, in the southernmost part of Morocco. Opposite, top left: On the icy and windswept plain of the High Atlas Mountains near Lake Tislit, Morocco. Top right: On the outskirts of Imilchil, Morocco. Center left: In the southernmost desert town, Mhamid, Morocco. Center right: In the High Atlas village of Ihoudiene, Morocco. Bottom left: Douirat, Tunisia.

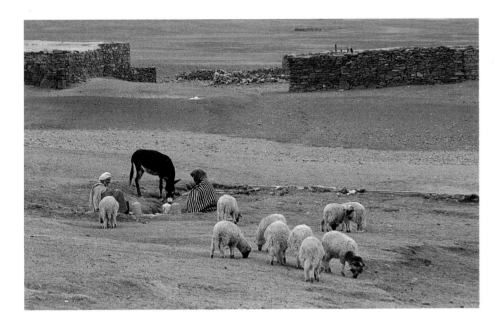
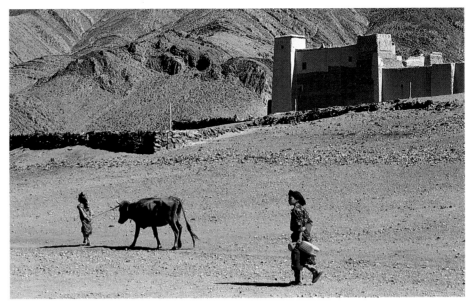

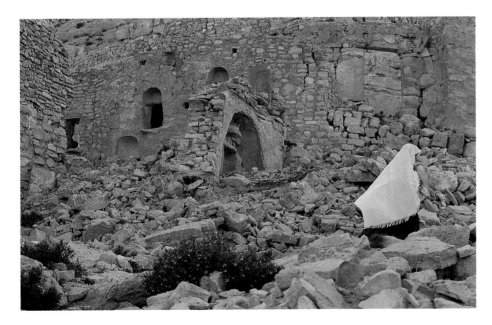
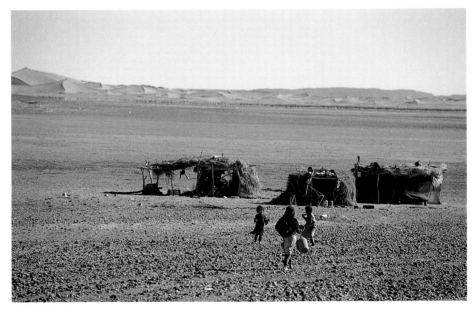

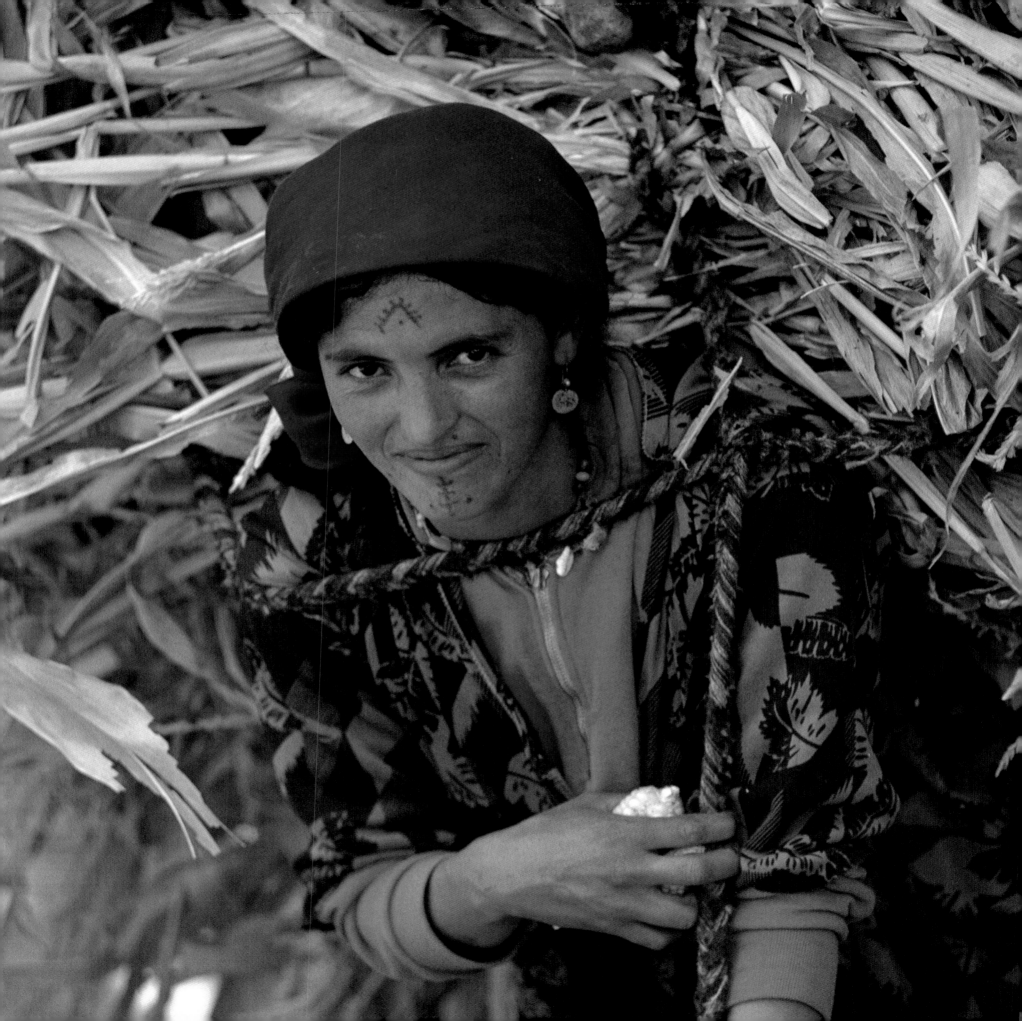

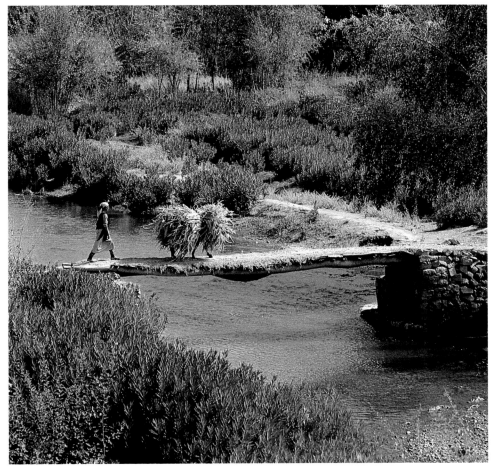

Opposite and above: Women returning from the fields with animal fodder along the Dades River, Morocco

CELEBRATIONS

Survival against odds is worth celebrating. Berber lives are enriched by ceremonies that mark the continuation of existence. While some are women-only events, as is common in Muslim cultures, others demand that men and women join together in celebration. In traditional Berber dance, men and women stand side by side and move in graceful unison. Voices, too, are joined in ancient songs, chants, and joyous ululation.

The joy of a wedding, with its strengthening of family bonds and promise of renewal, may be savored over several days, in a party that moves from the house of the family of the bride to the house of the groom.

The birth of a child, especially a boy, is another moment at which to celebrate survival. The most elaborate festivals are the women-only parties, marked by chants and ululation, that mark the rite of circumcision.

Other nonfamily occasions include the feasts of saints, which may require travel to distant shrines. Others celebrate myths or moments in history, such as the famous wedding festival of Imilchil, where the legend of a Berber Romeo and Juliet is celebrated by young men and women choosing spouses and announcing their intentions to marry.

Following pages: Women of the Ait Brahim tribe move swiftly in unison, chanting, at times ululating, on their way to a circumcision ceremony, a ritual of their traditional past. Two of the elders carry tall canes with a braided circle of bread covered in bright ribbons and bells attached to the top. Village of Sountate in the eastern High Atlas, Morocco

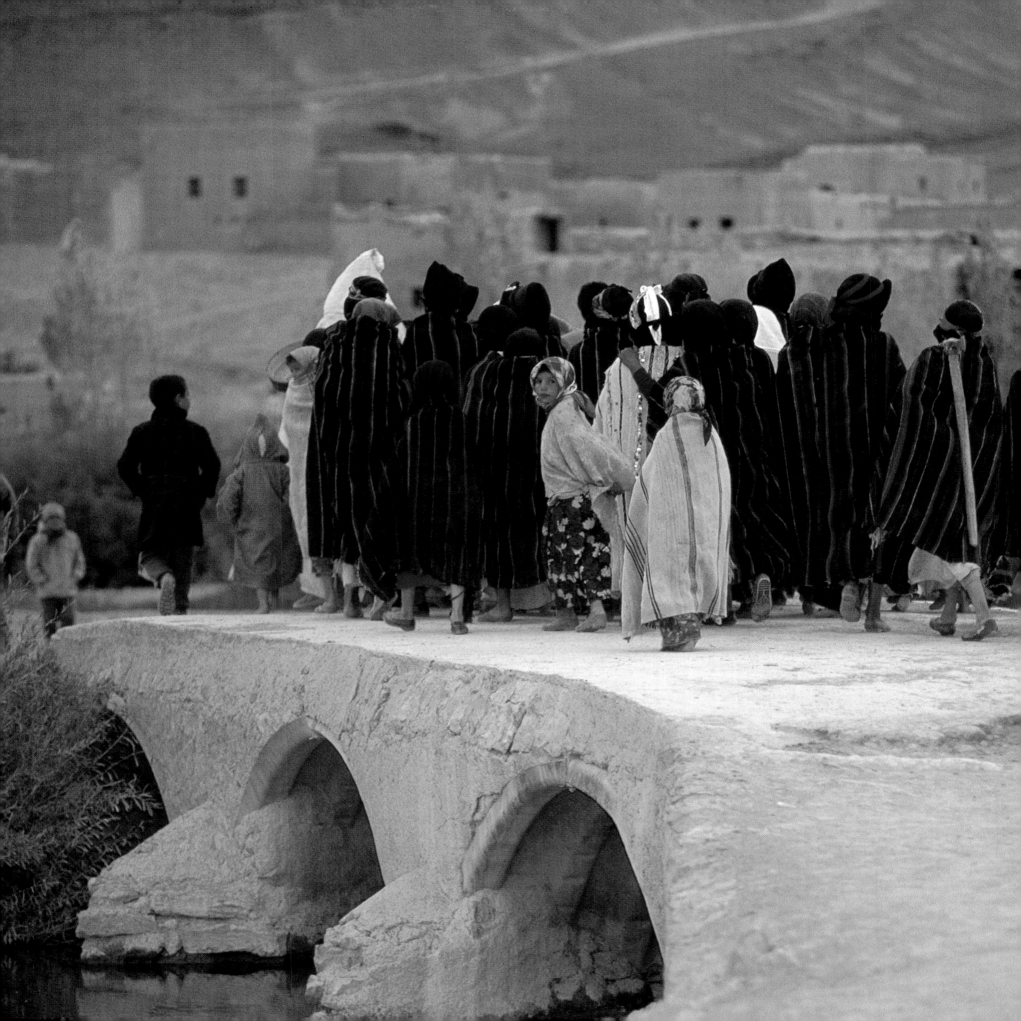

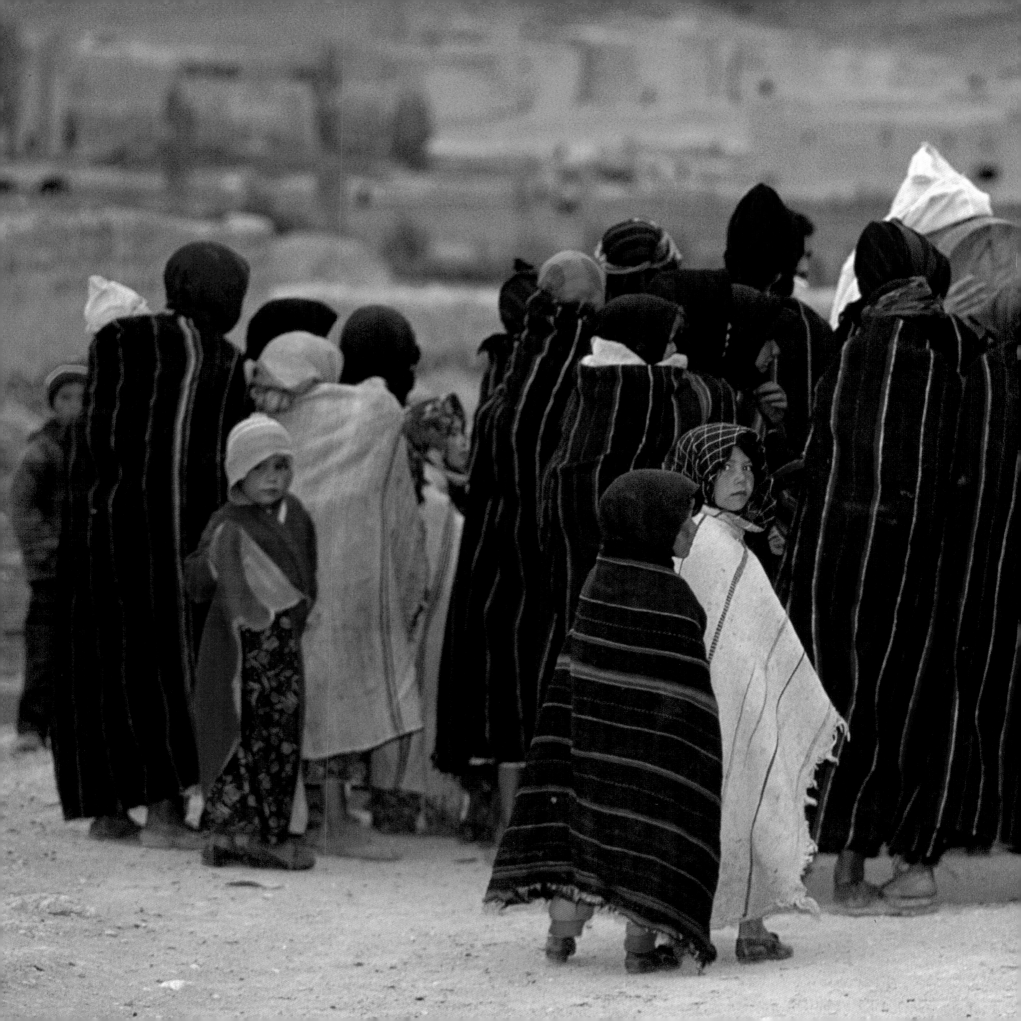

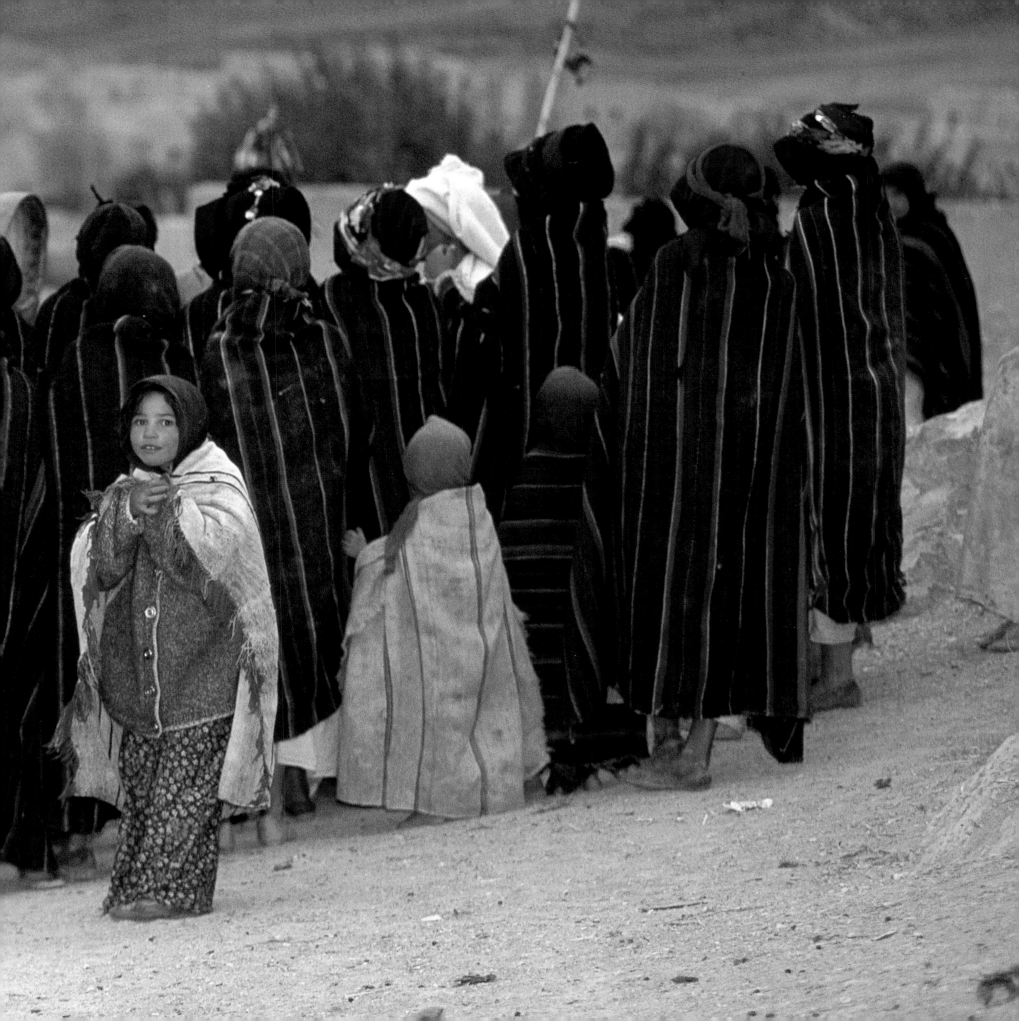

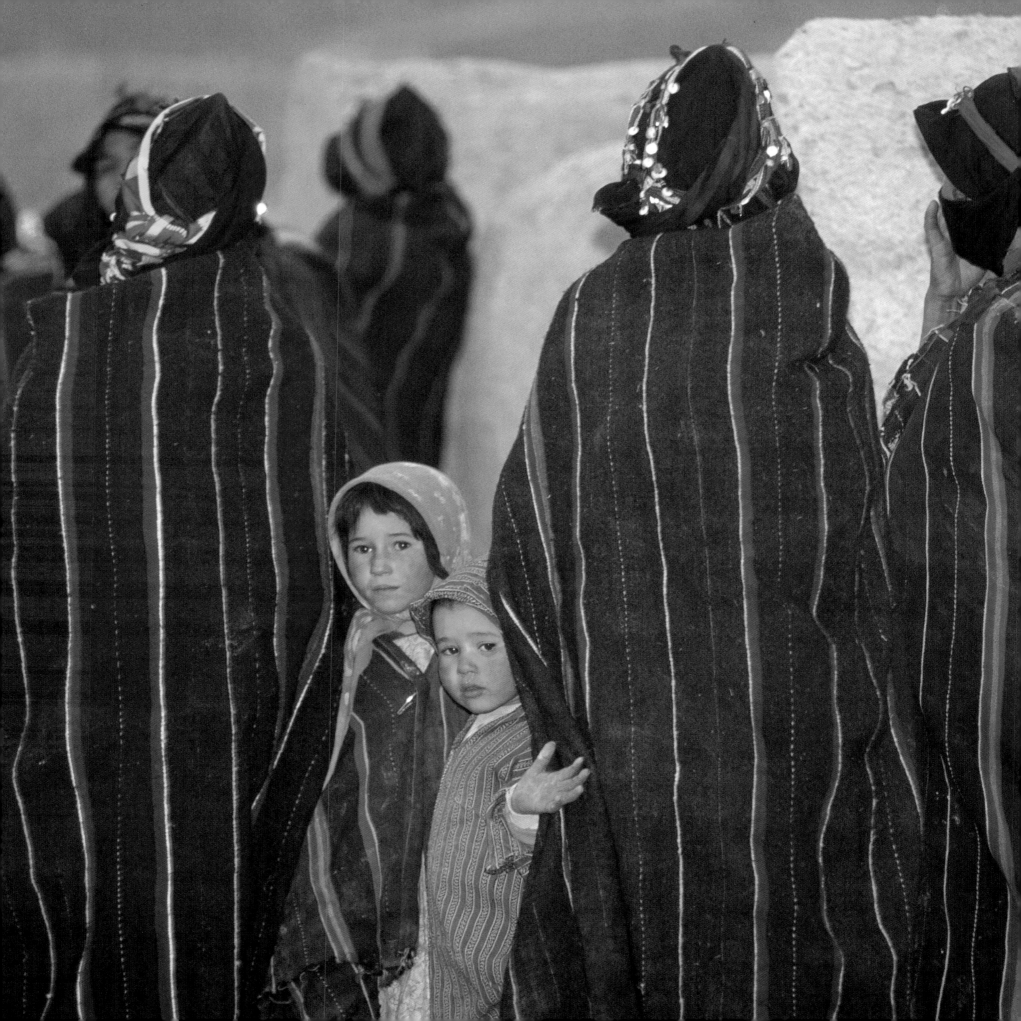

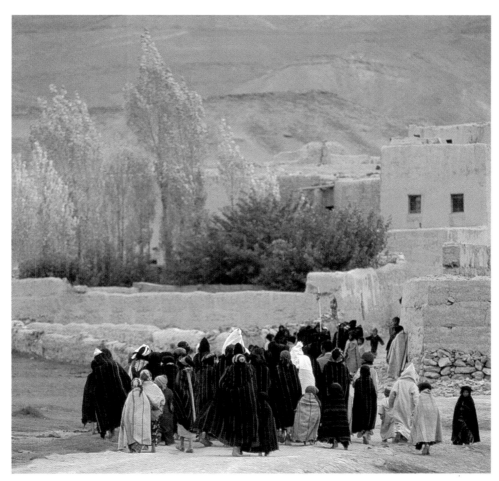

Following pages: Music is an integral part of Berber ceremonies. Men and women of the Ait Brahim tribe attending a week-long wedding celebration stand side by side and move in unison, undulating in rhythm as they chant, clap, and play the tambourine. Bouazmou, eastern High Atlas, Morocco

Above: Women of Sountate, Morocco, dressed in their traditional handiras, *gather for the procession to the circumcision ceremony.*

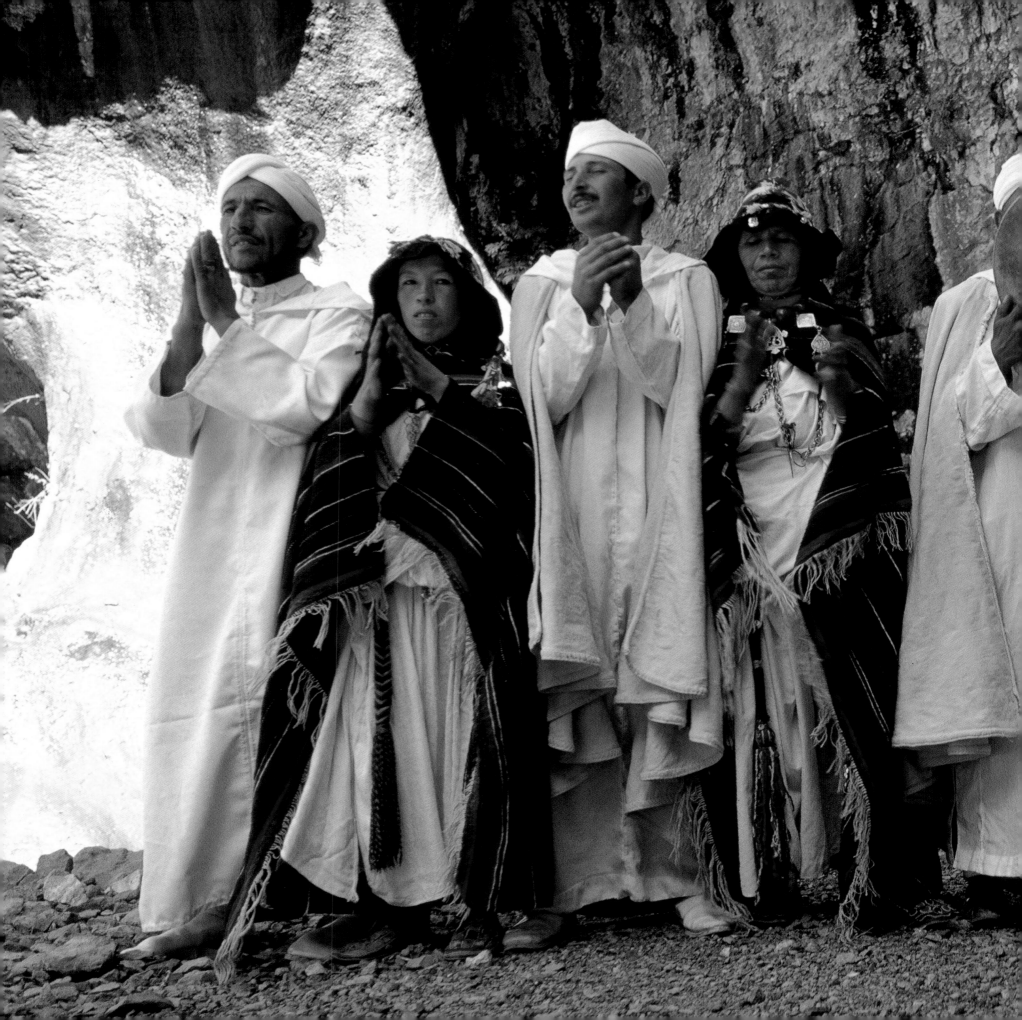

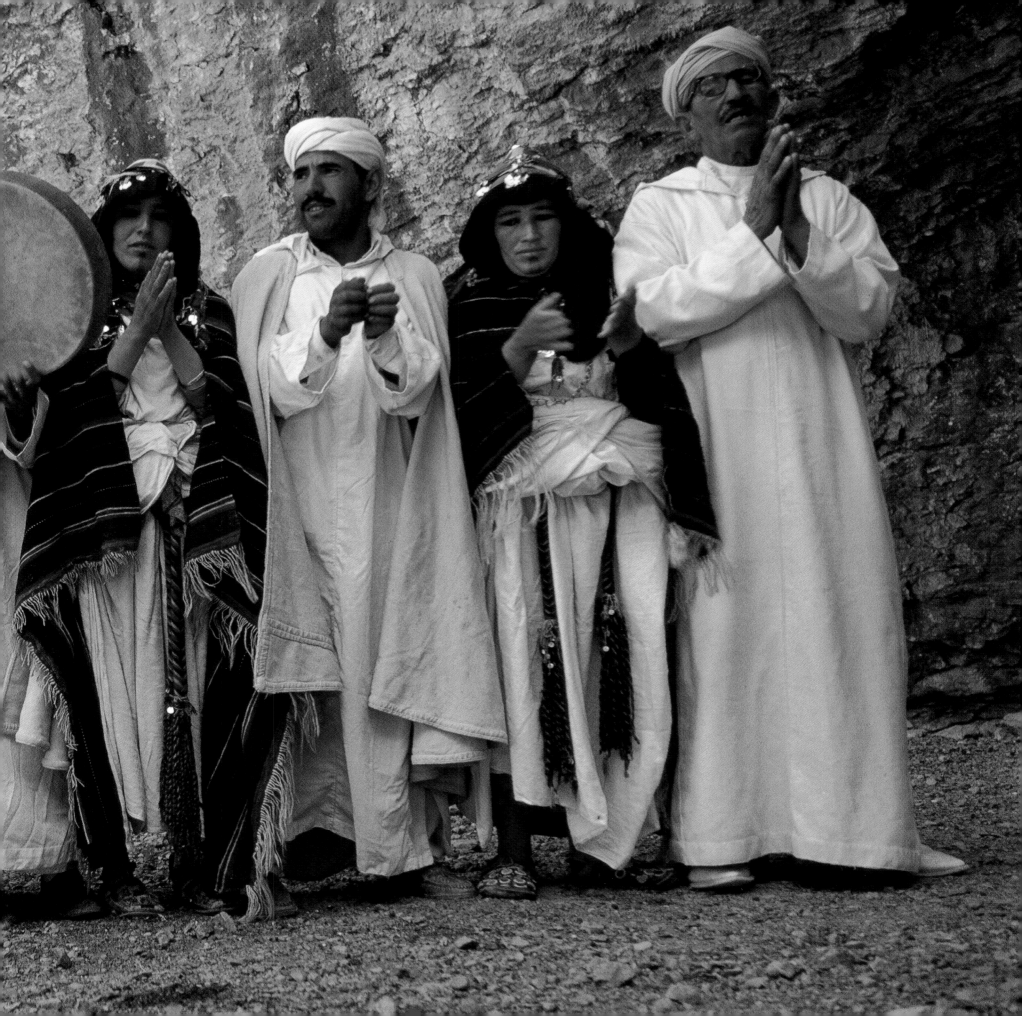

BIBLIOGRAPHY

Abouda, Mohand. *Axxam—Maisons Kabyles—Espaces et fresques murales.* Saint-Ouén: Publicité et Façonnage, 1985.

Barbero, Walter. *Tunisia.* Milano: ClupGuide, 1982.

Bourdier, Jean-Paul, and Trinh Thi Minh-ha. *African Spaces: Design for Living in Upper Volta.* New York: Holmes & Meier, 1985.

Bourgeois, Jean-Louis, and Carollee Pelos. *Spectacular Vernacular: The Adobe Tradition.* New York: Aperture, 1989.

Bureau d'Etudes et de Recherches d'Art de la Tutelle Générale des Societes Agricoles de Prevoyance. *Jeux de trames en Algérie.* Algiers: Editions SNED, 1975.

Centre Georges Pompidou. *Architectures de Terre.* Paris: Editions du Centre Pompidou, 1986.

Courtney-Clarke, Margaret. *African Canvas.* New York: Rizzoli International, 1991.

———. *Ndebele: The Art of an African Tribe.* New York: Rizzoli International, 1986.

Crowther, Geoff, and Hugh Finlay. *Morocco, Algeria & Tunisia.* Hawthorn, Australia: Lonely Planet Publications, 1989.

Davidson, Basil. *Africa in History.* Rev. ed. New York: Macmillan, 1974.

Dennis, Lisl, and Landt Dennis. *Morocco.* New York: Clarkson Potter, 1992.

De Rosa, Daniela. *Marocco.* Milan: Moizzi, 1994.

Dethier, Jean. *Lehmarchitektur.* Munich: Prestel-Verlag, 1982.

Devulder, M. *"Peintures Murales et Pratiques Magiques dans la Tribu des Ouadhias." Revue Africaine.* Algeria, 1960.

Fisher, Angela. *Africa Adorned.* New York: Abrams, 1984.

Fiske, Patricia L., W. Russel Pickering, and Ralph S. Yohe. *From the Far West: Carpets and Textiles of Morocco.* Washington, D.C.: The Textile Museum, 1980.

Kasriel, Michèle. *Libres femmes du Haut-Atlas? Dinamique d'une micro-société au Maroc.* Paris: Editions l'Harmattan, 1989.

Knopf Guides. *Morocco.* New York: Alfred A. Knopf, 1994.

Lamazou, Titouan, and Karin Huet. *Sous les toits de terre.* Lons, France: Publi-action, 1988.

Laouste-Chantréaux, Germaine. *Kabylie côté femmes: La vie féminine à Aït Hichem.* Aix-en-Provence: Edisud, 1990.

Ministère de l'Agriculture et de la Révolution agraire. *A la rencontre de la poterie modelée en Algérie.* Algiers: Editions SNED, 1975.

Murray, Jocelyn, ed. *Cultural Atlas of Africa.* New York/Oxford: Facts on File, 1981.

Nelson, Nina. *Tunisia.* New York: Hastings House, n.d.

Picton, John, and John Mack. *African Textiles.* London: British Museum, 1989.

Reswick, Irmtraud. *Traditional Textiles of Tunisia.* Los Angeles: Craft and Folk Art Museum, 1985.

Rogerson, Barnaby. *Morocco.* London: Cadogan, 1989.

Touring Club Italiano. *Morocco.* Milan: TCI, 1994.

———. *Tunisia.* Milan: TCI, 1990.

Wenzel, Marian. *House Decoration in Nubia.* London: Duckworth, 1972.

GLOSSARY

AFUS IZEM: A highly stylized motif symbolizing a lion's paw.

AKOUFI: A large storage vessel for grain, built in mud with relief decoration—particular to traditional Kabyle interiors (Algeria).

AKSOUL: A snow shovel.

ASSIOU A soft stone found in the Rif Mountains. It is ground into a powder and mixed with water to decorate pottery.

BABOUCHES: Leather heelless slippers worn by men.

BAKHNOUG: A large rectangular shawl worn by women of the mountain regions of southern Tunisia.

BIADA: White lime, used in the first coating of pottery before the decoration is applied (Rif Mountains).

BOUL THOR: A motif named after the tracks of oxen pulling a plow (Tunisia).

BURNOUS: A man's traditional cloak with hood, worn throughout the Maghrib.

CAID: A person responsible for an administrative district, leader.

CASBAH: The citadel of a town or, in rural areas, an inhabited fortress.

CHEHDA: A honeycomb motif (Tunisia).

COUSCOUS: A staple food of North Africa consisting of small grains of steamed semolina.

DJELLABA: A man's robe, usually cotton.

FADIS: A plant found throughout the Rif region. It is used by women to make a dye for decorating pottery.

FOUTA: A woven cotton fabric worn as a wraparound skirt by Berber women of the Rif region (in red and white stripes) and in the Great Kabylia (in red and yellow-orange stripes).

GHORFA: A small domed, rectangular structure particular to Tunisian architecture, though Roman in origin. It is characterized by its extreme versatility that also allows single units to merge one with another, side by side or above, to form tiers. It was once used for storing grain in a KSAR.

HAMBEL: A striped blanket or wall hanging, roughly woven by Berber women.

HAMMADA: A stony plateau of the Sahara, Morocco.

HANDIRA: A large woolen shawl worn as a cloak by Berber women. The different colors and stripes identify the different tribes.

HENNA: A plant grown throughout North Africa from which dye is extracted. It is used by Berber women to dye their hair and stain the skin.

HOUTET: A fish (Tunisia).

IKOUFANE: The plural of AKOUFI.

JEBEL: A mountain.

KHALKHAL: Engraved silver-alloy anklets.

KHATTAT: A small brush made of goat hair, used by women to decorate pottery.

KILIM: A striped flat-woven textile made in size according to its use: rugs, wall hangings, saddle blankets.

KOHL: A black powder made from antimony sulfide, mixed into a paste. It is used by women as makeup.

KOUBBA: A shrine or tomb of a local saint (MARABOUT) and often the place of female spirituality.

KSAR: A fortified stronghold or village.

MAGHRIB: Literally, "Where the sun sets," used to describe the three countries of Tunisia, Algeria, and Morocco.

MARABOUT: A local saint.

MATORRAL: A stunted vegetation found throughout the High Atlas Mountains—the result of damage inflicted by humans.

MERGHOUM: A flat-woven textile resembling a KILIM that consists of plain transverse stripes and a few decorated bands with geometric motifs. It is used as a floor rug or wall hanging (Tunisia).

MOUCHOT: A comb used in weaving.

OUED: A river.

OULILI: A spider.

PISE': Mud and rubble rammed between wooden slats to form walls.

SFIRA: Red earth (Rif Mountains).

SOUK: A market.

TAFROUGHT: A palm tree.

TAJINE: A traditional Moroccan stew cooked over a brazier. It is named after the flat earthenware plate with a cone-shaped lid in which it is cooked.

TAKEDCHA: An earthworm (Tunisia).

TARIFCHT: Berbers who dwell in the Rif region.

TARSASTE: A milk pot with curved lip to facilitate drinking (Rif region).

TASHKOUFT: A plate.

TAZZITOUN: An olive tree.

TEMCHRATT: A pair of scissors.

TEYED'MT: Wooden clips used to pull weaving tight across the loom.

TIDJAD: A bird (Tunisia).

TILIT: Seeds.

TIMZIN: Barley.

TIT' N-TESKOURT: The eye of the partridge.

ZITOUN: Olives.